THE PORTRAIT PAINTER'S PROBLEM BOOK

THE PORTRAIT PAINTER'S PROBLEM BOOK

BY PAUL C. BURNS AND JOE SINGER

WATSON-GUPTILL PUBLICATIONS/NEW YORK

First published 1979 in the United States and Canada by Watson-Guptill Publications,
a division of Billboard Publications, Inc.,
1515 Broadway, New York, N.Y. 10036.

Library of Congress Cataloging in Publication Data
Burns, Paul Callan.
 The portrait painter's problem book.
 Bibliography: p.
 Includes index.
 1. Portrait painting—Technique. I. Singer,
Joe, 1923- joint author. II. Title.
ND1302.B87 1979 751.4'5 78-32012
ISBN 0-8230-4186-7

Manufactured in Japan

First Printing, 1979

2 3 4 5 6 7 8 9/86 85 84 83

CONTENTS

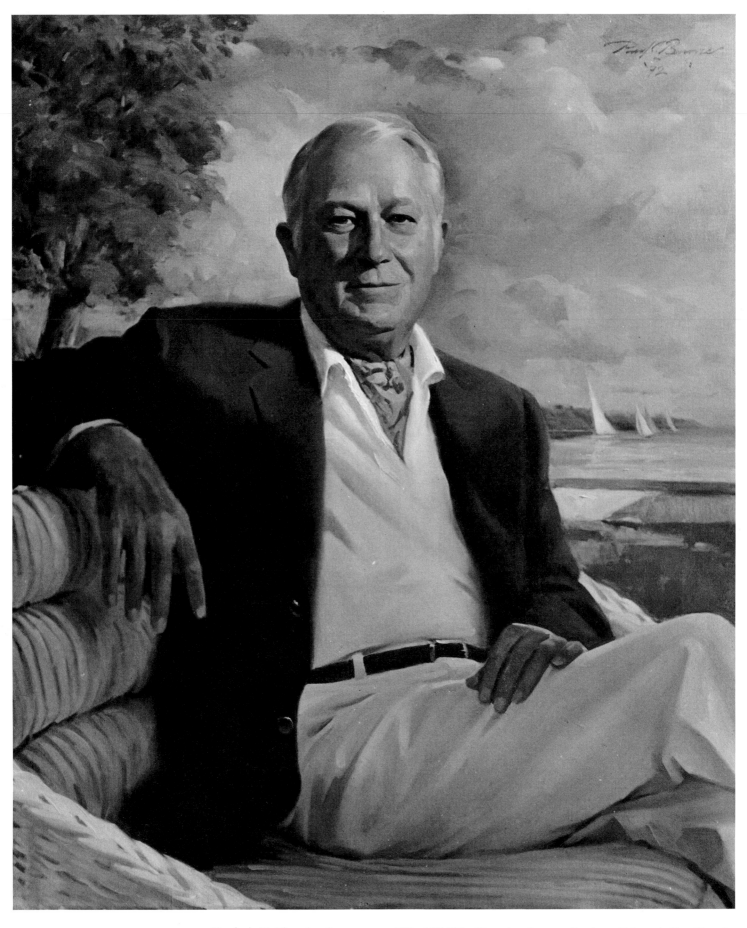

Frederic C. Church, *oil on canvas, 38" x 32" (97 x 81 cm), private collection. Although Mr. Church is a successful businessman, I've tried to convey the casual, amiable air he projected. I started another portrait of him in Nassau, but the one shown here was based on a subsequent sitting at his home.*

FOREWORD

Learning to paint is like learning to play a musical instrument—once you learn the basic techniques, you can play all sorts of melodies. But first you need certain essential ingredients in order to communicate with your audience.

What are these ingredients? First, there's attitude. You must have the desire to be a good artist, and then the persistence to practice your art as long as it takes to master it.

Then, obviously, you need the proper materials, such as canvas, paints, brushes, mediums (oil, turpentine, and varnish), rags, and a container filled with turpentine for cleaning brushes.

You must also have the perception or vision to really see what happens, for example, when light falls on a three-dimensional object, revealing the solidity of that form. Your ability to perceive this, in turn, will enable you to create the illusion of three dimensions on a two-dimensional surface.

You also need the technical ability that will enable you to record what you see. In drawing, this means you must be able to indicate the large shapes that are made up of masses and planes of various proportions, each revealed differently under different types of lighting. In values, this means you must be able to determine the correct value of objects and note the subtle changes created when various planes of the head move into the light or away from it into the shadow. You must also know how to control reflected light and emphasize, as Charles Hawthorne, founder of the famous Cape Cod School of Art in Provincetown, used to say, the "truth" of the halftones and cast shadows, because that's what makes form appear solid. In terms of color, this means you must be able to relate one color to another, such as those in the head with that of the background or the ones in the suit or dress with that of the hair. Comparisons in color are just as revealing as comparisons in scale. Just as a little fellow looks smaller when surrounded by a lot of big fellows, and looks bigger when all his buddies are smaller than he is, so a red scarf looks brighter against a muted green dress, or a dark background makes a light-haired model appear to come forward.

As a serious student of portraiture, you should also be well acquainted with the old masters of the past as well as the top professionals of today. Therefore, you must visit the finer galleries and museums and make copies of great paintings when you have time— they don't have to be exact copies, just close enough to enable you to see how your favorite artist, for example, applied his pigments. You should also visit art libraries to look through the marvelous collection of art books available and should begin to gradually acquire your own library of books about painting and artists.

Another essential ingredient for a portrait painter is patience and tolerance. Even though we're all different, with different personalities, temperaments, and backgrounds, when we're dealing with people, always remember to be kind and gracious to your sitters. You'll be well rewarded.

Finally, as Peter Paul Rubens once said, "The requirements of an Artist are a sound mind and a healthy body."

In closing, I'd like to wish you one last ingredient—luck. Happy painting!

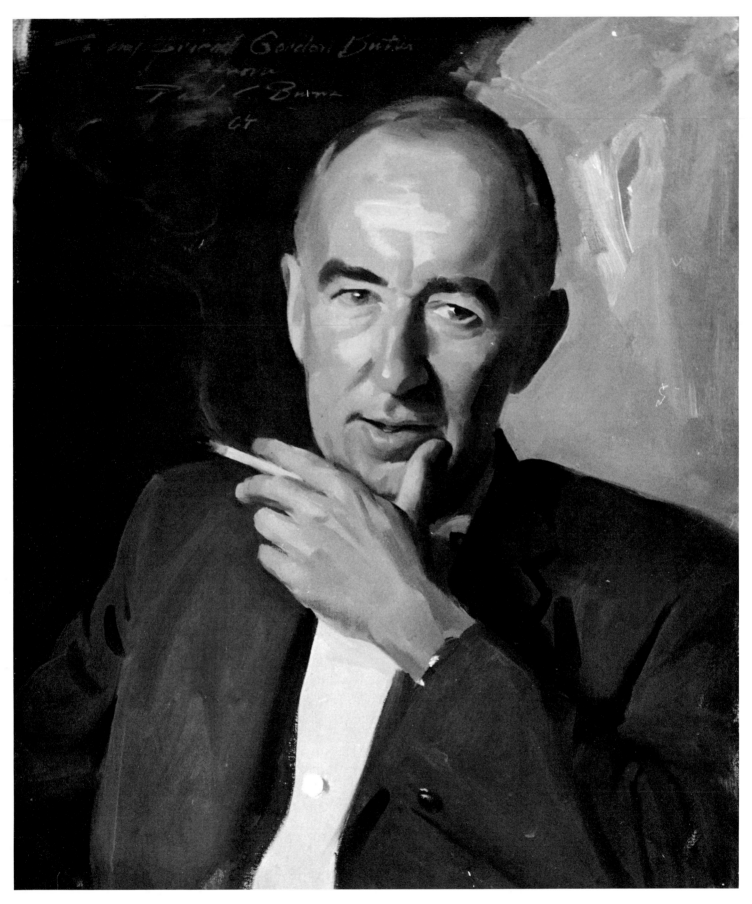

Gordon Butler, *oil on canvas, 24" x 20" (61 x 51 cm), Collection Ho-ho-kus Inn, Ho-ho-kus, New Jersey. This is the same person I painted in Demonstration 11 to illustrate backlighting. Another portrait of him (see page 102) hangs in Portraits Incorporated, New York, as a sample of my work. Gordon was a student of mine and a good friend, and I painted all three of these portraits from life. This is a casual pose Gordon often took.*

PURPOSE OF THIS BOOK	*The Portrait Painter's Problem Book* takes a comprehensive approach to some of the problems encountered in painting people, then offers concrete, practical concepts, advice, and techniques designed to help you overcome the difficulties you'll encounter in each particular problem through a series of full-color demonstrations.

The Portrait Painter's Problem Book takes a comprehensive approach to some of the problems encountered in painting people, then offers concrete, practical concepts, advice, and techniques designed to help you overcome the difficulties you'll encounter in each particular problem through a series of full-color demonstrations.

The first series of problems involves variations of skin and hair color; the second series, the vital factor of lighting in portraiture; and the third, such special portrait problems as eyeglasses, facial hair, and baldness—in all, twenty different problems confronted and solved in precise, detailed fashion.

My choice of problems was based upon the experience formed by my many years as a teacher, illustrator, and professional portrait painter, and on the questions of my students at the Ridgewood Art Association. Another source was the recollection of my days as a student and the problems that gave me the most trouble.

The purpose of this book, then, is to provide answers to specific problems that you're likely to encounter in your career as a portraitist. The solutions I offer are spelled out as accurately as possible, and are the product of lengthy experimentation, trial, and error. They've worked for me, and I hope they'll save many hours and days of groping and fumbling for you. I wish that in my day such a book had been available, for I know only too well the pain of frustration accompanying the slow road to artistic understanding and facility.

AUDIENCE

This book does not presume to teach the art of painting or of portraiture in general. Rather, it's intended for the more advanced painter who has already mastered the knowledge of drawing, color, tonal relationships, and general techniques of painting, and who is ready to proceed to more specific aspects of portraiture.

The ability to paint a human head is, therefore, a prerequisite to deriving benefits from this book. Thus, when I address myself to the concepts and techniques included here, I must presume that I'm speaking to artists sufficiently knowledgeable to grasp and follow the methods and procedures I'll be demonstrating.

HOW TO USE THIS BOOK

You can gain the most benefit from this book by first reading it through from beginning to end, then going back and executing the demonstrations exactly as indicated. By then, you'll have absorbed everything of value contained in the text and pictures and, hopefully, be able to incorporate some of these lessons into your subsequent efforts.

This isn't to say that my approach is the only way of painting people, since each artist must ultimately find his own way of attaining his goals. However, I offer solutions and techniques that I have gathered from my own work and the years of study and observation accumulated from schools, books, and museums. I arrived at my conclusions by being selective, and I urge you to do the same. First read and absorb everything this book has to say, then follow its suggestions thoroughly. Only then, feel perfectly free to retain whatever seems reasonable, and reject that which doesn't coincide with your own ideas.

STRUCTURE OF THE BOOK

The book opens with a brief discussion of the materials and equipment I've found most practical to use for the painting of portraits. At the end of this chapter I've added a brief section which contains some of my general observations about concepts and techniques in painting portraits.

Then there are twenty demonstrations, each showing how I solve a typical problem confronting the portrait artist. Each problem begins with an introduction describing the nature of the specific problem and the particular difficulties it poses, the materials employed in its execution, the precise color mixtures used, and the techniques utilized. Finally, there's an accurate description of each stage of the painting from beginning to end, accompanied by full-color pictures of each step.

The twenty problems are divided into three parts. The first part deals with coloring in portraiture, the second with lighting considerations, and the third, with special problems such as glasses, profiles, and painting a broad smile.

MATERIALS AND EQUIPMENT

A picture is only as good as the materials from which it was constructed. For that reason, an artist owes it to himself and to the ultimate possessors of his pictures, to be extremely careful in his choice of materials and equipment. Of course, an exception may be made of practice or experimental pictures whose survival is not their prime purpose. Thus, any person interested in serious painting must make it his business to learn all he can about the composition and character of art materials so that his choice will be based upon their quality and permanence.

In this section I'll describe the materials I use in my own work. These products have served me well over the years and I don't hesitate to recommend them to you.

COLORS I use only professional grade Winsor & Newton Artists' Oil Colours, with one exception that I'll explain later. These are the top colors of the firm's line and I have complete trust in their permanence and reliability.

My palette consists of:

cadmium yellow pale
yellow ochre
raw sienna
cadmium orange
cadmium red light
Indian red
burnt sienna
alizarin crimson
ivory black
French ultramarine blue
permanent green deep
zinc white or
flake white no. 2
raw umber (for toning the canvas and drawing only)

Although I normally paint with the full complement of colors, I occasionally execute a portrait with a limited palette. This is true, for example, of Demonstration 13, which was painted without the siennas and green, and of Demonstration 20, which was done in the three primaries only—cadmium yellow pale, alizarin crimson, and ultramarine blue, plus white.

I strongly advise artists to paint heads using limited palettes. A close study of Franz Hals' later paintings demonstrates just what can be accomplished with a limited palette—he used a red, a yellow, white, and a black, which he used to cool colors and lower their value. Experimentation of this type teaches you to fully utilize color and to paint simply and without fuss. At times, I also eliminate a certain color from my palette when I see no need for it in a particular painting.

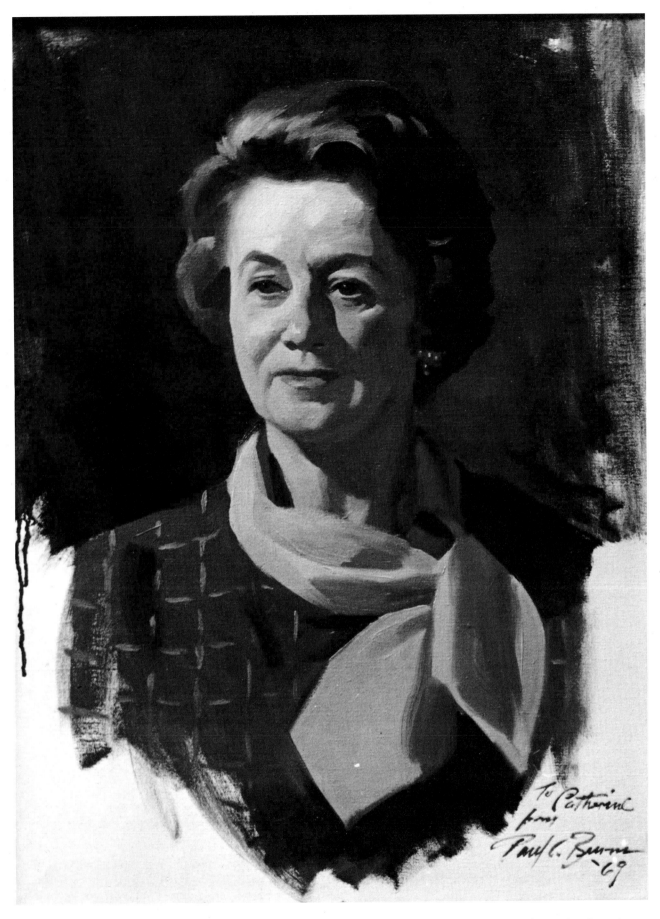

Catherine Gardner, *oil on canvas, 24″ x 20″ (61 x 51 cm), Collection Mr. and Mrs. Gardner. A demonstration portrait led Mrs. Gardner to ask me to complete the painting a bit more so she could buy it for her collection. Since my demonstration paintings usually take between two and three hours to execute, I took another day to finish this one. Note the strong shadows on the right-hand side produced by three-quarter lighting at eye level.*

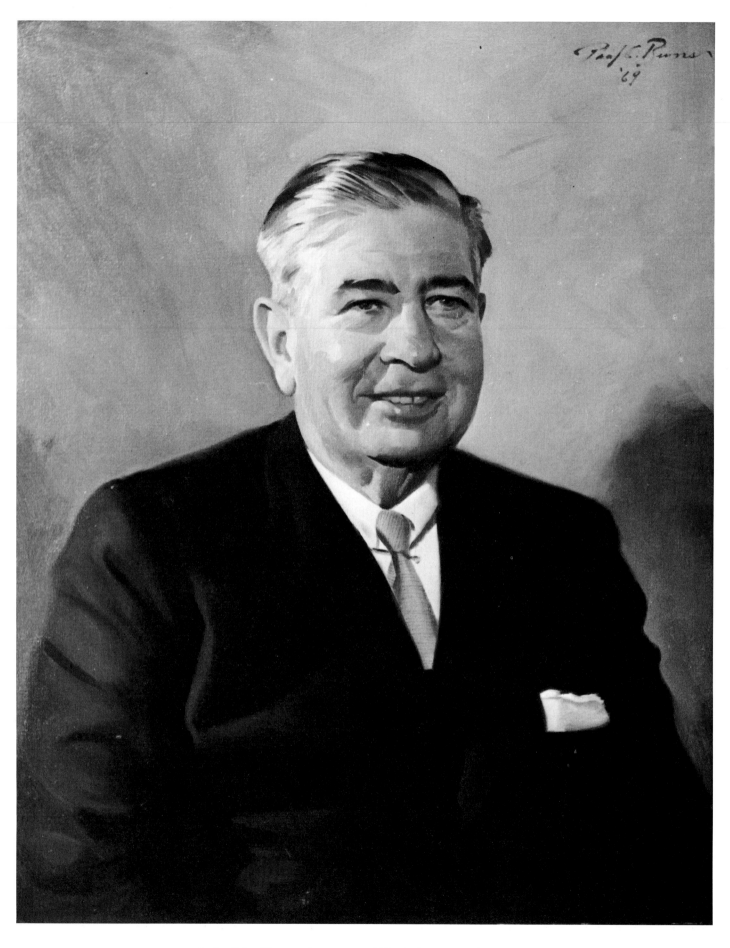

Judge John Flynn, *oil on canvas, 30″ x 24″ (76 x 64 cm), Collection Manhattan Club, New York City. Judge Flynn had been dead for several years when I was commissioned to paint his portrait. Although I'd never met the man, his wife and a close friend gave me a very good description of his coloring and characteristics. Armed with this information and a number of photographs, I executed what I'm told is a very credible likeness of the late justice.*

Some Notes on Color. I like certain tube colors for their individual characteristics. For example, I prefer ultramarine blue instead of cerulean or cobalt blues for its mauvish quality, which is especially appropriate for portraiture. A slight addition of ultramarine blue plus white helps cool and neutralize the warm beige tones in flesh. Cerulean or cobalt blue would tend to render such a mixture too green.

Indian red is very useful for its bluish rose quality. It's not as warm as its close counterparts—light red, English red, Mars red, and Venetian red—and is therefore appropriate for cooling down fiery flesh tones. If I want a *warm* earth red, I turn to burnt sienna.

I find alizarin crimson a most indispensable color for portraits. Its high-keyed, mauvish shade makes it a perfect component for mixing flesh tones with the addition of cadmium yellow and white.

I use raw sienna along with yellow ochre—which it resembles in hue—for the deeper tone it provides, without having to resort to black or burnt sienna to lower the value of the ochre.

Cadmium orange is a most useful color when mixed with ultramarine blue and white to attain a gray which is visually more interesting than that obtained with plain ivory black and white.

Ivory black is a traditional color that was used extensively by such portrait artists I admire as Van Dyck, Hals, Velasquez, and Gainsborough. Mixed with alizarin, it acquires a warm richness; mixed with ultramarine blue, it goes considerably cooler.

I don't use umbers in my painting, preferring to mix my own brown shades which seem richer in tone. However, I do use raw umber extensively for the initial toning or for drawing.

The only exception in my palette to the Winsor & Newton Artists' Professional Oil Colours line is my permanent green deep, which I select from their London Oil Colours list. I find the latter to possess greater intensity.

Because I prefer a soft, almost runny white, I often work a bit of linseed oil and turpentine into my tube white to render it more pliable before I begin painting. I sometimes store this mixture in the air-tight plastic cans in which 35mm film is sold, where it keeps very nicely for a period of several days. For my landscapes and frequently in these demonstrations, I occasionally mix flake and zinc whites together, since the combination provides me with the advantages of each—the body of flake white and the buttery quality of zinc white. However, I usually prefer to use flake white alone for my portrait work because I believe it to be the very best white available.

PAINTING
MEDIUMS
I use two painting mediums only: Pure double-rectified turpentine for toning the canvas or for massing tones in the earliest stages of the painting. And, a 50-50 mixture of turpentine and Winsor & Newton superfine linseed oil, which is manufactured in England. I use this medium to thin my colors in the latter stages of the painting.

BRUSHES
Although I own perhaps 300 brushes of every size, shape, and length, I believe a most credible portrait can be painted with a collection including less than a dozen. Naturally, brushes that are worn should be replaced immediately.

I employ flat and filbert-shaped bristle brushes for general painting, and flat and round sable brushes for the finishing details. I usually begin a painting with wide filbert or flat bristle brushes in size nos. 10 to 12 for massing in the larger forms; proceed to nos. 8 and 7 for more precise modeling of the smaller planes; go down to no. 5 or 4 for details; then conclude with a no. 6 round sable for the smallest highlights, such as the catchlight in the eye.

I never use blenders, since they tend to pull the tones together too smoothly and render the portrait too sleek. Instead, I use a no. 4 Landseer bristle brush that has ½″ (1.3 cm)-wide and 1¼″ (3 cm)-long, firm hairs. By wiggling the brush upward—not by stroking it—I can get a gradual change in color without making the colors too smooth. It's especially useful for scumbling hair tones together.

You can actually get by very nicely with the following complement of brushes for portraits up to 40″ x 32″ (102 x 81 cm): nos. 10, 8, 7, 5, and 3 bristle flats; nos. 10, 6, and 4 bristle filberts, a ⅛″ (0.3 cm)-wide sable flat, and a no. 6 sable round. The filbert brushes, which have an oval shape, are particularly good for scumbling or rubbing in the paint.

THE BRUSH CLEANER	The reason I consider so few brushes necessary is because I use a brush cleaner. This is a homemade device that allows you to clean your brush thoroughly after every stroke so that, in a sense, you begin each new stroke with a clean brush, negating the need for a large assortment.

THE BRUSH CLEANER

The reason I consider so few brushes necessary is because I use a brush cleaner. This is a homemade device that allows you to clean your brush thoroughly after every stroke so that, in a sense, you begin each new stroke with a clean brush, negating the need for a large assortment.

The brush cleaner is a simple, easily constructed device. It consists of a one-pound coffee can with the top removed, into which is placed a twelve-ounce peanut can, also with the top removed. Next, I break off the handle of a tea strainer and fit the strainer over the top of the peanut can. I then fill the peanut can to the top with turpentine. After each brushstroke, I rub the hairs against the strainer so that the residue of any remaining paint floats down to the bottom and the brush emerges paint-free. I then wipe the brush with a piece of rag, and it's perfectly clean and ready to accept a new paint mixture. When I take the brush cleaner on location, I simply cover the coffee can with a plastic top. Any turpentine that slops over the peanut can into the coffee can is easily replaced.

KNIVES

I rarely use a palette knife in portraiture. I only use it occasionally to scrape down an area of unwanted color or to clean my palette.

PAINTING SURFACES

I use two supports, canvas and Masonite boards, for my portrait work.

Canvas. For my serious work I use linen canvas exclusively. Cotton, I've found, besides being less permanent, tends to absorb the oil vehicle faster, which makes the paint layer dry more quickly and acquire undesirable spots of matte finish. But for sketches, experiments, or studies, cotton canvas is quite adequate.

My favorite linen canvas is Fredrix Rix Canvas no. 111, which has a single priming of lead white. The single priming provides me the slight degree of tooth I find more sympathetic to my style rather than the smoother double priming preferred by other artists.

Boards. Although I much prefer the spring and bounce of canvas, I occasionally paint on Masonite board, employing both its rough and smooth sides which, naturally, must first be primed. I've also worked on canvas affixed to Masonite. To get it to adhere, I spread a thin solution of lead white to both the back of the canvas and to the rough side of the board. The canvas is then rolled to smooth out any wrinkles or bubbles, and weighted down with books overnight.

Cardboard and paper surfaces can also be used for experimental purposes.

STRETCHERS

For canvases up to 40″ x 32″ (102 x 81 cm), I use the regular width (1¾″ or 4 cm) stretchers. For larger canvases, I recommend the wider (2½″ or 6 cm) stretchers in combination with crossbars for even greater support.

I always plane or bevel the edges of the stretchers over which the canvas will rest to reduce the danger of its cutting or wearing away the canvas in time.

PALETTE

In my studio, I employ either a hand-held wooden palette that allows me to move freely about and attack my canvas from any position, or the glass top of a table set on casters. The glass top is 15″ x 30″ (38 x 76 cm), ¼″ (.6 cm) thick, and is underlined with a piece of gray pebbleboard to provide a suitable medium tone over which I can squeeze out my tube colors and create my color mixtures.

If I feel particularly pressed for time, I occasionally load two or three palettes before commencing the portrait. This allows me to continue painting without stopping to clean a soiled palette.

I always scrape my palette clean at the end of each day and begin each new painting session with a freshly squeezed set of colors.

EASEL

I use a relatively simple but sturdy wooden easel in my studio work. It's set on casters and is able to tilt forward and backward to adjust to special lighting situations.

I also own a tripod easel that I can fold up and take with me for on-location portraits.

CAMERAS

I use Polaroid black-and-white pictures as guidelines to help me establish the correct value relationships and shapes of forms when the sitter can't give me enough posing time. For details, I employ a Mamiyaflex camera, which takes 2¼″ square negatives and

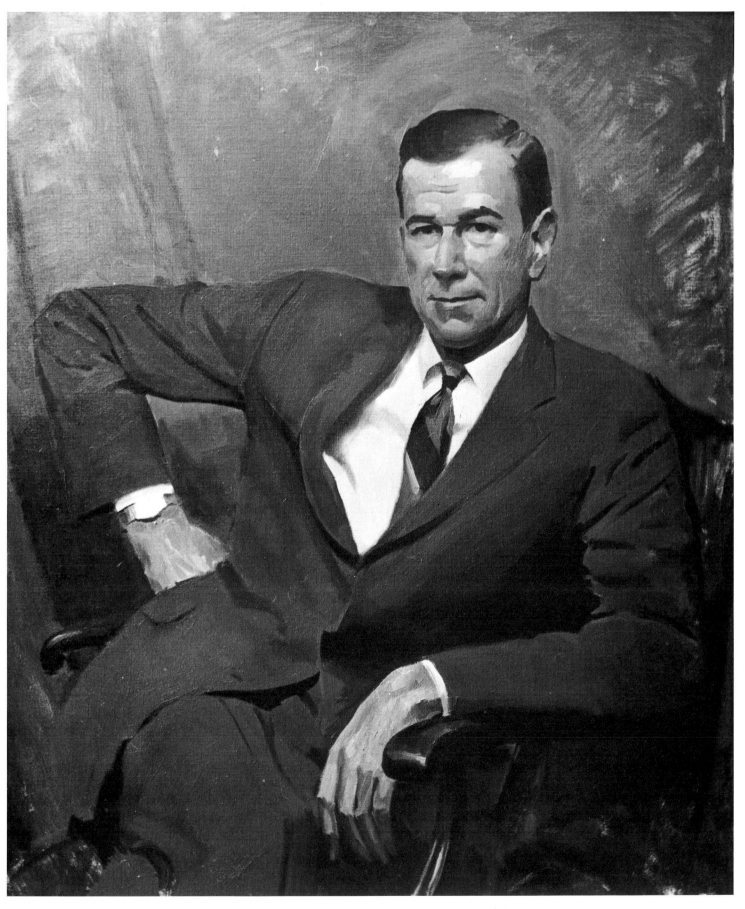

Trygve Sletteland, *oil on canvas, 36″ x 30″ (91 x 76 cm), Collection of the artist at Portraits, Incorporated, New York City. I met this gentleman at a social gathering and was so impressed by his striking appearance that I asked him to pose for a sample portrait I needed for my gallery. He agreed, and this was the happy result. As happens so often in such instances, Mr. Sletteland subsequently commissioned me to paint a portrait of his wife. Note the unusual angle of the right arm. Try blocking it out with your hand and see if it improves or detracts from the portrait.*

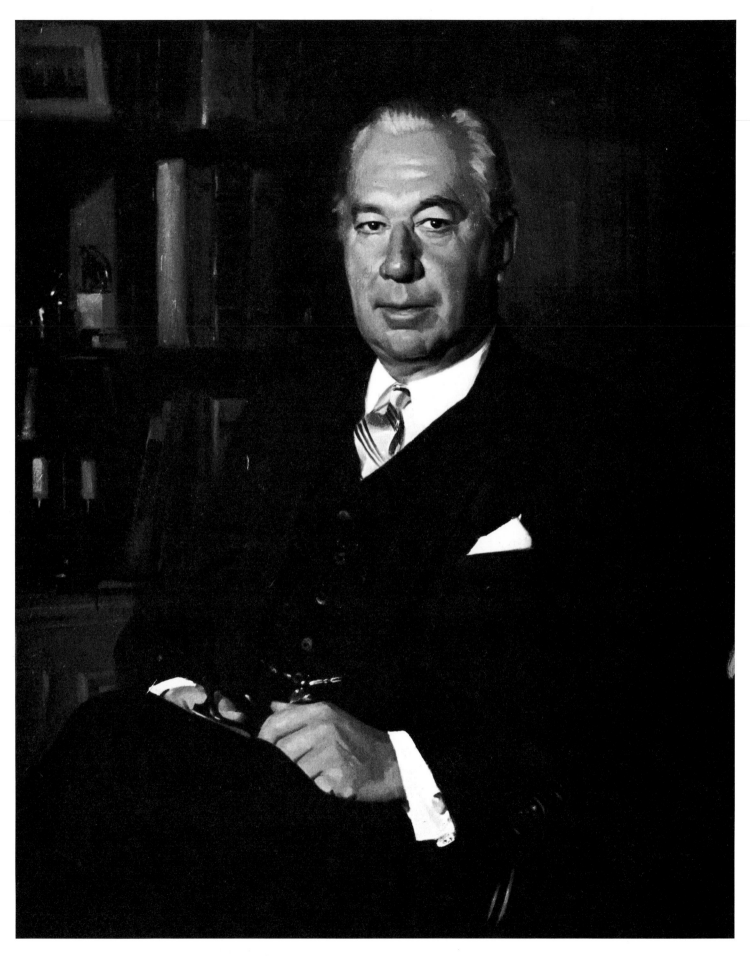

Raymond Ford Moreland, *oil on canvas, 38" x 32" (97 x 81 cm), Collection Shadyside Hospital, Pittsburgh, Pennsylvania. Although this is a fairly conventional pose, the character and forcefulness in the subject's face carries it out of the ordinary. There was a larger-than-life air about Mr. Moreland, who was also known as "The Governor," and I tried to capture that outstanding trait. I think the subject's level-eyed gaze contributes to the portrait's impact.*

enlarge the black and white prints as needed. However, I only use cameras to take photographs for reference when painting from life isn't feasible.

LIGHTING

Whenever possible, I prefer natural north daylight for my portraits. It's best when there are no trees beside the studio windows to cast the reflection of their foliage and thus influence the character of the illumination.

My studio windows are high, divided into two sections, and furnished with shades that roll up from the bottom. This permits me to control the angle of the light falling upon my model, canvas, and palette.

I have a bank of fluorescent lights that I can turn to when the daylight is dim, but I consider this type of lighting a poor substitute. Fluorescent lighting is generally too diffused and tends to reduce the strength of the forms.

Tungsten light, on the other hand, tends to be too warm. It can, however, be employed in specific situations, as noted in Demonstrations 12 and 13.

I also own a blue 150-watt reflector bulb, which casts a combination bluish-reddish light. When I'm forced to use my fluorescent illumination, I fill in the lights with this bulb which helps to bring out some of the reds in the flesh tones which might otherwise be lost.

RETOUCH VARNISH

I particularly like Vibert's retouch varnish, but this product has become increasingly difficult to obtain. In its place, I now use Winsor & Newton Superfine retouch varnish. I prefer brushing this varnish on to spraying it, which produces a spotty, inconsistent film.

FINAL VARNISH

I attach a note to the backs of all my commissioned portraits indicating that they're to receive a final varnish one year after their completion. This varnishing must be done on a dry day so that no moisture is trapped between the paint layer and the varnish, which causes it to bloom. I recommend the synthetic-based varnish prepared by Winsor & Newton for this purpose, since it flows on nicely and won't bloom. The varnished painting should then be left to dry overnight in a dust-free room.

MODEL STAND

Mine stands 18″ (46 cm) off the floor, is set on casters, and has sufficient room to comfortably accommodate a good-sized chair.

SCREENS AND DRAPERIES

I own a sizeable collection of cloths and draperies of various fabrics, sizes, textures, and hues to fulfill diverse background requirements. I also use a tall folding screen that I can adjust behind my sitter as is, or draped with the desired material.

ADDITIONAL EQUIPMENT

Finally, I find occasional use for *calipers* with which to measure the portrait's dimensions; a *mahlstick* with which to steady my hand; an inexpensive *gum turpentine* for general cleaning up; a *staple gun* and *canvas pliers* for affixing the canvas to the stretchers; a heavy piece of *glass* to remove accumulations of too-heavily builtup passages of paint; and a *mirror* which serves three purposes:

1. It provides me a reverse view of the portrait.
2. It doubles the viewing distance between the sitter or the portrait and me.
3. It can be used to amuse the sitter and keep him alert as he watches me paint.

PAINTING HINTS AND TIPS

Here's a collection of random suggestions and observations regarding my approach to the painting of portraits:

1. Don't paint a portrait in a single color scheme. It's the variety of hues that captivates.
2. Don't mix a huge glob of color for any one area. Use a number of varied mixtures for greater color impact.
3. Although many artists execute numerous preliminary studies prior to commencing the portrait, I believe in going immediately into the painting. This strikes me as a fresher and a more immediate approach.
4. Paint what you see before you. An artist is a recorder of visual facts, not a psychologist probing the sitter's inner self.

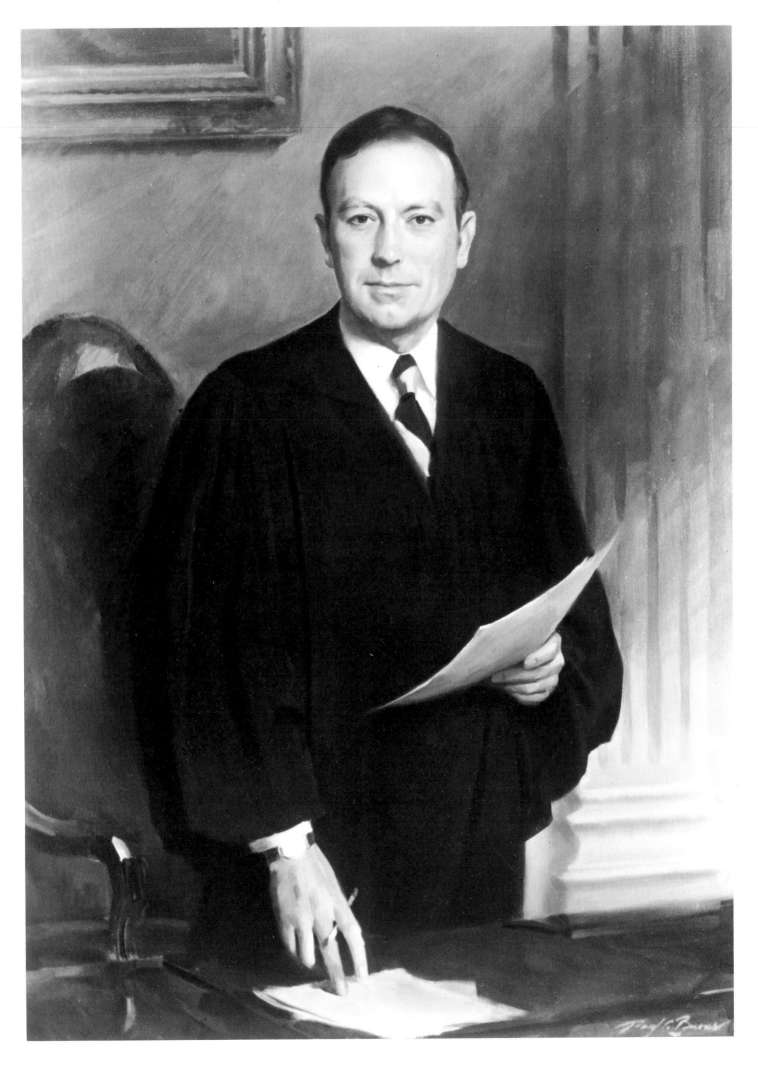

5. An overhead light is not the most appropriate lighting for a woman's portrait. It tends to cast long, oversized shadows and to produce a gross effect.

6. Always try to determine where the portrait will hang, then seek to light your sitter under an illumination most closely approximating the one under which it will be displayed.

7. It's sometimes beneficial to use two sources of illumination in a portrait, remembering at all times that the main source must be the stronger. This double type of lighting can help accentuate the modeling of the forms in the head.

8. Paint your sitter's head just a trifle smaller than lifesize. This creates the illusion of an intervening plane lying between the viewer and the painted head, thus promoting the sense of reality, since people see each other at some distance apart.

9. To achieve a thin line, such as the edge of a collar, it's best to first lay a broad stroke of, let's say, white—then go over it with the adjoining colors of the neck and the jacket until only a thin edge of white remains. This produces a more striking effect than attempting to draw in the line with a thin brush.

10. Don't lay in your highlights abruptly but lead up to them gradually with adjoining values.

11. Pin a sign on your easel with the legend: "Compare . . . relate!" This reminder, of course, refers to values and colors.

12. To keep canvases wet and workable for a day or two, store them in a refrigerator overnight.

Chief Justice Pierre Garven, *oil on canvas, 48″ x 34″ (122 x 86 cm), Collection New Jersey Supreme Courthouse, Trenton, New Jersey. Chief Justice Garven died after about six months in office, so I had to work from a composite of several photographs—I used as many as thirty. I also borrowed his judicial robe from his wife and got someone of about the same build to model the robed body. I'm told that it does look like him.*

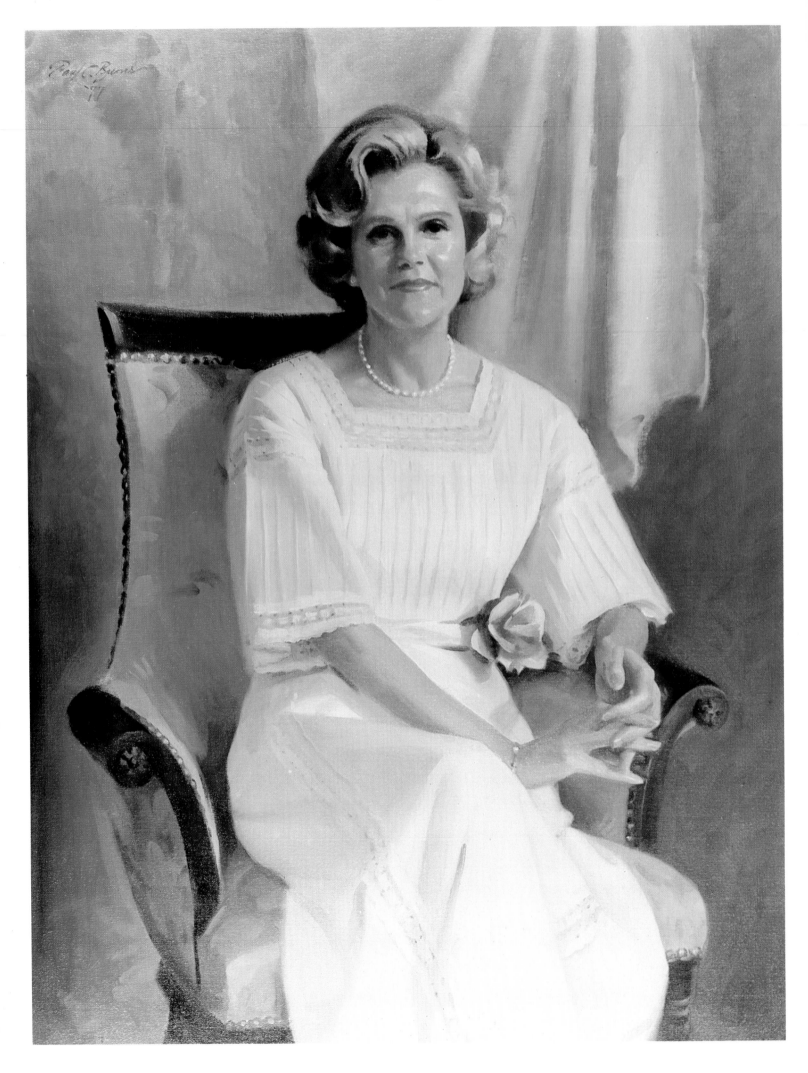

June Reitmeier, *oil on canvas, 34″ x 28″ (86 x 71 cm), The Reitmeier Collection. The problem in painting this formal portrait of Mrs. Reitmeier was that her house was carefully organized and a specific space—above the fireplace to the ceiling—had been allotted for this portrait. I worked a little under lifesize to get it to fit, painting her in a Mexican dress of which she was especially fond.*

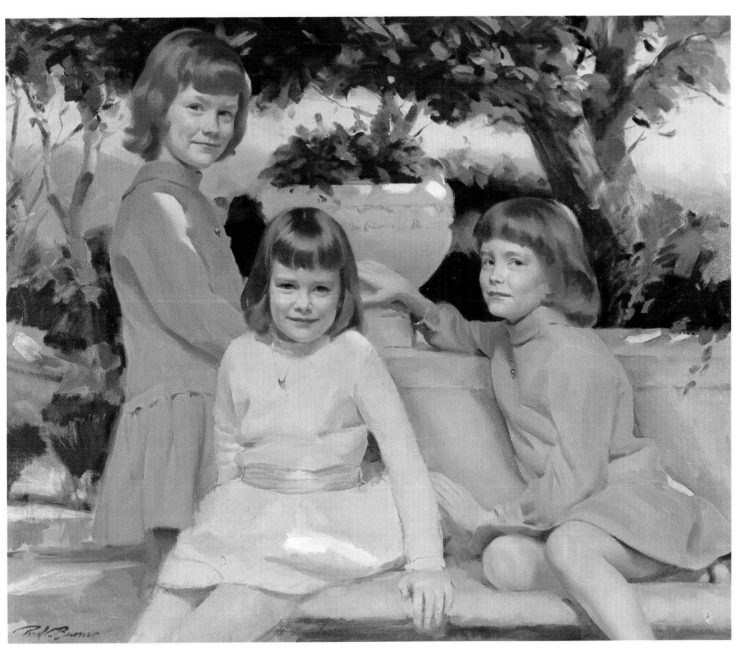

The Allen Sisters, *oil on canvas, 38″ x 30″ (97 x 76 cm), Collection Mr. and Mrs. David Allen. This was a difficult subject to paint, since it was hard to get the three girls to hold still. Finally, I discovered that the best way to manage the situation was to pose two girls at a time, and work from photographs for the rest of the information. I used hillocks of bundled drapery to create an outdoor appearance, which was used in the studio while I photographed the girls. I decided to use the background from a watercolor I had painted at Laguna Beach, California.*

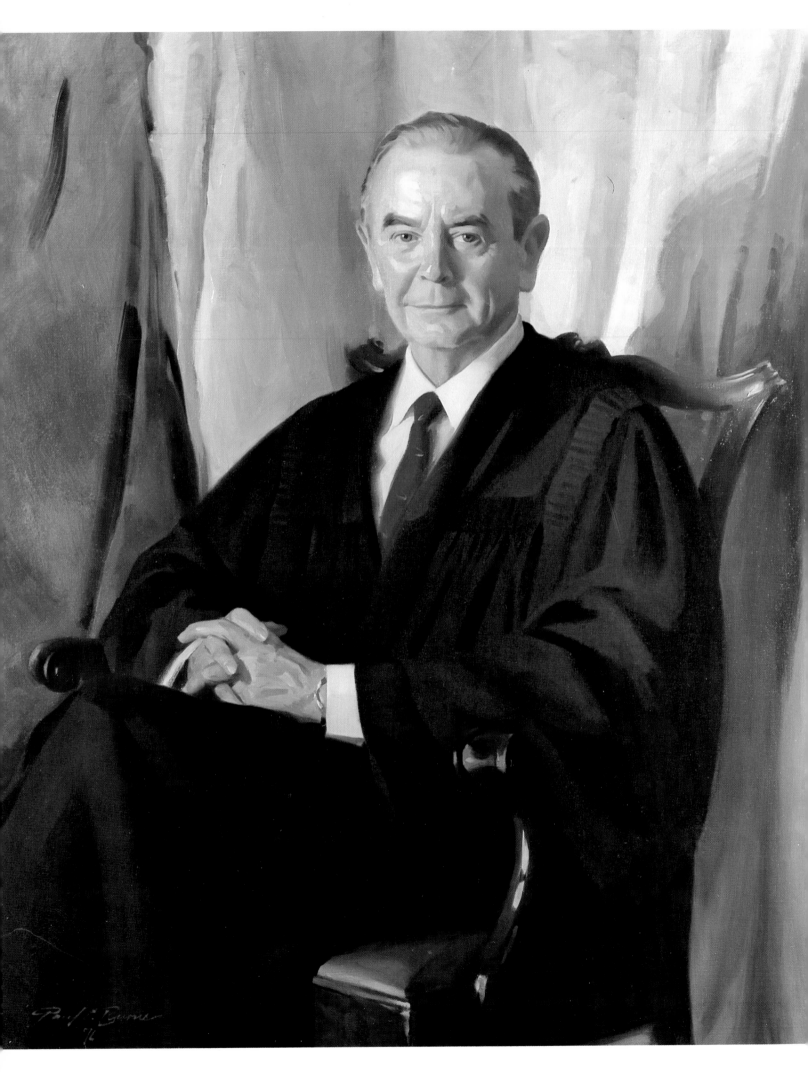

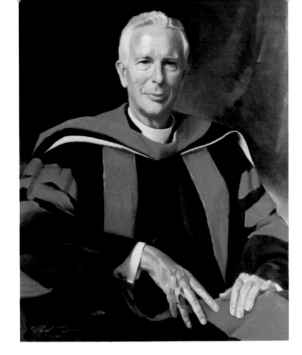

The Right Reverend Robert F. Gibson, Jr., D.D., *oil on canvas, 34" x 28" (86 x 71 cm), Collection Protestant Episcopal Seminary of Richmond, Virginia. Reverend Gibson, Bishop of Richmond, was retired, yet at the age of 72, he still managed to squeeze in four sets of tennis before he sat for my painting. He was also quite an accomplished carpenter and builder.*

Justice William J. Brennan, Jr., *(Left) Supreme Court of the United States, oil on canvas, 42" x 36" (107 x 91 cm), Collection New Jersey Supreme Court, Trenton, New Jersey. This portrait was painted on location in one of the conference rooms in the Supreme Court Building in Washington, D.C. There was a total of three sittings, each one four hours long, with a break for lunch in-between. I finished the portrait in my studio using black and white color photographs I'd taken as reference. I think that my personal observations of the man—his kindness and willingness to serve the public— come through in the finished portrait.*

Dr. William Hazell, Jr., *(Right) President, Newark College of Engineering, oil on canvas, 40" x 34" (102 x 86 cm), Collection Newark College of Engineering. Although Dr. Hazell was retired at the time of this portrait, I painted him in his academic robes because they lent color and a dignified note to his portrait.*

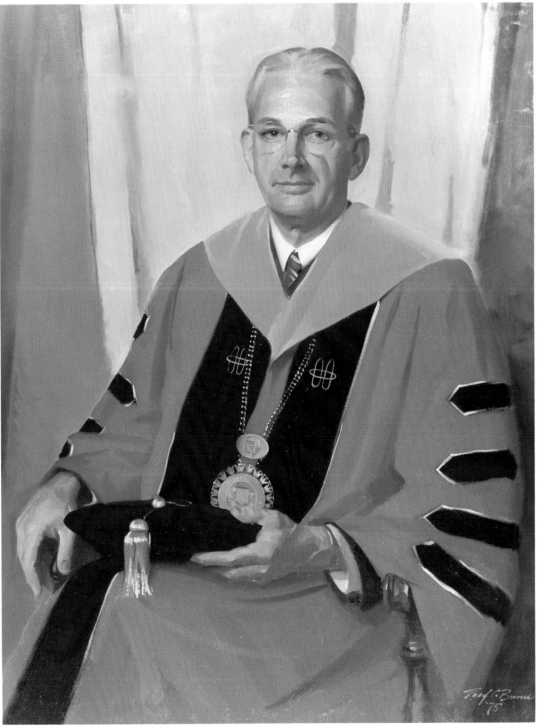

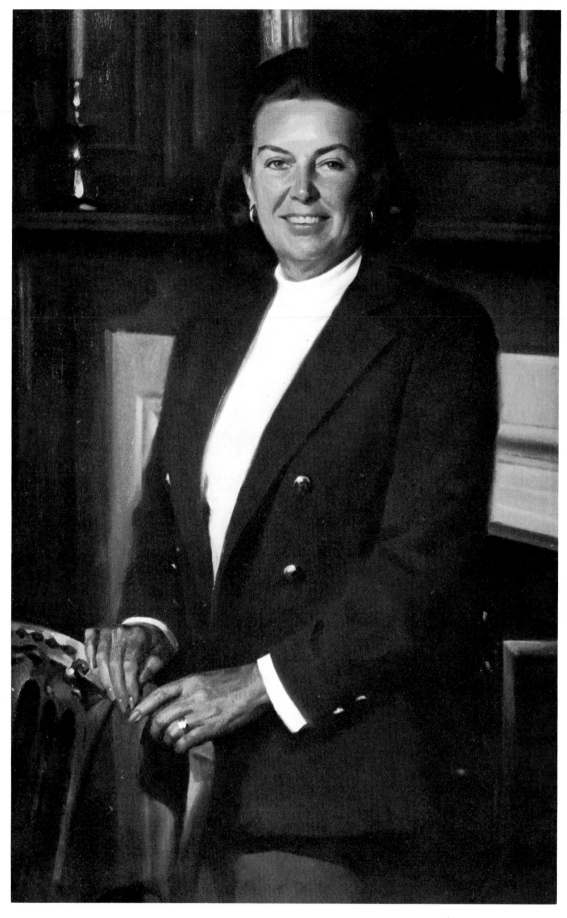

Mrs. Raymond Moreland, *oil on canvas, 38″ x 28″ (97 x 71 cm). It often happens that a commission to paint a man or woman results in a portrait of his or her spouse as well. This is one of a pair of portraits that I painted of Mr. and Mrs. Moreland. Note the standing pose. I try to avoid repetition by varying the way my subjects are lit, dressed, and posed. Painting the same thing over and over again stifles artistic impulse and creativity.*

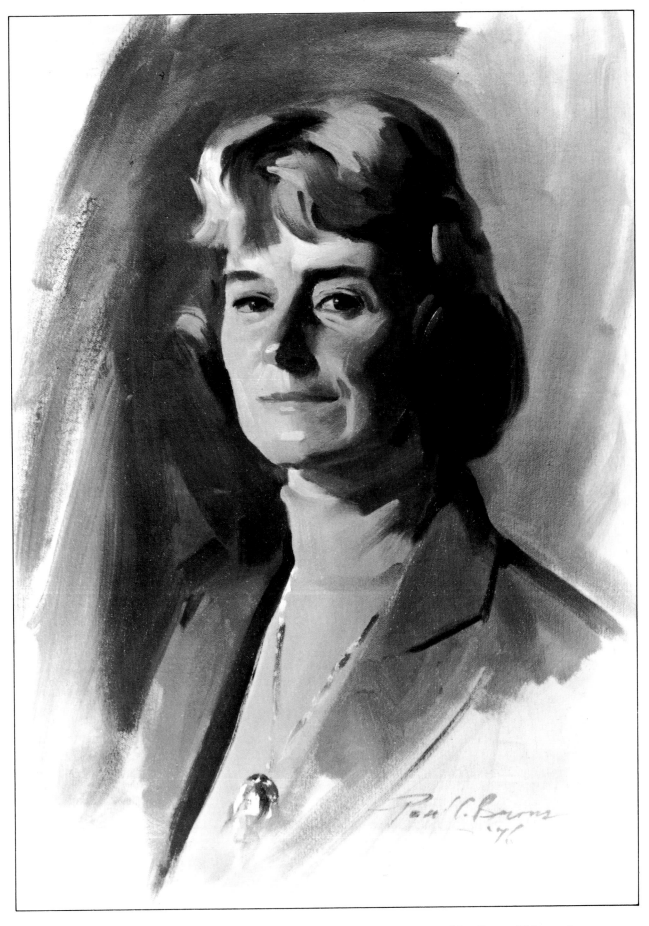

Biz Crotta, *oil on canvas, 24" x 18" (61 x 46 cm), Collection of Biz Crotta. This was done as an afternoon demonstration before a class. When she lived in Sweden, Biz Crotta used to be a stand-in for Ingrid Bergman.*

Dean Alvin Kernan, *oil on canvas,
40" x 32" (102 x 81 cm), Collection
Princeton University. Alvin Kernan,
Dean of Princeton University, sat for
three two-hour sessions. I worked
mostly on his hands and face and the
relationship of everything else to
them, and photographed his robe for
reference, so I could paint it later. The
photographs were taken under the
same lighting conditions as the actual
sitting; no artificial strobe lights or
electric lights were involved; the large
windows and north light of my studio
were sufficient.*

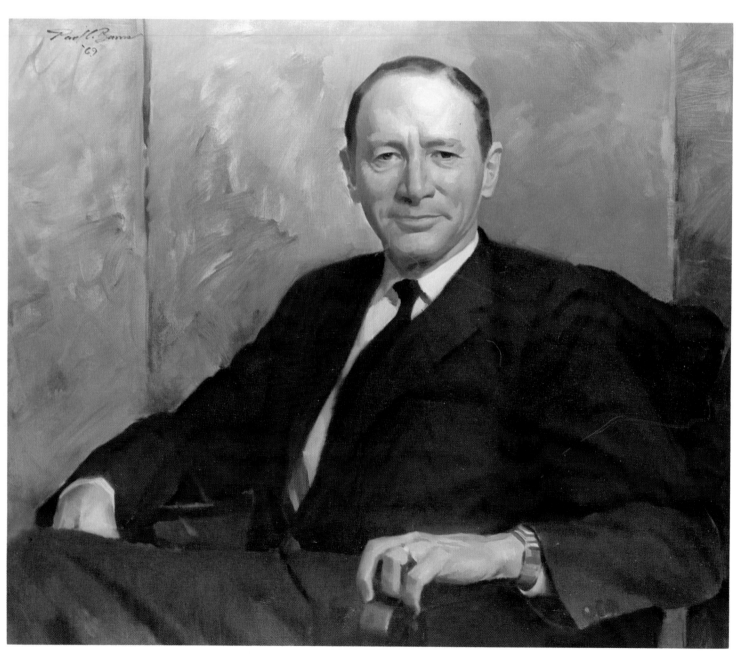

Gordon Tweedy, *oil on canvas, 30" x 36" (76 x 91 cm), Collection of the artist. This portrait of the
Chairman of the American Life Insurance Company of New York hung for some time at Grand
Central Art Galleries of New York as a sample of my work. At one time, the insurance company had
an office at Hong Kong, and after several trips to the Orient, Mr. and Mrs. Tweedy managed to
collect many artifacts. When I realized their liking for Oriental things, I tried to make the back-
ground, a series of varicolored washes, look like the old paper wrapping on Chinese firecrackers.*

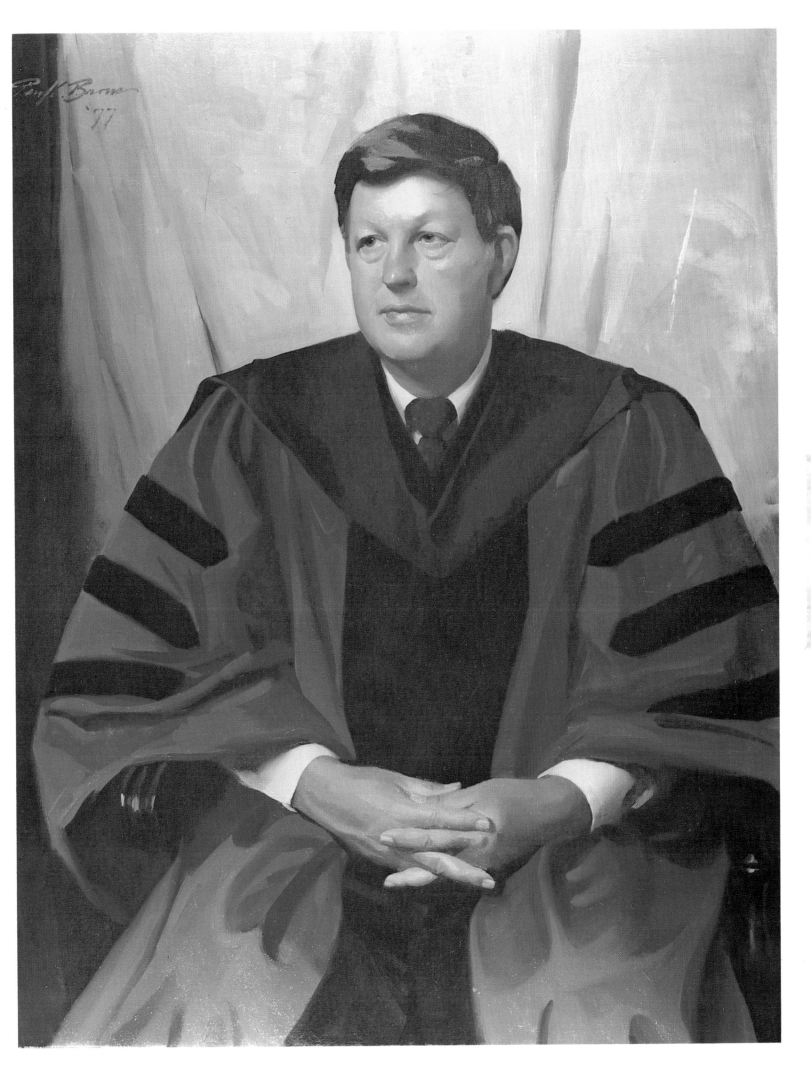

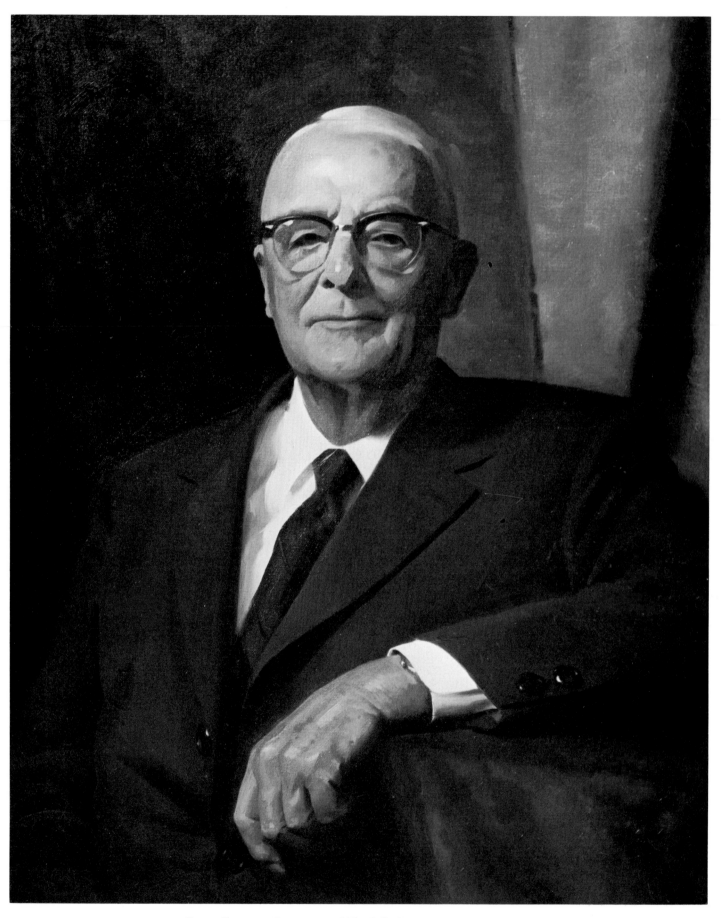

Stuart Cooper, *oil on canvas, 30" x 24" (76 x 64 cm), Collection of the Delmarva Power and Light Company. It's sometimes difficult to include head and hands in a painting of limited size, and the problem here was compounded because the subject was a large man. Since this painting was to hang in a boardroom where all the paintings were of the same size, the small size was a fixed factor I had to work with. I decided to place the subject on a platform, making him appear above eye level and emphasizing his size. The foreshortened perspective also made it easier to include his hand. To raise the hand nearer to his face, I built a wooden prop, draped it with cloth, and used it to support the arm. As you can see, the portrait painter must always be ready to invent and improvise.*

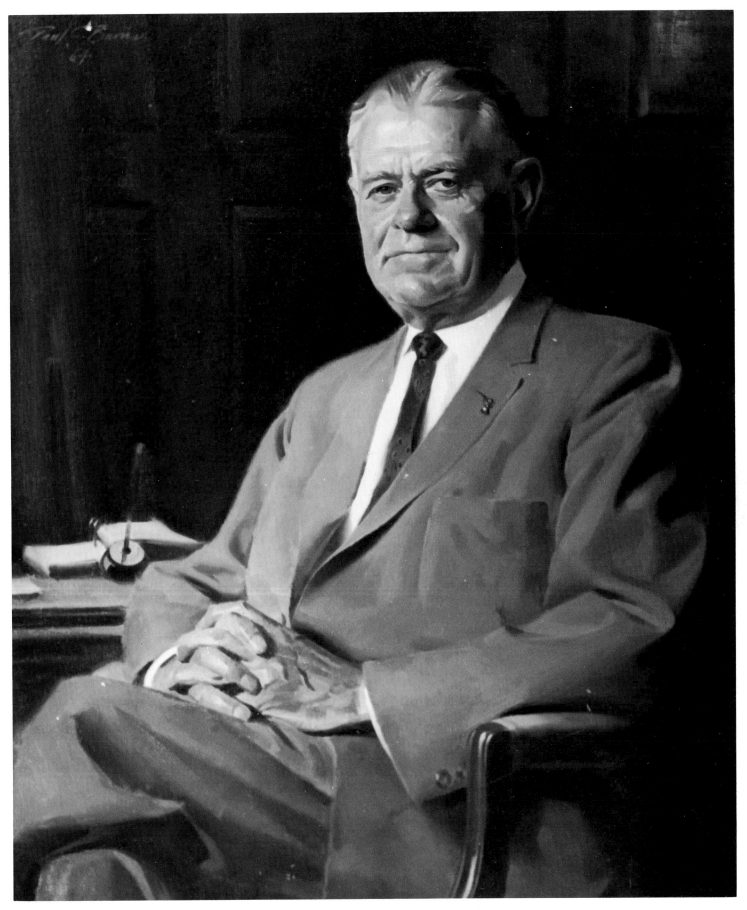

Merle Hoffman, *oil on canvas, 36″ x 30″ (91 x 76 cm), Collection Pascack Valley Savings Bank, Hillsdale, New Jersey. This subject had to be tricked into posing for what he assumed would be a photographic session. The reason for the subterfuge was the Board of Directors' wish to surprise Mr. Hoffman, who was president of the bank, with a portrait. Working from a photograph is a perfectly legitimate method of painting a portrait when, for some reason, posing from life is not feasible. However, it must be done so skillfully that no one can detect it.*

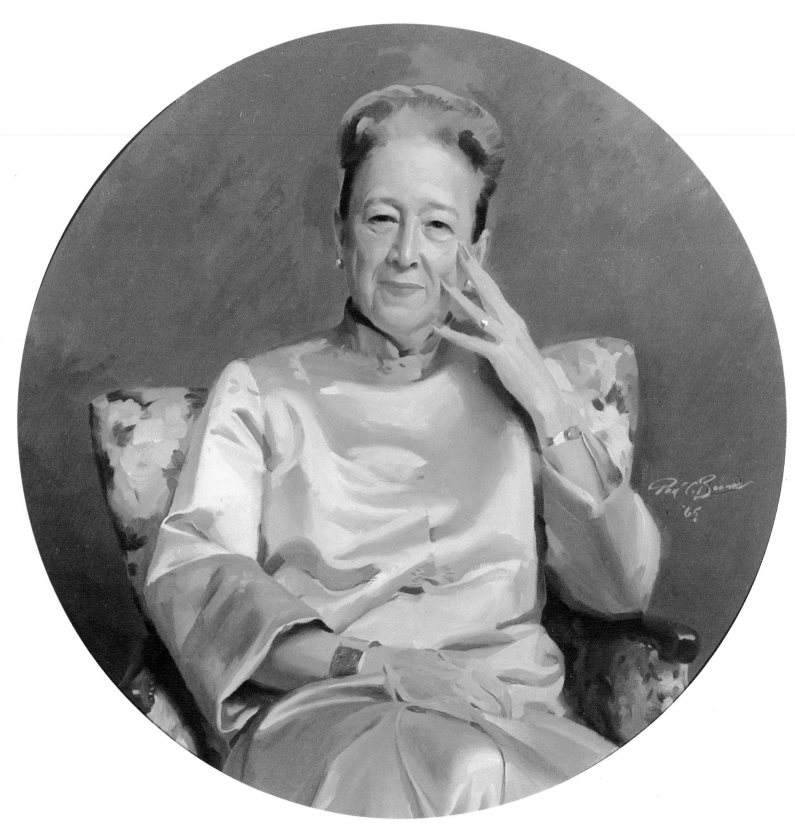

Charlotte Adams, *oil on canvas, 32″ (81 cm) diam., Collection Charlotte Adams. To paint author Charlotte Adams, I stretched a linen canvas over a round piece of ¼″-thick Masonite. In order for the canvas to adhere, I spread a thin layer of white lead on the rough side of the Masonite with a spatula, and on the canvas as well, then pressed the canvas onto the Masonite, covered it with cardboard, and weighted it with some books for several days until it dried. (This is the same principle used in painting murals on canvas on walls.) I cut the excess canvas on the back of the Masonite into fan-shaped, overlapping sections so it wouldn't wrinkle.*

COLORING

This section is concerned with the complexions of various racial or ethnic groups, and with variations within these groups. The combinations of skin, hair, and eye color selected are representative of subjects you're likely to encounter in portraiture.

DEMONSTRATION 1

LONG BLOND HAIR, BLUE EYES, TANNED SKIN

A physical type often encountered in our country is the blond woman with long hair and tanned skin. Frequently, blue eyes go with this kind of complexion. An individual with this coloration represents the healthy, athletic ideal at a time when fitness and outdoor activity are all the rage.

THE SPECIFIC PROBLEM The specific problem confronting me was to depict a deeply suntanned young woman without going too red or hot in the flesh, or too light or yellow in the hair.

Costume and Background. I selected a green blouse to set off the vivid reds in the face. I selected a light beige background to blend with the hue of the hair and harmonize with the greens in the blouse.

Lighting. On the morning of a rather overcast day, I used an overhead north light which fell at a 30° angle thus throwing much of the sitter's face into halftone. Since the sitter was a relatively shy person, this seemed appropriate to her nature. Strong highlights were formed on the plane of her right cheek and on her nose.

Palette. I used my normal palette (see Materials section) and a combination of zinc and flake white for my white.

Medium. I used a linseed oil-turpentine combination.

Painting Surface. I used a 20" x 16" (51 x 41 cm) single-primed cotton canvas.

Brushes. A no. 10 filbert bristle brush was used for the larger masses, as well as nos. 7, 4, and 1 filberts.

Time of Execution. The painting was done in a single session lasting between two and a half and three hours, working directly from the model.

Key Color Mixtures. The darks of the hair are generally a blend of raw sienna, ultramarine blue, and white. The highlights have overtones of the aforementioned mauve combination in conjunction with yellow ochre and white. An ultramarine blue and white combination is used to cool some areas, and burnt sienna and alizarin crimson to heighten the warmer accents in the hair.

Indian red and a touch of cadmium orange plus white are used for the reds in the nose, and Indian red and blue and white for the lips. A mixture of yellow ochre and ultramarine blue make up the area of the space between the nostrils and the mouth. The shadow under the chin is Indian red plus blue and white. The big highlight on the right cheek is white plus cadmium red and burnt sienna. The highlight on top of the nose is cooled with a mixture of blue and white, and at the tip of the nose, it's a warmer white plus alizarin crimson. The blue eyes are painted essentially gray because of the angle of light that strikes them.

Step 1. I employ a no. 5 flat bristle to lay in the major forms, using raw umber thinned down with turpentine. I'm careful to capture the tilt of the head, the effect of the flowing hair, and the accurate placement of the eyes, nose, and the other features. Since Nancy is smiling, I include the lines running from her nostrils to the edges of the mouth, which help to establish the shapes of a smiling mouth. In this beginning stage, I usually work with line only, saving any indications of tonal variations for subsequent stages of the portrait.

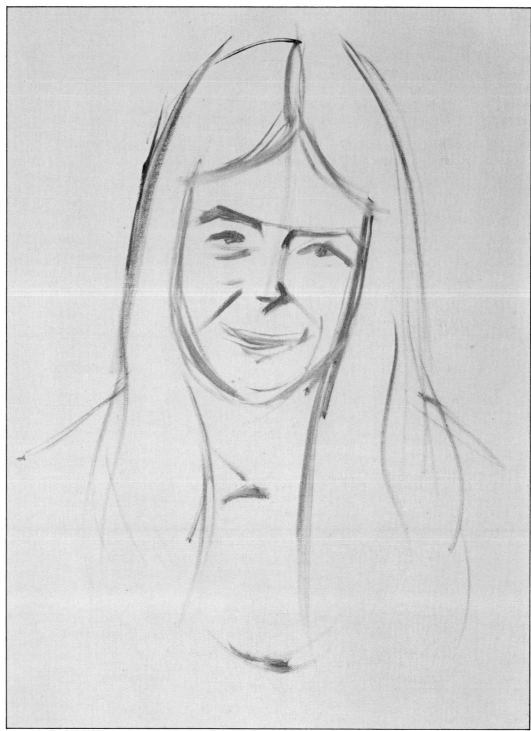

A key to successfully depicting tanned skin is the accurate application of highlights. To show the true value of tanned flesh tones, you need contrasting values. However, don't overstate these highlights just to get your point across, since this will result in over-modeling. Always put down the values exactly as you see them. If tan skin is oily, this will serve to accentuate the highlights. If the subject uses face powder, this will cut down the highlights in value.

A gray, overcast sky creates a light that will heighten the apparent warmness of the tanned skin by contrast. A blue sky will cool it. In sunlight, the tan will appear warmer. Tungsten light will act in the same fashion. A full, frontal light will accentuate the color in the tanned face, while diminishing the value contrasts there.

A costume of contrasting hue, such as blue or green, accentuates the intensity of the hues in the skin. In the case of a tanned skin, this would be the reds. Conversely, a red or orange blouse diminishes the intensity of these reds. A gray blouse neutralizes or modifies these reds. A white blouse serves to bring out the dark values (rather than the color) of the skin tones. A black blouse serves to lighten the same values. The same principles apply to the choice of background color.

Step 2. Now, I turn to color. I mass in all the large areas within the head, employing the body color for each appropriate area in broad, general terms. I break up the flesh tones, the hair, and the blouse into areas of light and shadow and paint them in accordingly paying no attention at this stage to details, but concerning myself chiefly with the large statement. I also indicate the background lightly with a no. 10 brush and add a touch of blue eyeshadow. A few selected areas of canvas are either left blank or lightly touched with white or near-white to indicate where the highlights will fall.

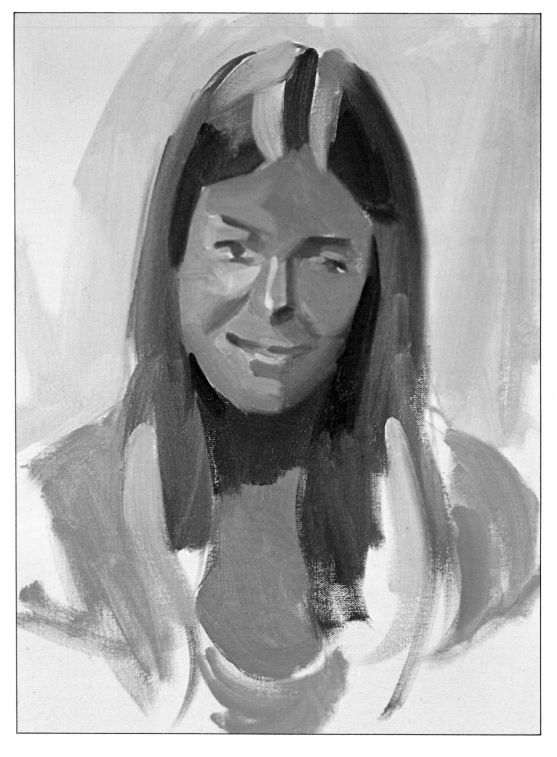

TIPS ON TAN SKIN

Since tan skin is essentially warm, your colors should lean toward the Indian reds, cadmium oranges, and burnt siennas rather than the yellow ochre or raw sienna elements in flesh mixtures. However, don't make the flesh all-warm. Introduce some cools into it, otherwise the skin will emerge looking like leather. The best way to do this is—rather than adding a blue or green directly from the tube to the flesh tone—mix up a small batch of ultramarine blue and white, or permanent green deep and white, and introduce touches of these mixtures into the skintone mixtures. Do this gradually, working the cools into the edges, not the center, of the flesh mixtures.

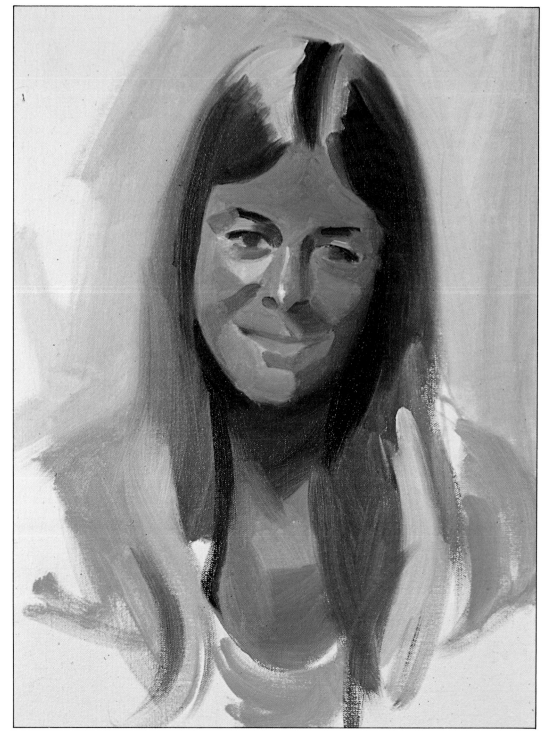

Step 3. I go deeper in tone all over the flesh areas, particularly in the forehead and in the breast area. I modify the background by graying it down somewhat—it has projected too much yellow. More blue eyeshadow is indicated above both eyes. The hair is deepened and modified with more additions of ultramarine blue and raw and burnt sienna. The shadow beneath the chin is intensified with a mixture of ultramarine blue, alizarin crimson, and burnt sienna. The highlights on the nose and cheek on our left are strengthened.

Blond hair reacts to light like any other object—it projects lights, darks, and middletones, depending upon the amount of illumination affecting it.

While its general tone may be a combination of yellow ochre, raw sienna, cadmium yellow pale, and white, blond hair needs some neutralizing colors to avoid a brassy effect. Using black to tone down the value of blond hair will render it dirty in appearance, red will turn it orangy, and blue will turn it green.

A mixture of alizarin crimson plus ultramarine blue plus white is the answer. The mauvish tone that emerges will effectively gray down blond hair so that it retains its yellowish quality yet doesn't turn muddy. Again, don't work this mixture directly into the general tone of the hair but work it gradually into its edges.

Don't be afraid to make the darks in the hair as dark as they really appear. If you don't, you'll be forced to lighten all the skintones to maintain the proper relationship of values.

Step 4. I now refine the portrait all over by blending areas where the tones come together such as in the hair, where I modify the halftones that bring together the lights and shadows. I don't use a big brush for this, since it may result in the loss of the smaller planes and produce a too-smooth, slick effect. Instead, color is laid in in blocks resembling mosaics, which produces a sparkling, lively effect. Those areas of canvas that had been left blank are now filled in. More emphasis is placed on modeling smaller areas such as the flap of skin forming the smile. A premixed mauve mixture is added to areas of the hair and to flesh tones, as needed.

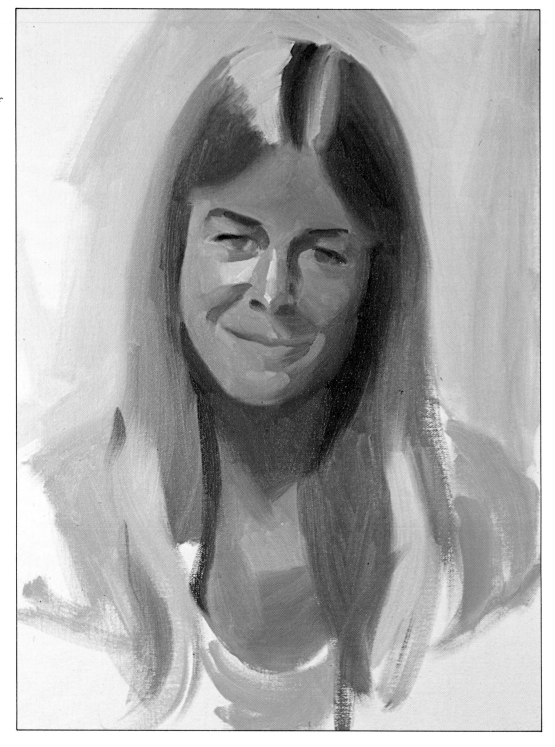

Kathy Kloeber, *oil on canvas, 34″ x 28″ (86 x 71 cm), Collection of the artist. Here's another painting of a young, blond woman in a decidedly different mood from the one below.*

Step 5, Nancy Anderson. *The locket is established. Mauve is added to the hair along the left ear. The skin tones in the breast area are graduated so that the light planes drift naturally into the darker ones. The edge of the hair falling against the left-hand side of the face is sharpened. The background is extended with additional strokes of yellow ochre plus the ultramarine blue and white combination. A no. 2 sable and a no. 2 bristle brush are used to attain the details in the eyes. In those areas where two distinct edges come together, the paint is applied somewhat more thickly.*

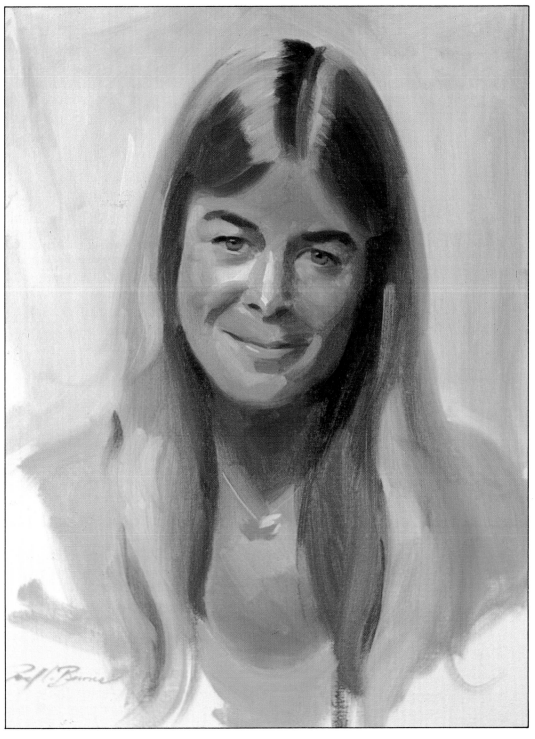

DEMONSTRATION 2

REDDISH WAVY HAIR, WHITE SKIN

A complication developed during the execution of this painting and since you're likely to encounter a similar situation, I'll describe it to you. I had especially selected this young lady for her pale complexion, but she gave me quite a shock when she came in to pose. She had visited the beach in the interim and had acquired a considerable sunburn! However, I chose to proceed with the painting.

THE SPECIFIC PROBLEM

I was faced with the problem of depicting the pale, ivory quality of a redhead's skin, which was now bright red in a number of areas. I had to find and record enough places where the skin was its normal, luminous self in order to give meaning to this demonstration.

Costume and Background. I wanted a greenish background to set off the red of the hair. Lacking the proper drapery at that moment, I took an old bedsheet and spattered it with green paint to obtain the effect I was seeking. A portrait painter must be eternally prepared to improvise!

Lighting. A natural north light was my main source of illumination. I supplemented it with a 150-watt blue reflector lamp, which warmed the light areas of the face and cooled the shadows. Whatever luminosity was present in the head would now be accentuated.

Palette. I used a full palette of colors, with a zinc/flake combination for my white.

Medium. My medium was a linseed oil/turpentine combination.

Surface. I painted on a 20″ x 16″ (51 x 41 cm) single-primed cotton canvas, toned a combination of permanent green, white, and ivory black.

Brushes. I used filbert brushes nos. 10, 8, 7, and 6.

Time of Execution. The work was divided into two days. On the first, I worked two hours from the model. After storing the canvas in a refrigerator overnight to keep the paint wet, I worked on it again the next day.

Key Color Mixtures. There are many areas where the tone of the bare canvas has been left. This is a device that saves time and also helps to achieve a sense of unity in a painting. It's most evident here in the model's upper left eyelid.

The cheeks, which are illuminated by the reflector lamp, are cadmium red light and yellow ochre plus white in the lighter areas. The reds of the sunburned nose are composed of alizarin crimson, Indian red, and yellow ochre. The shadow cast by the nose is made up of raw sienna, burnt sienna, and white, plus a touch of green. The area just above the lips is a mixture of permanent green deep and white blended with cadmium orange and white. The upper lip is alizarin crimson and black, while the lower lip is a mixture of cadmium red and alizarin crimson.

The deepest shades in the hair are alizarin crimson, ivory black, burnt sienna, and ultramarine blue; with cadmium orange and burnt sienna used for the middletones of the hair.

Step 1. On a green-toned canvas, I draw in the sitter's head more accurately than usual. Instead of merely employing line, I also decide to add suggestions of tone to indicate the areas of shadow in the portrait, for a change of pace. Since the initial drawing serves as a kind of map to guide the artist in the execution of the portrait, the more correct and detailed it is, the easier are the chances of arriving at the goal sooner and with less difficulty. However, using line only or a combination of line and tone is a completely arbitrary decision.

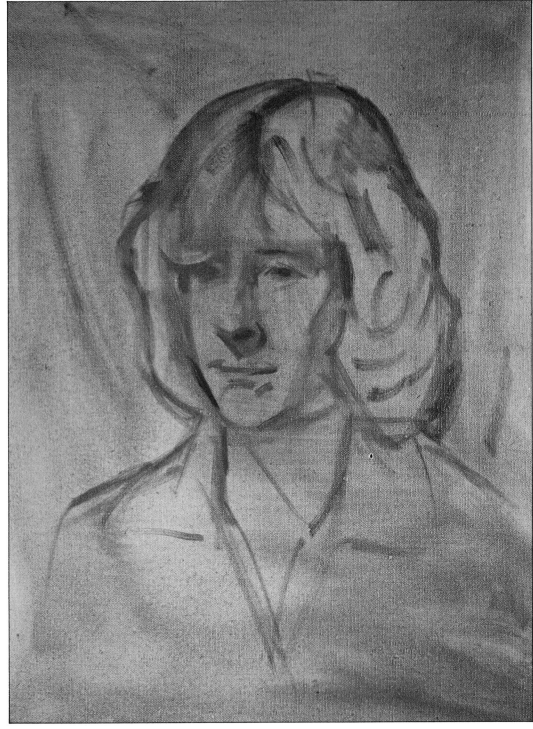

PRINCIPLES OF PALE SKIN

Pale skin so common to redheads (when they keep out of the sun) tends to be thin, tender, and luminous. It often projects an ivory or greenish cast. The shadowed side of the head is high in key and the changes of tone and hue are gradual. The paleness of such skin poses the danger that the artist will go too white in his color mixtures and the portrait will emerge chalky, vapid, and ghastly.

Step 2. Now I use my big brushes to mass in the larger forms. Note that there's a considerable amount of mauve in the red of the hair. Many areas of the green-toned canvas are used to represent the halftone and shadow portions of the head. The pink in the cheeks and on the nose are indicated with alizarin crimson, and lights are placed on the nose and the forehead with ultramarine blue and white plus alizarin crimson and white. The light areas of the face are painted with decidedly warm color. The background is indicated. The shirt is broken up with tones of blue and mauve. Permanent green, yellow ochre, cadmium yellow, and white are used in the greenish shadowed area below the chin. The warm reflected light under the chin is also painted.

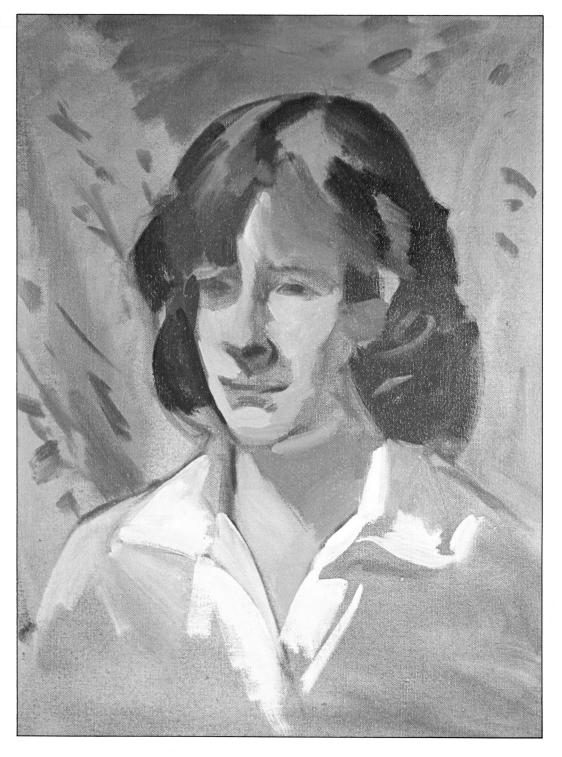

TIPS ON PALE SKIN

You must strive for a subtle balance of the pale rose and pale olive nuances in such skin. To do this, mix up two separate batches of color—perhaps a permanent green, yellow ochre, and white for the olive shade; and a cadmium red light, raw sienna, and white for the warm rosy shade. Armed with these two *blended* mixtures, you can proceed to record the subtle nuances of pale cool and warm colors in the complexion. But don't use raw green and red just as they come out of the tube for this mixture or it will result in a drab, muddy skin color.

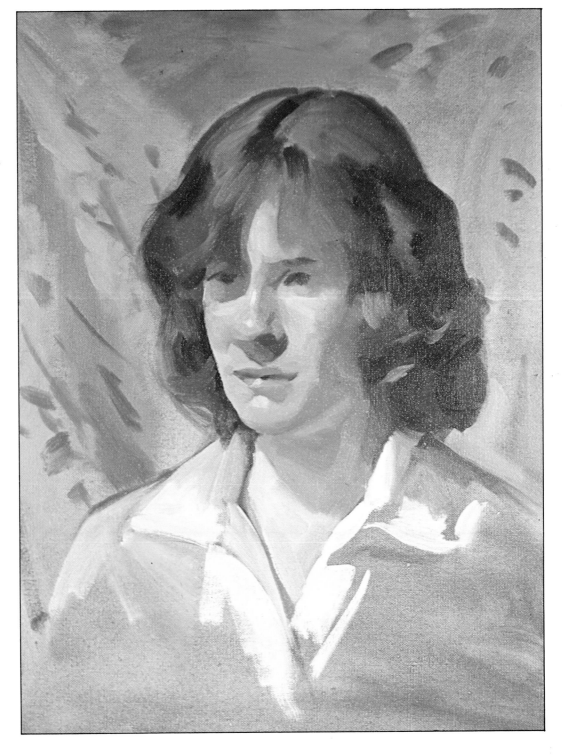

Step 3. The entire portrait is brought along and further refined. The nose and cheeks are made redder, the lips are painted in, the hair is blended and its shape corrected. Likeness is now nearly achieved as I concentrate my effort to render those small and delicate planes that represent Sheila's characteristics. In this and subsequent stages, it's the close attention paid to halftones that helps to establish the individual's features. Highlights on the nose and chin are likewise introduced.

Step 4. In this stage, I feel that the face has perhaps gone too warm, and so I cool it down, particularly in the shadows. The side of the nose where it flows into the cheek is more carefully defined. The eyes and lips are drawn with more care. There's a general blending of transitional areas in the head, particularly where the skin and hair come together. The face is growing a bit softer now, but its modeled effect is still maintained.

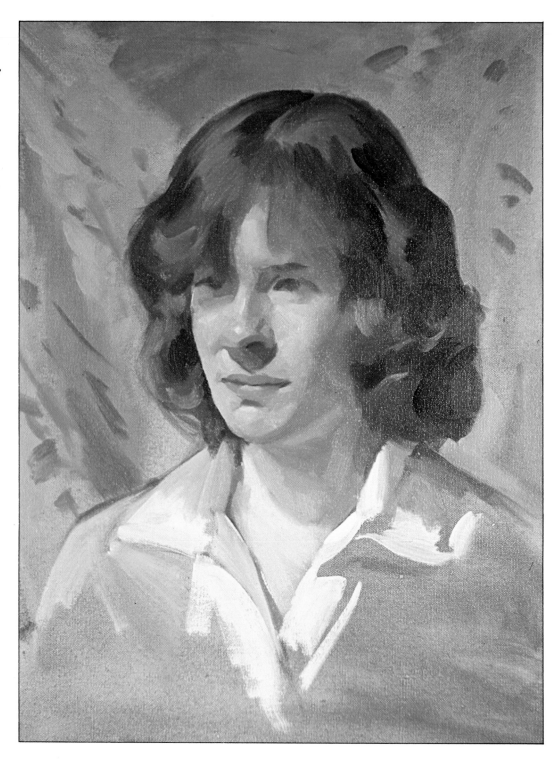

Kathy Schreiber, *oil on canvas, 34" x 28" (86 x 71 cm). Kathy's mother attended a class I taught. Since she requested a sketchy treatment, you'll note that the hands and other areas are merely suggested. In painting Kathy, I tried to capture the impish vitality of this young redhead.*

Step 5, Sheila Gelber. *The eye on the right is refined. The value of the light on the forehead is related to the value of the hair falling over the brow on our right. Although the portrait is basically completed, I'm not satisfied with the result and feel it requires additional work. Therefore, I store the canvas overnight in the refrigerator and plan to resume the next morning without the model's presence. With the paint kept wet so that it can be painted into, I refine the hair, adding gold and olive tones to the strand on the left, over the eye. I also sharpen the edges on the fold of skin running from the right nostril to the corner of the mouth. You can never consider a painting finished until you've solved its every problem. Too often painters compromise their standards and let a picture leave their studio despite doubts and misgivings. You owe it to yourself and your patrons to always do your best on every painting you execute.*

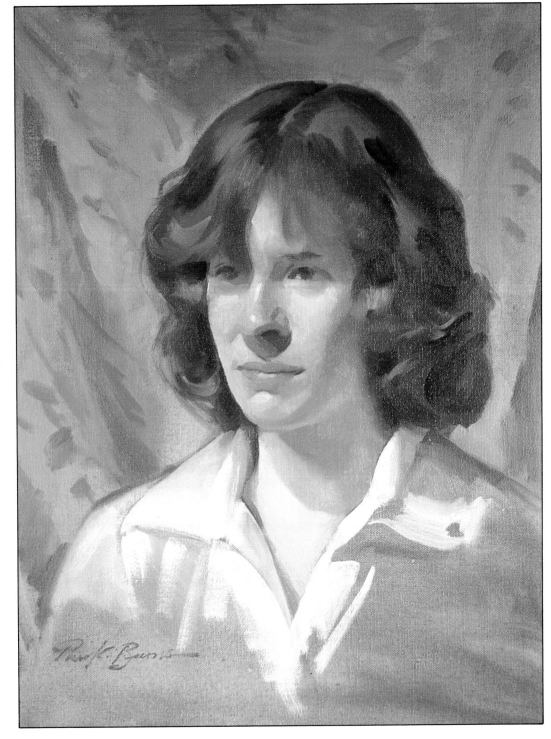

DEMONSTRATION 3

BLACK HAIR, OLIVE SKIN, BLACK EYES

This coloring might be designated the Latin complexion, since it's found so often among people with origins in the Mediterranean countries—southern Italy, southern France, Greece, and Spain. However, as you'll note, it differs from the Mexican or Indian coloring described in Demonstration 7.

THE SPECIFIC PROBLEM

The problem was somewhat similar to that faced in Demonstration 5—that is, to paint a person of fairly low contrasting coloration and yet attain a variety of colors, along with vibrancy and sparkle.

Costume and Background. I chose a light gray background in order to heighten the colors of the skin and to fully exploit the whites of the shirt.

Lighting. Since this portrait was painted in the evening, I used the bank of fluorescent lights in my studio. This type of light emphasized the reds in the face and created sharper shadows then would have resulted from daylight illumination.

Palette. The full palette of color was used, along with flake white/zinc white.

Medium. A linseed oil/turpentine combination was employed.

Surface. I used a 20″ x 16″ (51 x 41 cm) single-primed cotton canvas, toned a gray color composed of black and white then wiped down with a cloth while still wet.

Brushes. My brushes were as follows: nos. 8 and 6 bristle filberts; a no. 6 bristle chiseled flat; nos. 5, 3, and 2 bristle flats; and a no. 0 long-haired round for details.

Time of Execution. The painting required a single sitting of two and a half hours.

Key Color Mixtures. The cooler highlights on the forehead are painted with a permanent green and white mixture and the somewhat warmer ones with yellow ochre and white. The tones around the eyes are achieved with Indian red, ivory, black, white, and a touch of permanent green. The same mixture is used for the bridge of the nose just before it goes into the shadow. Note that the left nostril is warmer in color than the right. This is because light is shining through the skin in that area.

The lips are on the cool side—a mixture of Indian red with a touch of ultramarine blue for the darker portions, and burnt sienna for the warmer portions. The highlights on the chin are made up of Indian red, yellow ochre, and white.

The dark hair is a mixture of ivory black and white, with burnt sienna used for the warmer accents. Ultramarine blue is added to the lighter areas of the hair.

SPECIAL NOTE

In this portrait, I employed a grid system to place the various features onto the canvas. This first involves laying down a number of vertical and horizontal lines over the canvas in the initial stage. Then, by holding up the brush to the sitter's head as if it were a plumb line, you note where the various features fall, and transfer these findings to corresponding lines on the canvas. The horizontal lines also help determine the accuracy of the angles of the features when the head is tilted.

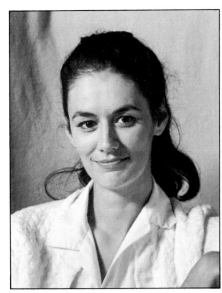

Step 1. I used a grid system to draw the head on canvas in this demonstration. As I described in the accompanying text, with a no. 3 flat brush, I run a number of vertical and horizontal lines across the canvas, then use a no. 5 brush as a plumb line to estimate, then place, my sitter's features within the proper squares. The slanting lines are used to check the tilt of the sitter's head.

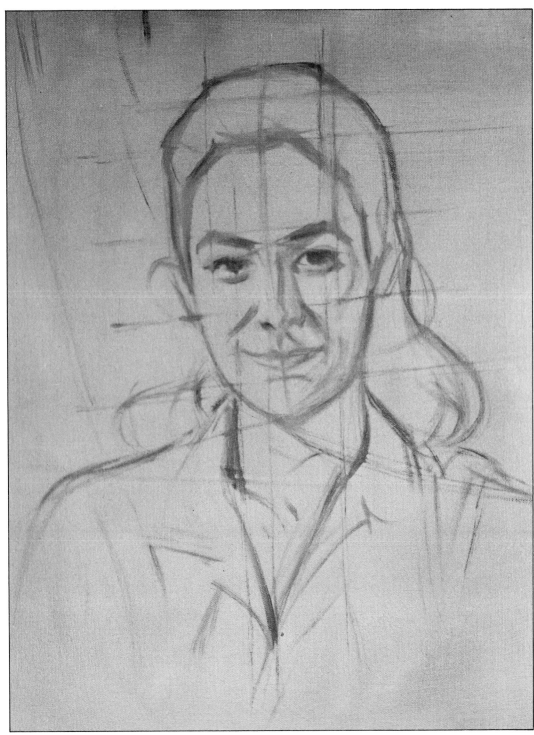

Olive skin is usually yellowish or greenish in cast, with a minimum of warm reds. The reds that *are* there usually tend toward the earthy Indian reds and away from the brighter cadmiums and oranges. The halftones are decidedly greenish, and there's a considerable number of yellow ochre and raw sienna accents evident throughout the skin area. Blue sky striking olive skin introduces greenish highlights.

Step 2. I turn to my nos. 6 and 8 filberts, and a long-haired no. 6 chisel brush to mass in the shadowed side of the hair with pure black, then proceed to the lighter areas of the hair by adding some blues and whites to the black. Next, I use ultramarine blue, permanent green, yellow ochre, and white to paint in the blouse and sweater. I now proceed to paint in the shadowed side of the face with a mixture of Indian red, cadmium orange, permanent green deep, and white; then I proceed to the light side of the face, using white, raw sienna, some green, and a touch of Indian red. The lips are next—they're Indian red and ultramarine blue. The highlights on the forehead are put in with white, cadmium orange, Indian red, and a touch of permanent green. The background is put in with ivory black and white, with additional touches of ultramarine blue and yellow ochre.

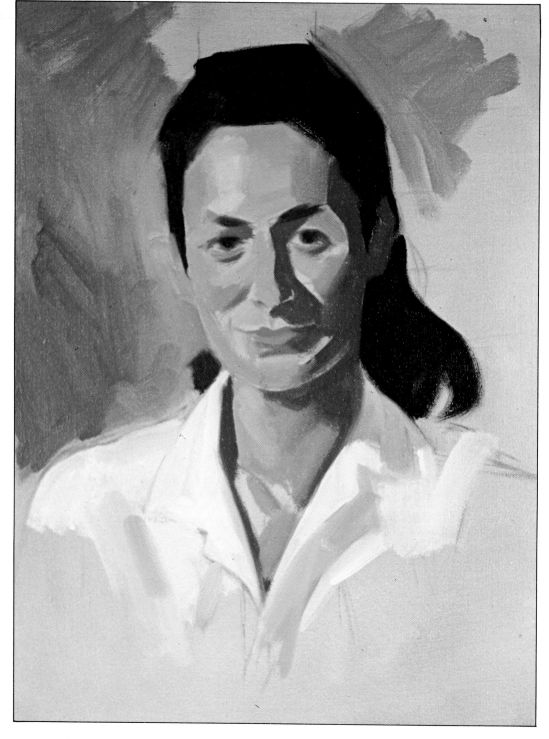

TIPS ON
OLIVE SKIN

The challenge is to attain the rich coloration olive skin projects without letting the portrait get drab and dirty. To do this, you can make your colors a bit stronger than they actually appear in order to emphasize the obvious olive greens, and let the subtle reds mix into them without allowing the mixture to go black. White must be used judiciously so as to retain its luminosity, and to lend the skintones a live, vibrant appearance.

Since this type of complexion basically entails the successful mating of reds and greens, you can't allow either hue to dominate, nor should you use greens or reds as they come from the tube, but rather, you must rely on combinations of *mixed* reds and *mixed* greens.

Step 3. The value of the background on the left is blended somewhat. The nose, lips, and eyes are related and refined. The edges of hair are softened and blended so it flows in and out of the forehead. The eyebrows are darkened. In this stage, I use the smaller flat brushes in sizes 5, 3, and 2, and a no. 0 round. Likeness is now close, and the head is modeled and its form made to appear to turn.

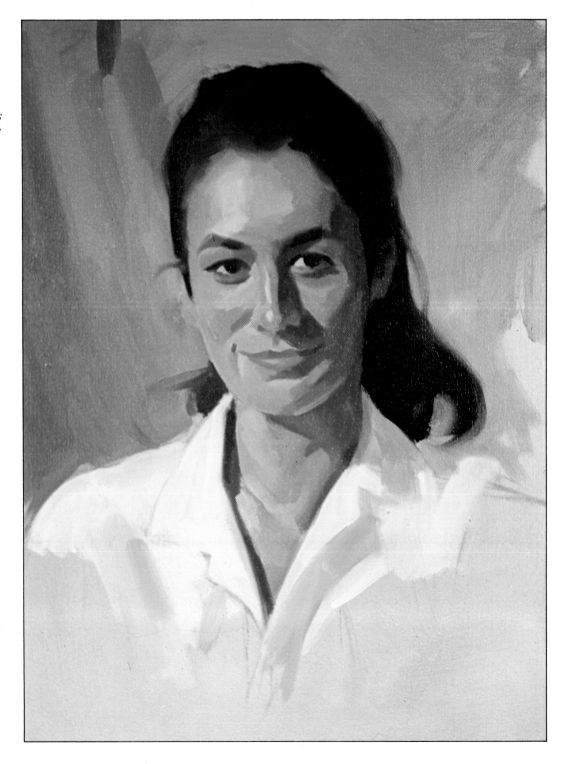

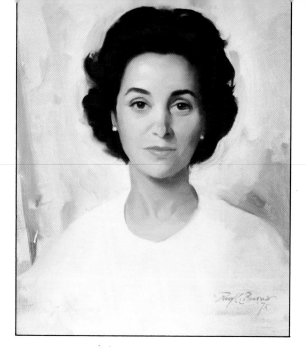

Yolande Greene, *oil on canvas, 20″ x 16″ (51 x 41 cm), Collection Edward and Yolande Greene. The portrait of a woman with olive skin and black hair is handled differently in this example.*

Step 4, Michele Prestwick. *Pale blue highlights are placed in the eyes. All parts of the head, neck, and blouse are carefully finished. Blues, mauves, and ochres in the blouse and sweater are spotted with pure white highlights. The nose is redrawn and repainted to appear straighter. Deeper accents are placed in the background around the shoulders. Random wisps of hair are drawn more carefully and a stray curl is put in on the left, above the collar. Always look for such touches to add—they lend spirit and verve to the portrait.*

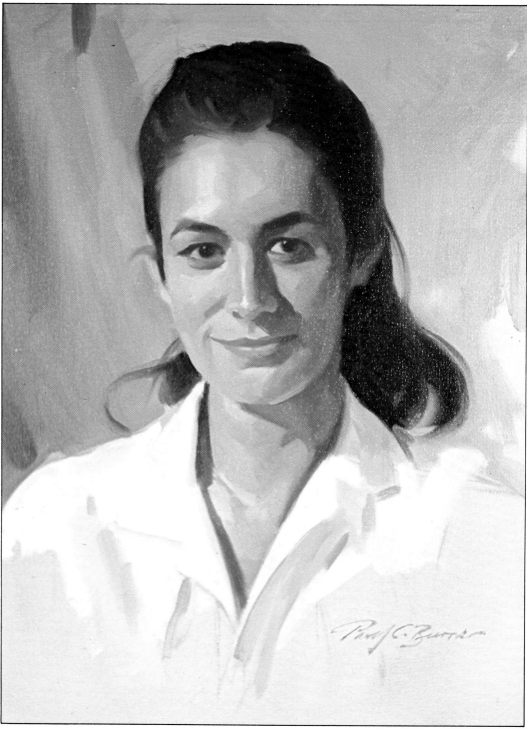

DEMONSTRATION 4

BLACK SKIN, AFRO HAIRDO

Black skin and Negro hair present a number of intriguing painting challenges to the aspiring portraitist. There are, of course, degrees of tone and color in all skins, ranging from the whitest white to the darkest dark. If you intend to paint people, you must be able to confront every type of complexion.

THE SPECIFIC PROBLEM
The specific problem was to paint a person with a fairly close range of value and color between skin and hair, while avoiding monotony and achieving a lively, interesting pictorial statement.

Costume and Background. I chose a bright yellow blouse to emphasize the rich chocolate-brown tones of my sitter's skin. The yellow of the fabric reflected up into the face and influenced the color of the underside of her jaw. A light background was selected in order to set off the darks of the face and hair.

Lighting. The portrait was painted on a summer morning in New Mexico. The locale was an old church with the light coming in through the open doorway, which combined the warm accents reflected from a sandy road with the blues of the clear sky. The model stand was set some distance from the door.

Additional illumination—a warm, amber light—came in from three side windows, and is represented in the painting by browns and raw siennas. This type of illumination created rich, deep olive tones in the shadows.

Palette. A full palette was used, with flake white as my only white.

Medium. A linseed oil/turpentine combination was used.

Surface. I worked on a 20″ x 16″ (51 x 41 cm) single-primed cotton canvas.

Brushes. I used a no. 4 bristle Landseer brush for scumbling the hair; nos. 8 and 5 bristle filberts; nos. 10, 6, 4, and 1 bristle flats; and a no. 6 sable round for catchlights in the eyes.

Time of Execution. The painting took a total of two and a half hours to complete.

Key Color Mixtures. The darks of the forehead are burnt sienna, ultramarine blue, white, and a touch of Indian red. The dark of the left temple contains the above mixture, with alizarin crimson instead of Indian red. The earlobe is red due to the usual heavy accumulation of blood in that area.

The gray of the highlights on the cheeks is a mixture of ultramarine blue, burnt sienna, and white, while the general cheek tone is burnt sienna, cadmium red, ultramarine blue, and white. The lips are done with ultramarine blue, Indian red, and white. The shadow on the nose is a warm burnt sienna, black, and alizarin crimson. The light reflected by the yellow blouse onto the jaw is achieved with the addition of yellow ochre, and the teeth are a blend of ultramarine blue and white.

The hair is a mixture of black, ultramarine blue, burnt sienna, alizarin crimson, and white.

Black skin contains elements of grayish-purple hue. I, therefore, relegate it more to the red family of colors. When the blue sky strikes this color, a purple combination ensues. The highlights emerge a kind of mauvish tone, particularly in the lips. Negro hair falls into the same category. Another factor of dark skin is its relatively lower range and variety of hue than is usually present in Caucasian complexions. So, to enliven the painting, you must prod yourself to *think* in terms of more variety of color, which will result in your *recording* more variety.

Dark skin is neither decidedly warm nor cool—its temperature is usually determined by the warmth or coolness of the light illuminating it. While white skin reflects light, black skin tends to absorb it, unless the skin is oily or wet. Of course, there are dark complexions (as there are light) that lean to the warm or the cool sides, being markedly reddish or warm, or bluish or cool in character.

A costume of light value and of vivid color will accentuate the hues of dark skin. A dark costume will point up the subtlety of the dark flesh tones. The same principles apply to the color and tone of the background.

Step 1. This time instead of merely drawing in raw umber and in line, I use color to block in the major masses and indicate the big darks of the form. With a no. 6 flat brush, I mass in the hair, which is broken up into a light and shadow side. Likewise, the shadow side of the face receives a tone of ultramarine blue, raw sienna, burnt sienna, and white. A suggestion of the blouse is indicated, and a light tone is laid in to provide a hint of the background.

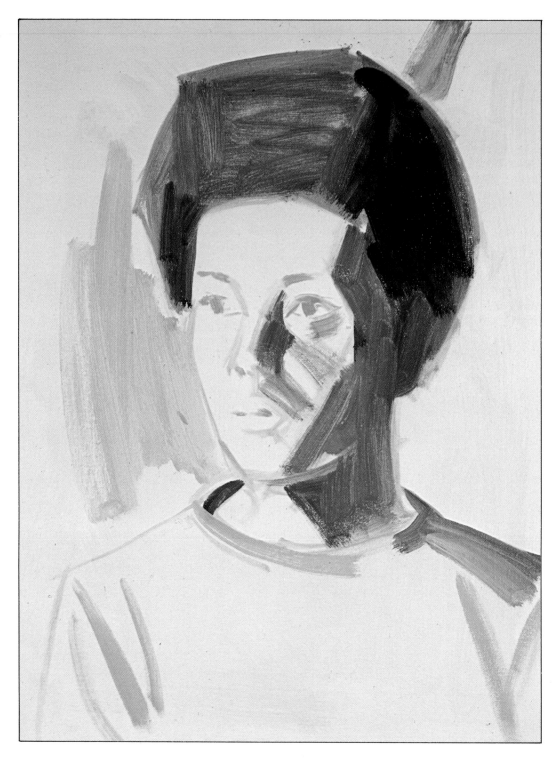

PRINCIPLES OF NEGRO HAIR

Negro hair, worn in the so-called Afro style, produces a precise contour and an abstract pattern of almost two-dimensional, flat, matte material. This is advantageous for recording the overall shape, but it offers little variety of hue. The artist must realize that the hair can't be painted as a uniform mass of pure black, but rather as a combination of darks. Since there are no clearcut breaks or divisions evident inside this general mass, you must look for tonal and color distinctions within it.

There's also the problem of texture. Negro hair worn in an Afro is generally soft; yet, at first glance, it appears solid and immovable.

Step 2. The local color (actual hues) of all the areas are laid in so that, except for a few spots purposely left blank, the total canvas is covered with paint. (The blank areas will subsequently represent the highlights.) The triangular light on the forehead is composed of burnt sienna, ultramarine blue, and white. The underside of the jaw, which catches the reflected light from the yellow blouse, is painted. A bluish/purplish tone is applied to the lips and a similar tone added to the neck on the left. Alizarin crimson and white are combined with ultramarine blue and white and some strokes of burnt sienna for areas of the background. The blouse is a combination of cadmium yellow, ultramarine blue, and yellow ochre, with touches of cadmium orange on the right sleeve and—naturally—large proportions of white.

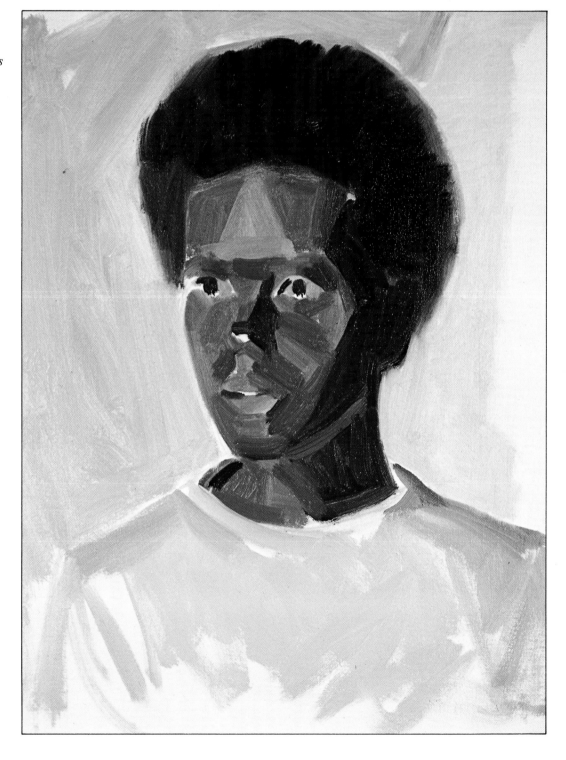

TIPS ON
DARK SKIN

Don't use pure black mixed with white to paint dark skin. Instead, turn to the Indian red, black, and white combination for the cooler dark skin; and to the burnt sienna, black, and white combination for the warmer dark skin. An alternative is to substitute alizarin crimson plus ultramarine blue for the black in the above two mixtures. If the skin tends toward the olive, add touches of green to it.

Look for subtle blue, mauve, green, and olive accents in dark skin. Wherever they appear, accentuate them, since they'll add interest and sparkle to the portrait.

Step 3. The head is refined all over. More blue accents are introduced into the flesh in order to cool it where so indicated. The revealed teeth are painted in. The blouse is carried down to the bottom and some green accents are introduced into it. More attention is paid to the hair in order to capture its soft, fuzzy quality. The lighter areas of the hair are painted with blues and blacks, and the darker portions are a mixture of ivory black, alizarin crimson, and burnt sienna. The flesh tones are made deeper all over. I look for those revealing planes in the dark skin which best catch the light, and paint them in carefully.

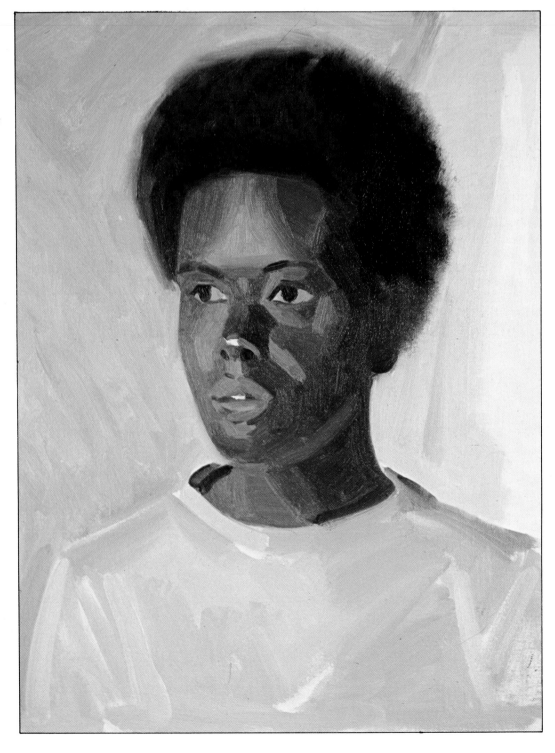

After massing in the overall tone, look hard for those subtle gradations of tones from light to shadow. There's often quite a bit of blue in Negro hair. If it's there, put it in. For deeper, richer, shadows in the hair, use a mixture of alizarin crimson and burnt sienna, with blue and white and black and white in the lighter areas.

To depict the texture and character of Negro hair, don't try to draw each strand with a no. 1 brush. Instead, go for the overall impression. One approach is to leave the areas where the hair and the background coincide wet, then scumble the two areas with a Landseer brush (see Materials section), in effect, pushing the colors together. You can follow the same procedure where the hair and the skin meet.

Step 4, Faye. *The overall refinement of all the elements in the portrait continues. The blouse is completed. The background receives additional touches of burnt sienna to minimize its mauvish quality. All the planes within the head are modeled with more delicacy, with careful attention paid to those intervening areas where features run into each other—the cheek into the nose, the lower areas of the eye sockets, the upper lips drifting into the cheeks. Highlights are placed in the nose and into the eyes with a no. 6 round sable brush. The Landseer brush is used to pull the hair together so that it retains its highly individual, soft, and fuzzy quality.*

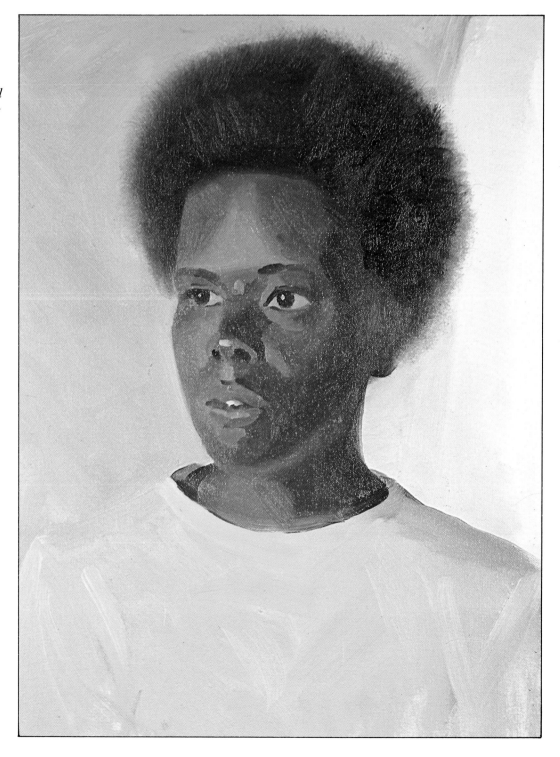

DEMONSTRATION 5

WARM SKIN, BROWN STRAIGHT HAIR, BROWN EYES

This type of coloration was included because of its prevalence among our population. Most Americans are brown-haired and brown-eyed, and this factor in itself poses an interesting number of challenges which will be discussed as we proceed.

THE SPECIFIC PROBLEM

I had to paint my sitter—who is an attractive, sympathetic person—in dynamic and forceful fashion in order to fully exploit his vigorous, masculine presence. To do so, I kept his facial planes blocky and distinct, with hard edges, and made certain not to soften or blend them together too much.

When working with a so-called "average" coloration, you must be particularly careful not to let the portrait grow bland or tedious. To avoid this, you must emphasize those outstanding features or characteristics that are apparent.

Costume and Background. Since Mr. Wanamaker sat for me at his place of business, I had to adjust to the circumstances, something I can normally control when working in my studio. I posed him in a dark suit, which was calculated to serve as an appropriate foil for the warm skintones and the white of his shirt. I chose a cool green background to emphasize the warm brown, outdoorsy tones of his face.

Lighting. The illumination came from a large bay window. It cast a cool north light that created lots of greens, blues, and mauves in the hair and skin.

Palette. I used my full palette with a combination of flake and zinc whites for my white.

Medium. A linseed oil/turpentine combination was used.

Surface. My support was a 20″ x 16″ (51 x 41 cm) single-primed cotton canvas that had been toned with a raw umber/raw sienna tone earlier that day, and was now dry.

Brushes. Since the entire portrait is executed in large forms and masses, I confined myself to five fairly large bristle brushes—a no. 10 and two no. 7 bristle filberts, and two no. 5 bristle flats.

Time of Execution. I must point out that this was merely a study leading to a larger portrait of Mr. Wanamaker. It took me approximately 2½ hours to complete the painting demonstrated here.

Key Color Mixtures. The light area on the temple is formed by running an ultramarine blue and white accent into the basic burnt sienna and white fleshtone to create a kind of cool, mouse gray effect. The eyes are basically burnt sienna and ultramarine blue, with a touch of ivory black. The nose is cadmium red light, with yellow ochre and a touch of the mauve combination. The lips are Indian red, yellow ochre, and white.

Step 1. The canvas is toned with a raw umber/raw sienna mixture which provides a medium-toned value halfway between the darkest and the lightest values, and one from which I can now work toward both ends of the tonal range. Using raw umber thinned with turpentine, I do a line drawing, aiming for a fairly close representation of the sitter's features and contours. Getting this stage down as accurately as I can helps me to achieve likeness as early as possible.

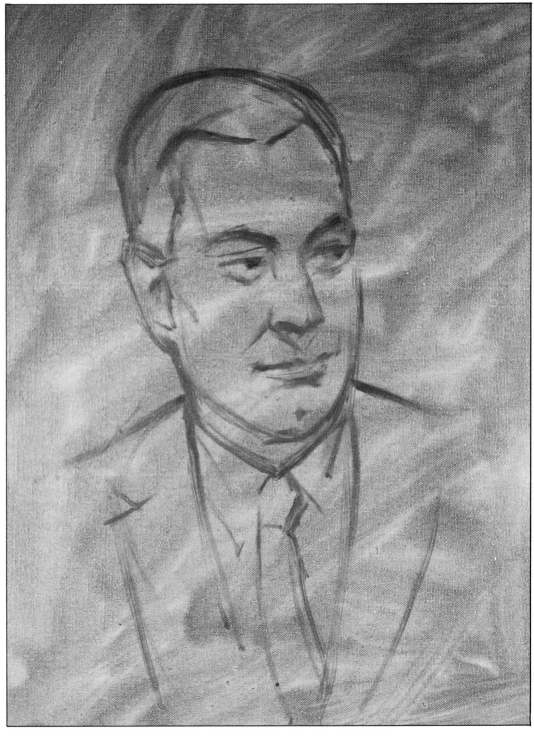

Warm skin must not be painted with too much emphasis on burnt sienna, raw sienna, or cadmium red, or the skin will resemble leather. Also, since most artists tend to paint skin warm anyway, the danger here is, therefore, an overemphasis on the warmer aspects of an already essentially warm complexion.

The receding planes of a warm complexion are generally cooler than the frontal planes. They may tend toward the brown side, but it's likely to be a cool, gray, mousy brown.

Step 2. I mass in all the areas that will be painted in the subsequently vignetted portrait. The background is left untouched. I begin by putting in all the darks in the indicated areas such as the hair, the suit, the eyebrows, the shadow beneath the chin and that cast by the nose. By getting the dark masses down early, it's easier to establish all the value relationships within the form. There is little attempt at this stage to model with any degree of fidelity. I'm mainly seeking to establish my value contrasts and, at the same time, to place local color as accurately as possible.

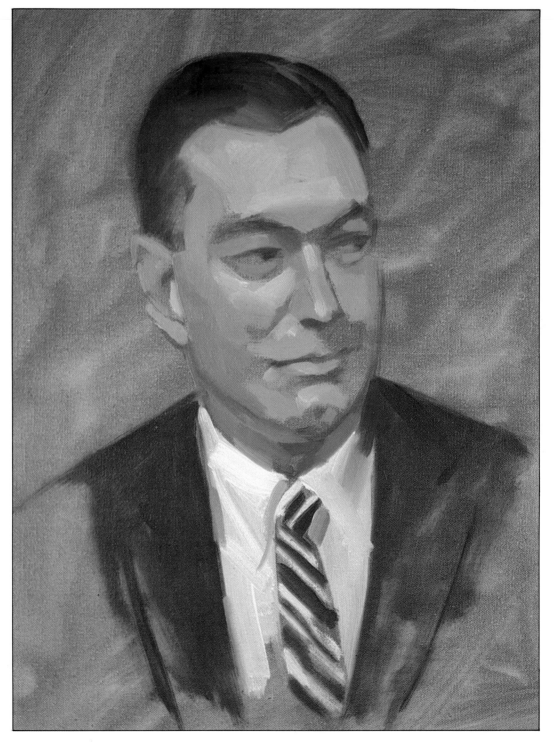

Use the blue and white, green and white, and mauve (ultramarine blue, alizarin crimson, and white) color mixtures to reduce the natural warmth of the skin, particularly in the halftones and shadows.

Step 3. In this stage I carry the process of refinement a bit further. The planes within the head are further broken up and more carefully modeled. The areas adjoining the hair and flesh are blended and softened in selected spots, rendering the transition between hair and skin more natural and realistic. A combination of Indian red and alizarin crimson is used in order to add some warmer reds, pinks, and beiges to the face. Highlights are placed on the bridge of the nose, in the forehead, at the corners of the mouth, and on the chin. The jacket, tie, and background are left untouched from the first stage.

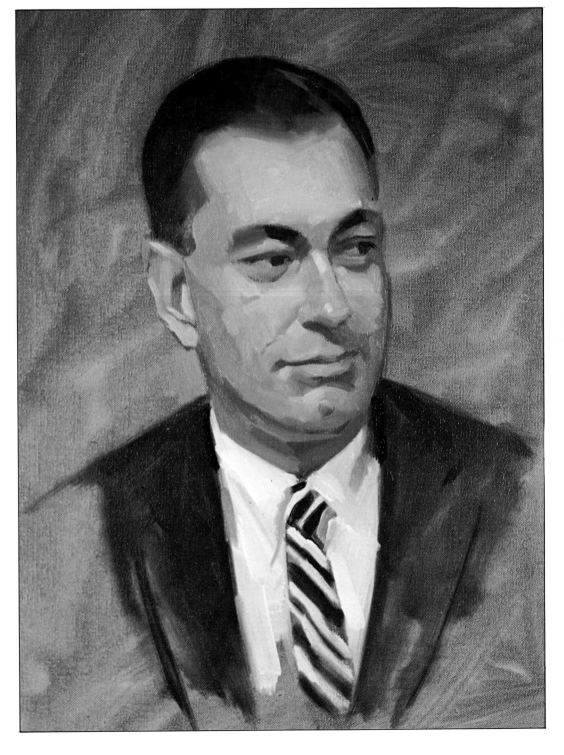

Straight hair, in contrast to curly, presents a harder, more brittle appearance. It's best painted with straighter, longer brushstrokes rather than scumbled in with short strokes. Also, note that straight hair tends to create sharper contours than curly or frizzy hair.

Look for and record the cool blues in the lighter areas of the brown hair which may be present due to the blues reflected from the sky.

Step 4. Work is done to enliven the background, which receives a measure of light blues, greens, tans, and mauves. Raw sienna is used extensively in many of these mixtures. The suggestion of a stripe is indicated in the suit. The facial tones are rendered warmer with additions of alizarin crimson, Indian red, and white. The forehead and temple areas are carefully modeled to provide the illusion of the hair and skin blending in realistic fashion—too often, with a straight-haired sitter, the hair-skin transitions are rendered too sharply. Darker accents are introduced into the eyes, eyebrows, and ear.

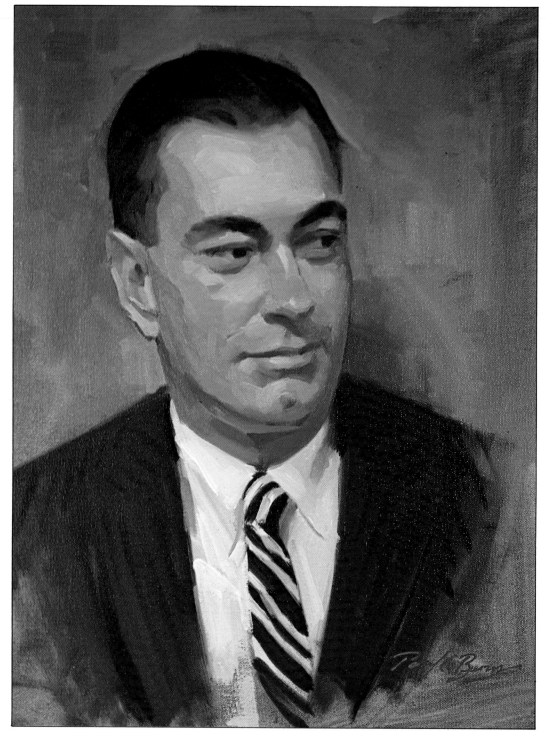

John R. Wanamaker, *oil on canvas, 36″ x 30″ (91 x 76 cm), Collection Mr. and Mrs. John R. Wanamaker. I've painted the members of the Wanamaker family many times (see page 125). This is a larger portrait of the subject of this demonstration.*

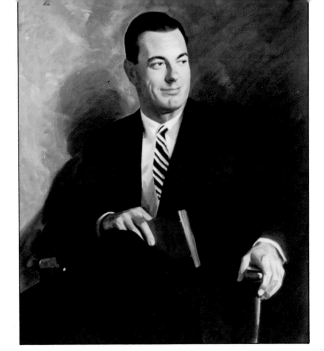

Step 5, John Rodman Wanamaker. *Now, the forms in and around the nose, forehead, lips, chin, and cheeks are painted, with particular attention paid to the smaller planes. The areas of the cheek where the plane turns and recedes back into the ear are given special care. The shoulder of the suit is softened into the background as the edge recedes. The reflected light beneath the chin is strengthened. Most of the work in this stage is centered within the head, with the light areas being painted last.*

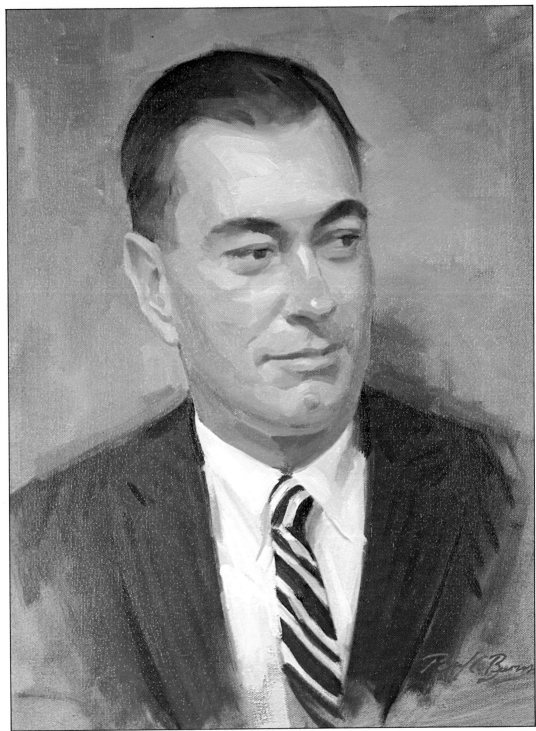

DEMONSTRATION 6

ORIENTAL SKIN

Oriental skin comes in a wide variety of hues and tones ranging from pale ivory to a deep brown. Rather than assume Oriental skin to be unequivocally one fixed color, you must determine each sitter's complexion individually. The model I've chosen for this demonstration reflects merely one type of Oriental complexion.

THE SPECIFIC
PROBLEM

The challenge here was to keep the facial planes flat, yet achieve sufficient modeling. This necessitated very close and careful observation so that the gradual changes of value didn't emerge either too bland or too obvious.

Costume and Background. A gray/mauve background was selected to complement the ochre-ish skintones.

Lighting. Only one source of artificial light was used, without any of the secondary lights that might have cast reflections into the shadows and nullified their strength. The light, coming from the left, struck the sitter's turned face head on, producing a good highlight on her left cheek and creating a bright catchlight in her right iris.

Palette. Although a full palette was squeezed out, I actually used a minimum of colors in this portrait. Little of the tube green was employed.

Medium. Again, my medium was a linseed oil/turpentine combination.

Surface. I used a 20″ x 16″ (51 x 41 cm) single-primed cotton canvas.

Brushes. I used nos. 8 and 5 bristle filberts; nos. 6 (two), 4, and 2 bristle flats; nos. 5 and 2 Landseer bristles for scumbling and merging colors; and finally, a no. 6 camel's hair round for highlights.

Time of Execution. The painting required two sittings. The first, working directly from the model, lasted two and a half hours. Then, an additional half to three quarters of an hour was required the following morning, after having stored the painting in a refrigerator overnight.

Key Color Mixtures. The basic facial tone color mixtures are a combination of yellow ochre, permanent green deep, and Indian red. The highlights on the forehead contain a small amount of the ultramarine blue and white mixture, while the highlights on the cheeks are painted with cadmium red light, yellow ochre, and white, plus a touch of the blue-white mixture. The shadow under the chin is a mixture of raw sienna, ultramarine blue, and a touch of burnt sienna.

The lips are Indian red with a touch of cadmium red. The eyes are black and burnt sienna, and the hair is ivory black and ultramarine blue. The highlights on the hair contain some of the grays and mauves of the background, but they're kept down in value to avoid a too-busy effect.

The background tones are composed of ultramarine blue, Indian red, raw sienna, and the appropriate additions of white.

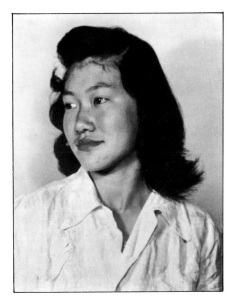

Step 1. With raw umber and white thinned with turpentine, I draw in the main contours and features of my model. At this stage, I'm chiefly concerned with getting the proper placement of the various features—likeness is a consideration I'll face later. The simplicity of this sketch can be misleading to a painter who begins with a very elaborate drawing; however it serves my purpose—which is to obtain the big shapes in as few lines as possible and to capture the most outstanding aspects of the subject. Such a drawing may be compared to a caricature in which the essence of a person is captured with a few telling strokes.

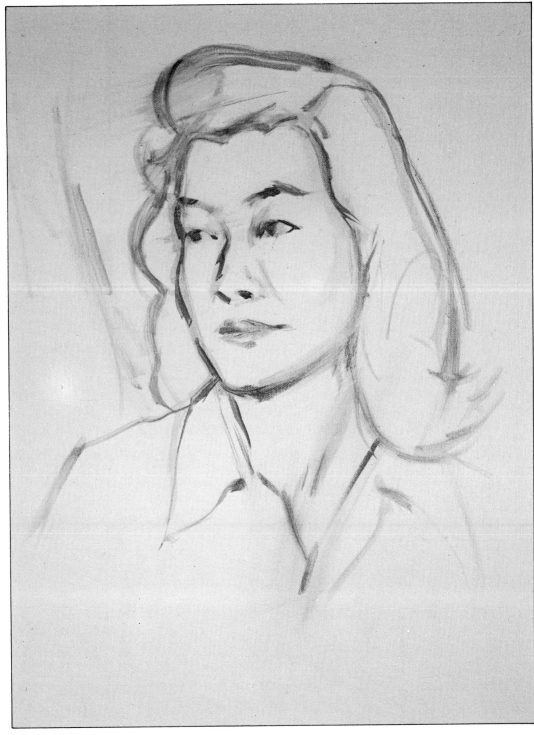

Oriental skin generally falls into the yellow ochre category, but with decided areas of reddish or greenish coloration. It may sometimes present a grayish appearance, but this can be misleading. You must look for the ochre tones that are present.

There's much blue in Oriental hair. In ivory-skinned Orientals, the darkness of the hair accentuates the paleness of the skin. The dark eyes tend to create strong catchlights.

Although this isn't a color consideration, you must remember to take into account the facial characteristics peculiar to the Oriental race—the flatness of the features, the width of the cheekbones and base of the nose, and the fullness of the lips.

Step 2. The face and hair are massed in with basic hues. There's quite a bit of mauve in the hair and background. The white of the collar is put in so that the tonal relationship between it and the darkest darks can be established early. Areas of canvas are left blank for subsequent placement of highlights. The eyes, lips, nostrils, and the shadow of the jawline are indicated. The general skintone in the light is mixed with yellow ochre, raw sienna, white, and ultramarine blue.

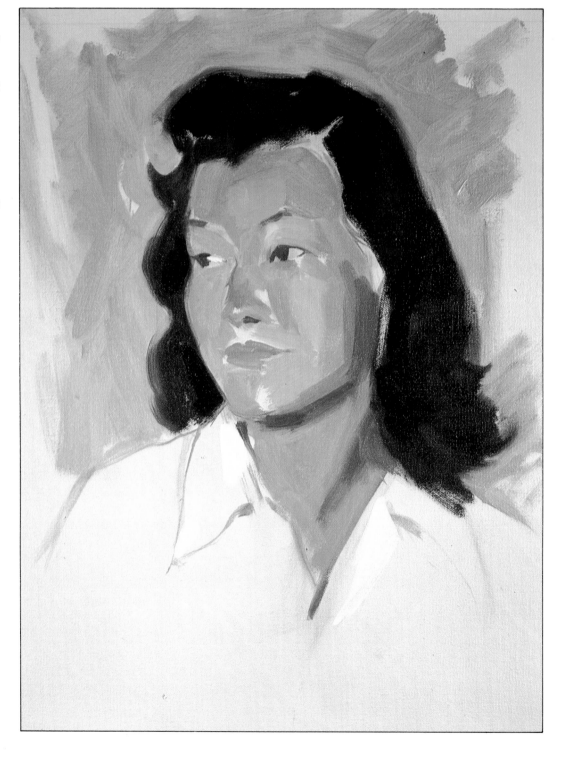

Avoid the overuse of pure yellow ochre. Instead, mix it with raw sienna to darken it, with Indian red to warm it, and with ultramarine blue plus white or with permanent green plus white to cool it. Be wary of using too much blue in the mixtures, lest you end up with a ghastly green complexion. Look for decidedly olive tones where the halftones turn into the shadows. Keep your reds at a minimum. Finally, in your attempt to achieve tonal variety, don't go too deep in value or you'll end up with an overmodeled head.

Step 3. The planes of the flat Oriental face are painted in broadly. The values are more clearly defined. The halftones are cooled with additions of blue. An effort is made to depict the satiny texture of the blouse. The eyebrows are darkened and the shape of the eyes is more clearly indicated. The edges of the hair meeting the skin and the background are modulated. The nearest cheek is defined with a warm touch of red to suggest its color. The line between the lips is painted in to show the smile.

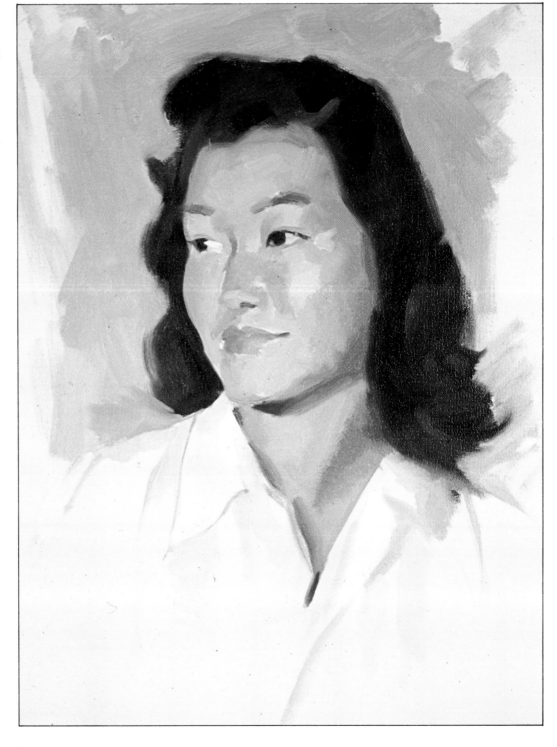

Amy Hattori, *oil on canvas, 20″ x 16″ (51 x 41 cm), Collection of the artist. Amy, who is currently attending an American college, is a young, modern Oriental woman.*

Step 4, Oriental Woman. *All the features are more clearly defined. The shadows in the face are strengthened. Catchlights are placed in the irises. The blouse is more carefully drawn. The top of the head is more accurately painted. I could have stopped at this stage and considered the portrait finished. However, I wasn't totally satisfied. I decided to continue the following day. Having stored the canvas in the refrigerator overnight, I resumed painting for another half hour or so the next morning, working without the model. I felt that the painting needed additional depth and refinement. I proceeded to work on all areas at once, adding minor corrective touches. The differences between this stage and the previous one are hardly noticeable—perhaps I sensed what was needed more than I saw it—yet I felt that I shouldn't let go of the portrait until it fulfilled me both visually and esthetically.*

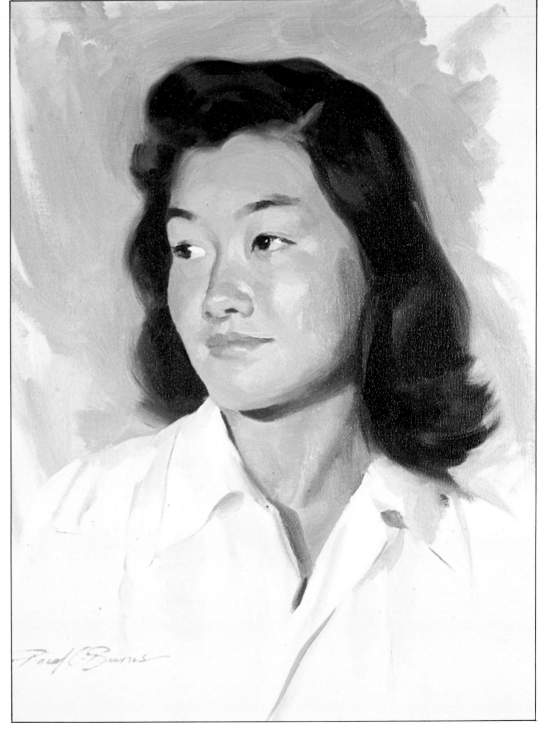

DEMONSTRATION 7

MEXICAN/INDIAN COMPLEXION

The complexion of this ethnic group is somewhat similar to Negro skin, but is usually somewhat lighter and leans more toward the brick-red side of the spectrum. Mexicans (as is my model) are often *mestizos*—a mixture of Caucasian and Indian blood that results in some striking skintone combinations.

THE SPECIFIC PROBLEM

I posed my model outdoors in bright sunlight, since this lighting seemed most appropriate for her type of complexion. I had her wear a white costume, which is likewise characteristic of the southwest. The challenge was to retain likeness despite the deeply squinted eyes, and to keep the deep, dark shadows thus produced in balance with the rest of the values.

Costume and Background. The white of the costume reflected bright lights into the high cheekbones. You must be careful, however, not to allow the reflected lights of white clothing to get too high in value or they'll diminish the depth of the shadows.

Lighting. I painted the subject under outdoor lighting, in bright sunshine, around noontime.

Palette. I used a full palette, with a zinc/flake white mixture for my white.

Medium. My medium was a linseed oil/turpentine combination.

Surface. A 20″ x 16″ (51 x 41 cm) single-primed cotton canvas was used.

Brushes. I used a no. 10 bristle flat for the background and for massing in the large forms, and also nos. 8, 6 (two brushes), and 2 bristle flats. I also used nos. 8 and 5 bristle filberts.

Time of Execution. The painting took two and a half hours to complete.

Key Color Mixtures. The basic forehead color was burnt sienna, raw sienna, plus touches of yellow ochre. The warmer cheeks are a blend of burnt sienna, cadmium orange, and Indian red. The tip of the chin is Indian red, and the light reflecting into the jaw is a combination of raw sienna and the green/white mixture.

The area below the nose is composed of raw sienna, burnt sienna, and the ultramarine blue and white mixture for cool accents. Warm tones there would cause the area to protrude too much. The shadow beneath the head is ultramarine blue along the edge; and cadmium orange, ultramarine blue, and Indian red within the neck. The dark shadow areas within the head are basically ultramarine blue and alizarin crimson, with overtones of Indian red or ultramarine blue and yellow ochre in the more olive-hued areas.

The highlights on the hair are ivory black, white, and ultramarine blue.

Step 1. I begin by dividing my canvas and the photograph into four equal parts. This constitutes the grid system in its most simple form and it helps the placement of the features. My drawing in this first stage is more careful and detailed than usual. Not only are the features placed in proper perspective, but there's also a definite effort to achieve likeness from the very start. I use raw umber mixed with white and thinned with turpentine to lay in the lines and to mass in such darks as the hair and the deep shadows of the face caused by the bright, noonday sun.

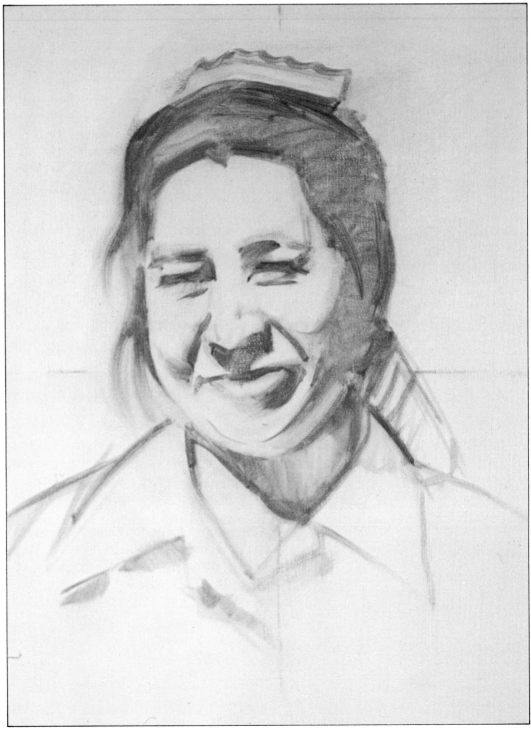

The background on the right of the model's head was deliberately kept wet so that the hair could be blended into it. The edges of the model's rather sleek hair are painted with long decisive strokes to express the character of the hair. Where the hair meets the skin, softer edges are recorded.

Since the sun shone through the material of the white uniform, cadmium orange and ultramarine blue/white accents appear to show the blue of the sky and the warms of the sunlight beneath the collar.

Step 2. Now I introduce color. The background, which was a white-washed wall in shadow, is made up of ultramarine blue, alizarin crimson, white, and mauve accents. The hair is blue-black all over. The cap and the collar receive touches of alizarin crimson and cadmium yellow to heighten the illusion of brilliant sunshine. The face is painted in broad planes of warm reds and yellows with blank areas of canvas left in the forehead, cheeks, nose, lower lip, and upper lids in anticipation of the strong highlights that will follow. A suggestion of halftone is placed at the edges of the cheek on our right, where it rolls into the shadow. The lips are painted with Indian red and a touch of cadmium red light, which is somewhat cooler than the rest of the skin tones. The scarf is shown as a gray mass.

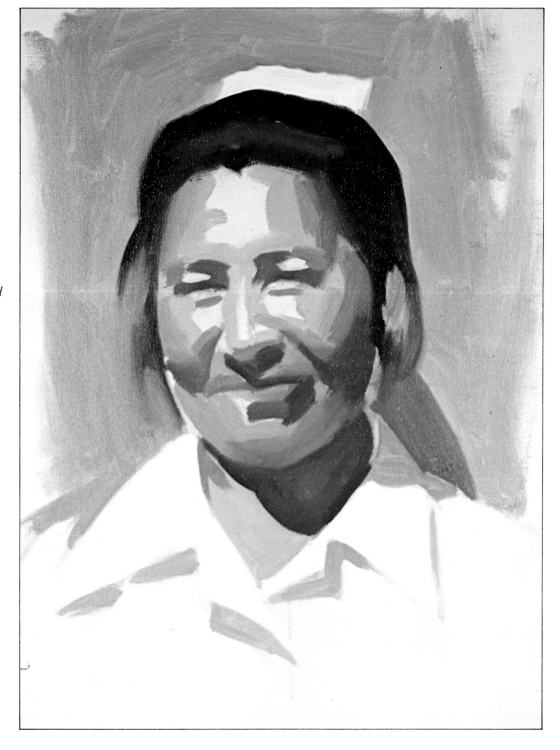

PRINCIPLES OF
MEXICAN/INDIAN
COMPLEXION

Mexican/Indian skin tends toward the Indian red, raw sienna, yellow ochre tones, and away from the blue and olive accents of black skin. Their skin tends to be oily and therefore highly reflective.

This group is most frequently found in the southwestern areas of the United States, where the sunlight is quite powerful. This causes people to squint, resulting in a slitty-eyed expression in which distinct irises can't be detected or defined. When painting them, it's therefore important to depict the shapes of the eyes and of the adjoining areas accurately.

Mexican/Indian hair tends to be very straight, and very black and lustrous. It contains lots of bluish accents. Indians and mestizos are apt to have wide faces with flat features. Their heads are often pear-shaped, wider on bottom than on top.

Step 3. The facial features are starting to come together. There's much more overall redness evident in the skin. The hue in the highlights is more pink than the rather copper color of the darker flesh areas. The lips are more carefully painted in and the highlight on the forehead is adjusted with an intervening, darker plane. All the transitional areas in the head are brought closer together. There's a suggestion of the curve of the hair sweeping back under the cap. The background is filled in, and warmed and subdued with touches of burnt sienna.

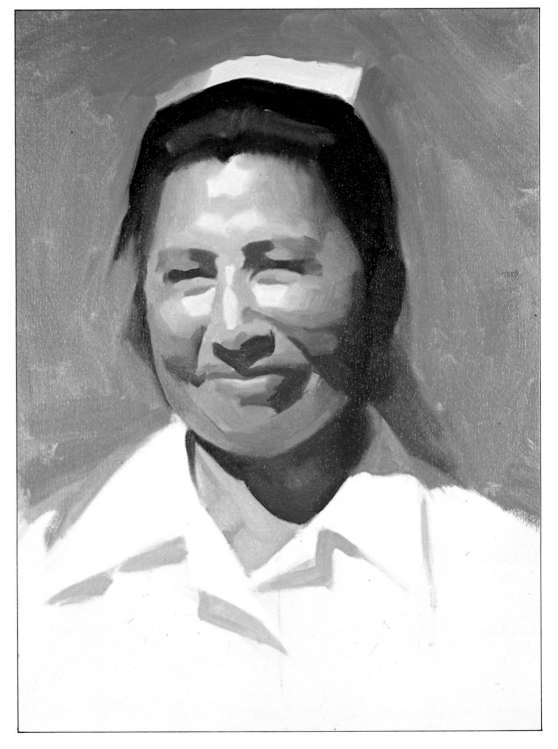

The highlights on Mexican/Indian skin tend more toward the cooler Indian-red side than the hot cadmium-orange side of the spectrum. The general flesh tones are composed of raw sienna, yellow ochre, Indian red, and white, with ultramarine blue and white or permanent green and white for the cooler accents, and burnt sienna for the warmer. However, avoid using an excess of burnt sienna. Look for the decisive olive tones in the halftone areas. Use a minimum of cadmium reds and oranges in the skin shadows to avoid a drab, muddy effect.

Mexican/Indian hair usually has little, if any, brown in it.

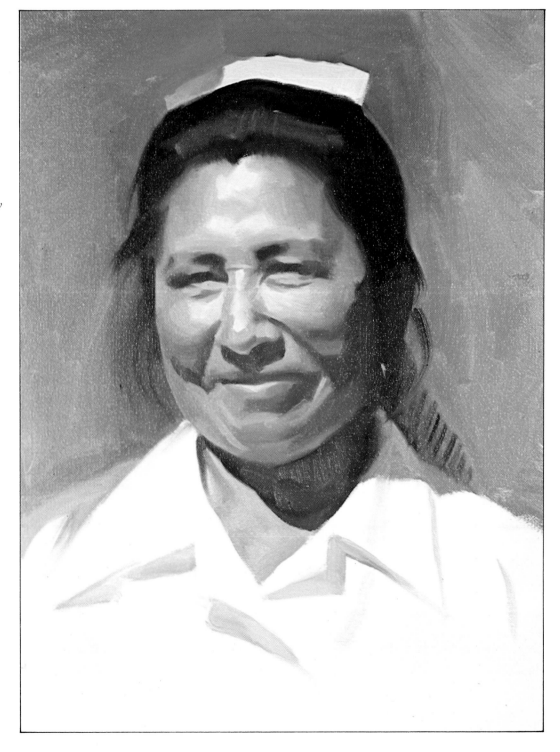

Step 4, Mexican Woman. *The strong shadows in the head are deepened even more. Reflected light is shown in both cheeks. The smile becomes more evident as the play of the muscles around the mouth is accented. The wet background color is blended into the hair to provide a more realistic transition. The squinted eyes are represented by dark slashes of shadow, but I'm careful to keep them in tonal relationship with the other deep darks in the face, so they don't become too dark. Note how deep and dark is the shadow beneath the chin—this is the effect that the bright sun in that part of the world produces.*

DEMONSTRATION 8

WHITE HAIR, RUDDY COMPLEXION

This type of so-called high complexion is quite common among Anglo-Saxon males. It's usually accompanied by blue eyes, and it provides a striking contrast of red, white, and blue that's fun to paint.

THE SPECIFIC PROBLEM

Here, I was faced with the challenge of painting a ruddy-skinned gentleman without having him emerge as a lobster-faced Santa Claus figure.

Costume and Background. I selected a reddish background to harmonize with the florid complexion and to keep it from emerging too fiery by contrast. The blue costume casts some cool reflections up into the lower parts of the face.

Lighting. The portrait was painted in the evening under a strong 150-watt GE blue photo floodlight, which cast a pinkish illumination.

Palette. A full palette was employed, including my flake white/zinc white combination, but I found no need for Indian red.

Medium. A linseed oil/turpentine combination was used.

Surface. I used a 24″ x 20″ (61 x 51 cm) single-primed linen canvas, Fredrix no. 111.

Brushes. I employed a minimum of brushes for this portrait, which was painted in rather broad planes. I used nos. 10, 8, 6, and 4 bristle flats.

Time of Execution. The painting took two hours to complete.

Key Color Mixtures. The light areas of the flesh are basically cadmium orange, cadmium yellow pale, and white. The temple area between the eye and ear is raw sienna, ivory black, white, alizarin crimson, and cadmium red. The nose is burnt sienna and raw sienna, with touches of cadmium red light and ultramarine blue just above the nostril. The light area under the nose is cadmium orange, cadmium red light, and some yellow ochre. The lips are alizarin crimson, ivory black, and a touch of cadmium red light to hold down the purplish tone.

The highlight on the cheek is cadmium red light plus alizarin crimson and white, and the area just above it is burnt sienna plus ultramarine blue and white. The basic halftone areas are raw sienna and permanent green deep and white; or raw sienna, ivory black, white, and a touch of cadmium orange in the darker areas of halftone.

The hair is a blend of warm raw sienna and burnt sienna in the dark areas. The eyebrows, which at first appear pure white, are related to the whiteness of the shirt and the kerchief.

Step 1. I lay a vertical light line down the center of the canvas to help me place the head in the approximate middle. I then proceed to make the initial drawing in a mixture of raw sienna and white. I'm particularly concerned with the effect of a light head against a dark backdrop, and I paint in the dark reddish background around the contours of the head and shoulders to indicate to myself how the finished portrait will look. A light tone suggests all the shaded areas within the head.

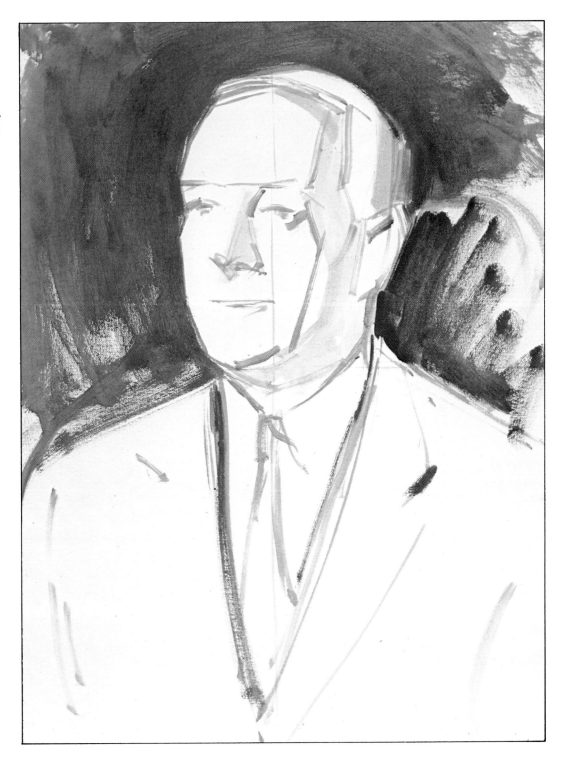

Despite the obvious redness of such skin, it contains both warm and cool accents and should be painted as such. Painting it as an all-warm complexion will render your efforts ineffective.

The lobe of the ear and the cheek often constitutes the reddest areas of the florid complexion, and the top half of the face is usually redder than the bottom half. A ruddy complexion appears less so when struck by the blue of the sky. A sunset, however, renders it even more florid.

White hair and blue eyes serve as complements to florid skin—another proof of nature's wisdom in arranging pleasing skin-hair-eye combinations. Halftones in florid skin often appear olive or greenish. The greener you make them, the redder the light areas of skin will emerge by contrast.

Step 2. The first thing I do is mass in the blue suit in order to establish a value and color relationship and keep my flesh tones from emerging too dark. At this stage, the tones of the skin are painted rather thinly. I try to cover the whole canvas with the appropriate color and to quickly establish the lights and shadows. Halftones and highlights will be saved for later. The hair is divided into lights and darks and painted accordingly. Likeness is confined to accuracy of the larger shapes—so far there's no effort to go after the smaller planes. The reds of the tie are put in so that they'll keep the reds of the face from emerging too intense.

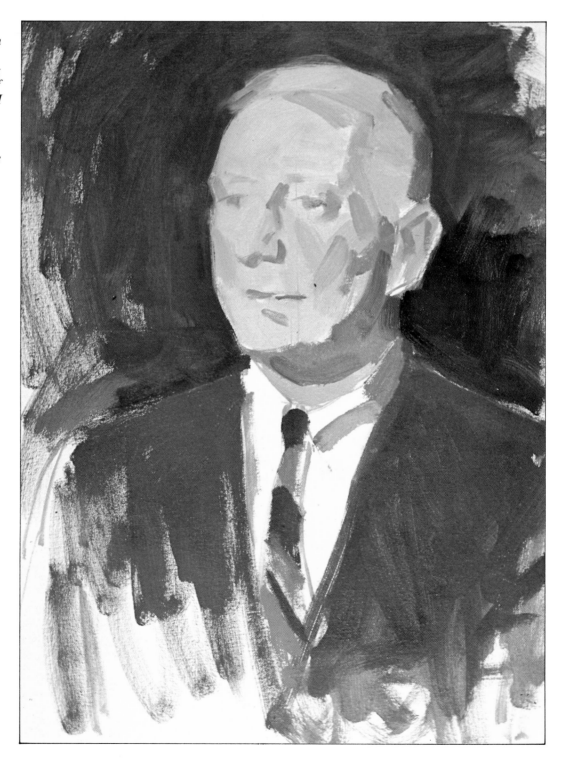

To emphasize the redness of ruddy skin, surround it with lots of greens; to minimize its reddish effects, stick to yellows, reds, and blues that contain no purplish accents.

When painting a ruddy-skinned woman, make sure the red of her lipstick is in correct color relationship with the reds of her face. You must constantly relate colors and values.

In order not to go too dark too soon, keep the key of the painting high throughout the portrait and save the really dark darks for last.

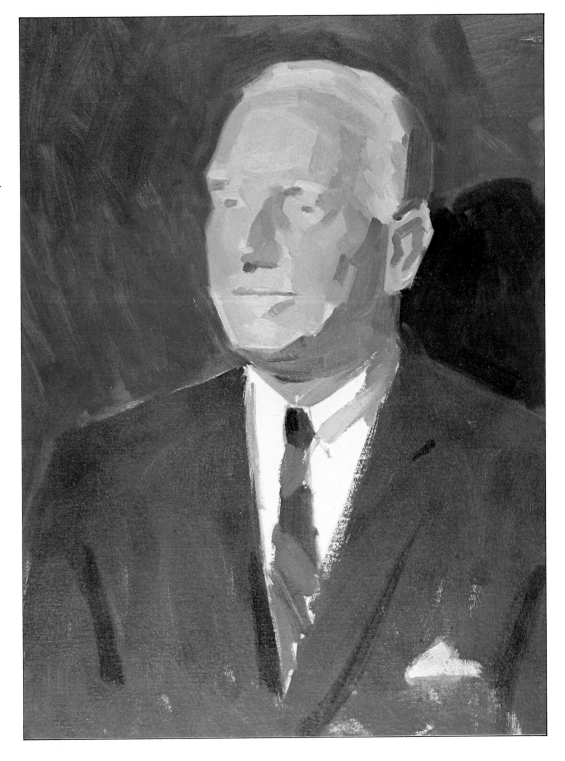

Step 3. I'm starting to pull the whole thing together. The half-tones, which will show the head turning and receding into shadow, are more carefully indicated. The paint is laid in more thickly all over, but particularly in the lighter areas. The shadow of the shirt collar is toned down. The background and suit are filled in, but the eyes have been painted over so that they appear less finished than in the previous stage. You must never be afraid to correct or repaint something if it appears not quite right.

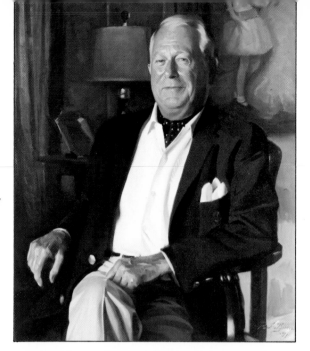

Frederic C. Church, *oil on canvas, 36" x 30" (91 x 76 cm), Collection of the artist at Grand Central Art Galleries, Inc., New York.* Here's another portrait in which a ruddy complexion and white hair are featured. When I first painted the portrait in Nassau, there was too much reflected light, so I decided to make another attempt when the Churches returned. I went to their home for more photographs and make additional sketches, and this painting was the result. However, they preferred the painting shown on page 6.

Step 4, Reggie Wilde. *The half-tones rounding the chin, jaw and mouth are painted in boldly. Highlights are placed on the cheek, the temple, the chin, and the tip of the nose. The eyes are reworked. The white eyebrows are put in after relating their value to the nearly pure white of the shirt. The dark underside of the cheekbone is shown. The shirt, tie, jacket, and kerchief are crisply delineated. I could have continued much further with this portrait—further breaking down the planes and probing for details— but I felt that the statement that I'd intended to make had been made, so I decided to leave it as is.*

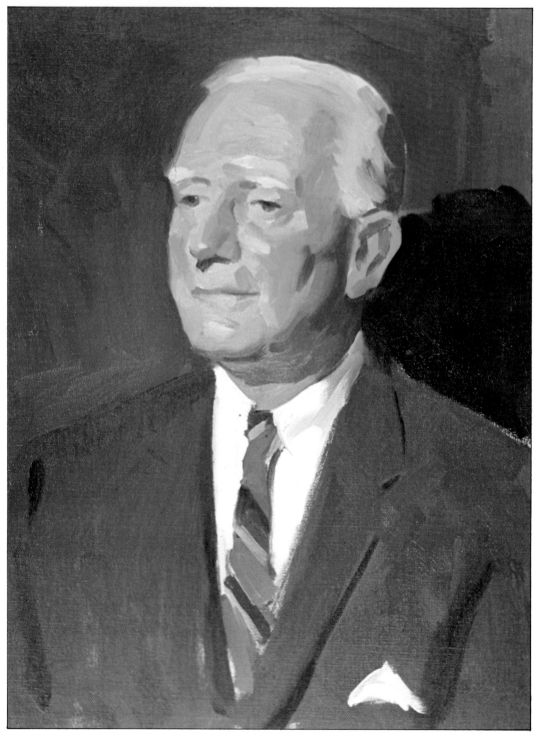

LIGHTING

Demonstrations 9 through 15 deal with the challenges posed by various lighting arrangements. The advantages, disadvantages, and obstacles presented by each kind of portrait illumination are discussed, considered, and evaluated.

DEMONSTRATION 9

FRONT LIGHTING

A number of difficulties evolve from the special characteristics of front lighting. It's not the easiest light by which to paint a portrait, which is exactly why I included it among the problems confronting the portrait painter.

THE SPECIFIC PROBLEM To attain the feeling of a rounded head, despite the availability of a minimum full tonal range is difficult because front lighting doesn't contain deep shadows.

Costume and Background. I began the painting with my model wearing a white blouse. Upon taking a second, closer look, I decided that she required more color and value in the costume, so I had her add the blue jacket, which provided a more satisfying pattern. The blue velvet of the jacket also added definite sparkle and lift to the portrait. I added the scarf for a decorative touch.

Since a dark background would have lightened the flesh tones, and vice versa, I selected a background of medium tone.

Lighting. Flat front lighting was issuing from the same height as the model's head. The day was an overcast one.

Palette. I began this portrait with a limited palette of three colors plus white: alizarin crimson, cadmium yellow pale, ultramarine blue, and a zinc/flake white combination. After a while, I realized that this was insufficient to capture the hue of the hair, so I added black and burnt sienna in the fourth and fifth stages of the demonstration.

Medium. I used a linseed oil/turpentine combination.

Surface. My support was a 20″ x 16″ (51 x 41 cm) single-primed cotton canvas, colored with an acrylic tone of black and white, and blown dry with a hair-dryer to accelerate the drying time.

Brushes. As a result of the changes instituted during the course of this portrait, and due to some difficulties I experienced with its execution, I used more brushes than normal. They included nos. 12, 19, 8, two no. 6, 4, and two no. 2 bristle flats; nos. 8, 7, 6, and 1 bristle filberts; a no. 0 bristle round; and a no. 6 camel round for highlights.

Time of Execution. The painting required two sittings. The first was of two and a half hours duration. Then the canvas was stored in a refrigerator overnight and work was resumed the following morning for another hour.

Key Color Mixtures. In any portrait executed in the primaries only, the skintones and hair are apt to contain elements of the three primary colors, in varying proportion, with more of the reds and yellows in the warmer areas and more of the blues in the cooler areas.

The addition of burnt sienna and black in the latter stages of the portrait tended to diminish the overall mauve quality the portrait was beginning to assume. It helped me to obtain the good rich, warmer darks I wanted in the hair, and to achieve the true tone of the dark blue jacket.

Step 1. Over the dry gray tone of an acrylic wash, I make a rather careful drawing in a mauve tone. Some pictures come more easily than others. For some reason, this was one of the more troublesome ones. At this stage, I'm going ahead with a limited palette of the three primaries plus white. I haven't yet included the dark jacket that will appear in the subsequent stages. In this preliminary drawing, I'm looking mostly for those large masses that will enable me to better grasp the volume of the shapes within the head.

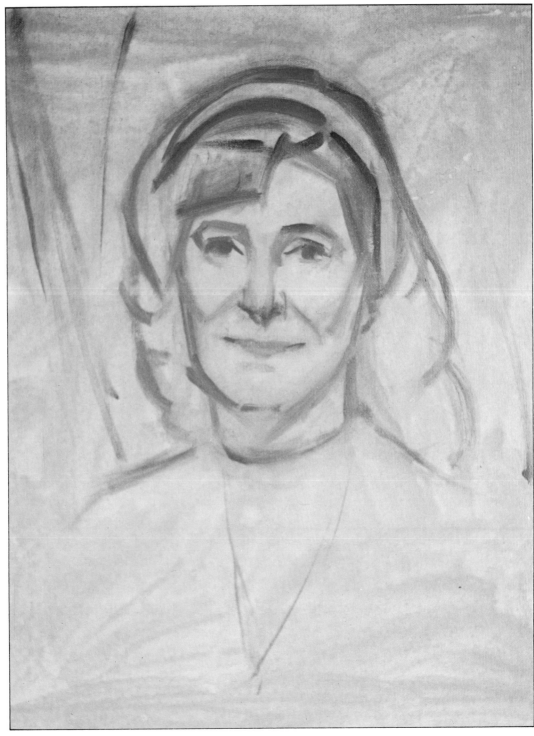

Front lighting tends to negate shadows, thus forcing the artist to work harder to attain the three-dimensional, modeled effect in the head. Since front lighting results in fewer areas of shadow, halftones assume more importance here than in portraits executed under other types of illumination.

This is the kind of illumination that minimizes value but accentuates color, since it lights more of the head than do the other types of illumination. Thus, a person with a pale, colorless complexion won't take too kindly to front lighting.

Female subjects and young people, particularly girls, tend to benefit from this type of lighting, but male subjects tend to suffer, since it renders them less rugged and virile. This illumination was much favored by Renoir and Gainsborough, both noted for their paintings of women.

Front lighting is also good for revealing the color of irises.

One disadvantage of working under front lighting is that it tends to cast a glare onto the canvas, making painting more difficult. However, tilting the easel forward helps alleviate some of this difficulty.

Step 2. Now I proceed to fill in with the three primary colors. The frontal light produces a minimum of shadow, and I model carefully to assure that the head will appear to turn and seem to recede into the darks of the hair. The background is massed in with the full array of color I have at my command. The hair emerges a kind of mauve shade and I'm beginning to think of adding additional colors. I'm also dissatisfied with the effect produced by the white blouse. Changes are clearly in order.

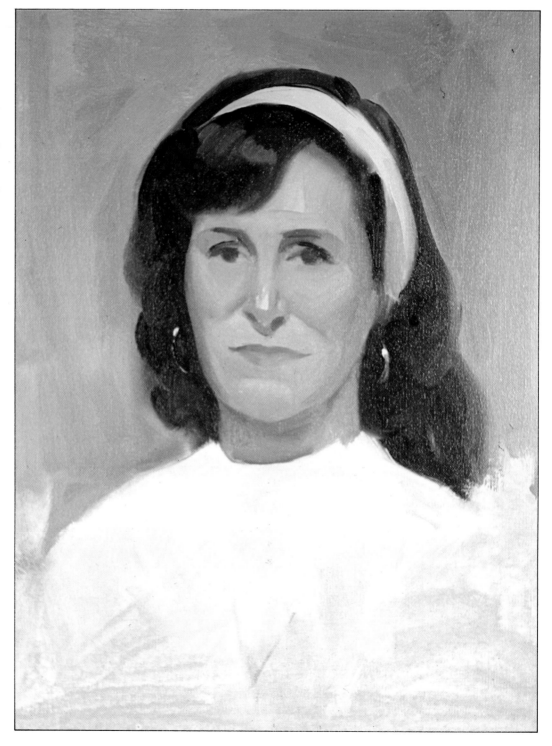

Look for and record the subtle, delicate turns of the facial planes. Make sure you model sufficiently to counteract the effect of flatness this kind of illumination produces. Look for and emphasize the color aspects of the subject.

Step 3. I now pay more attention to the features. The eyes, nose, and mouth are more carefully drawn and the folds of the cheeks are indicated. The mouth is curved upward to show the smile. The cheeks are rounded and the eyes somewhat narrowed to suggest the movement of the muscles in a smiling face. The highlights on the nose and the forehead are fortified. However, I still feel that the portrait lacks something. I decide to institute changes the following day when the second sitting will commence.

Step 4. At this stage, I add ivory black and burnt sienna to the palette, having found that the three colors I've been using are insufficient. Sometimes such a strictly limited palette is enough—at other times, it just won't do. I use the ivory black and burnt sienna to lend the hair the warm, deep richness it calls for. I blend the transitional areas of hair and skin—which have remained wet—together with my thumb. I add darker values to the hair ribbon. The eyes and eyebrows are darkened as are the shadows in the face. Finally, I put in the jacket and the locket.

Barbara Eaton, *Past President of the Ridgewood, New Jersey, YWCA, oil on canvas, 28" x 32" (71 x 81 cm), Collection Barbara Eaton. This portrait was painted under the bright front light of an east window—which meant I could only work afternoons on the portrait. The light emphasizes the delicate ivory tones of the subject's skin.*

Step 5, Diedré Burns. *Had I doggedly gone ahead with my original plans, the portrait would not have emerged to my satisfaction. An artist always must remain flexible and not hesitate to drastically alter his approach at any stage of the painting. I paint in the lighter values in the jacket, seeking to capture the character of its texture. Cool blues and greens are introduced into the sitter's left upper lip area. The expression now seems correct and I'm more pleased with the portrait.*

DEMONSTRATION 10

THREE-QUARTER LIGHTING

This is the most common illumination in portraiture. It produces a good balance of light, halftone, and shadow in the head, and for this reason, it's the lighting most often used, particularly in commissioned portraits. But just because it is so widely employed, there's no valid reason to either favor or avoid it.

THE SPECIFIC PROBLEM I wanted to paint my subject, who is a famous and distinguished personality, so that his attractive, virile, and sympathetic qualities were immediately evident. I had to be careful to de-emphasize the bluish/greenish dark tones of his chin and jaw areas, which would have lent an undesirable, ominous, and uncharacteristic tone to the portrait. Mr. Rockefeller also has a slight tendency to curve his mouth downward. I carefully avoided such a line, which would have given him a dour expression that doesn't reflect his warm and obliging personality. A portrait painter is obligated neither to flatter nor deceive, but to present his sitter in his most favorable light.

Another difficulty was the problem of insufficient painting time. Mr. Rockefeller had limited posing time to grant me, and I had to catch him between business discussions. This is one more obstacle a professional portrait painter must confront and overcome.

Costume and Background. The dark suit matched the value of the background on the left and served as a foil to project the face forward. The lighter areas of the background set off the top of the head and the shoulder on the right.

Lighting. The painting was executed in Mr. Rockefeller's office. I had two mornings and one afternoon to complete it. Fortunately, on the second day, the sky was overcast and I was able to get in much valuable work. The change of light between the morning and afternoon sessions was another difficulty to which I had to adjust. The light issued from the northwest side for one light source, with the blinds on the other windows drawn.

Palette. I used a full palette, with a zinc/flake white combination.

Medium. My medium was a linseed oil/turpentine combination.

Surface. A 20″ x 16″ (51 x 41 cm) single-primed cotton canvas was my support.

Brushes. The brushes I used were nos. 10, 6, 4, and 2 bristle flats; nos. 8, 5, 3, and 2 bristle filberts; a no. 1 sable flat, and a no. 6 sable round.

Key Color Mixtures. The background is a mixture of permanent green deep, white, and ivory black, with accents of raw sienna in the folds on the left-hand side, plus touches of alizarin crimson to minimize some of the vivid green. Burnt sienna is used in the junction between the background and the shoulder on the left.

The basic flesh tones are cadmium red light, yellow ochre, and white, with addition of the ultramarine blue and white combination to cool it. The chin and lips are a blend of Indian red and white, while the cheeks contain cadmium red light, cooled by the blue and white mixture. The shadows in the face are basically raw sienna and Indian red, with blue and green accents added where needed.

The hair is a mixture of black and white, with touches of burnt sienna to warm it.

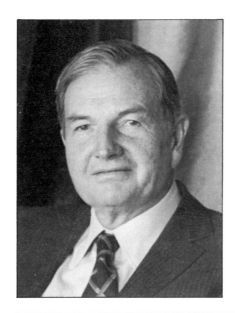

Step 1. Mixing raw sienna, ivory black, and white, I draw in the head, laying a dark mass to the left of the sitter's lighted side. The shapes of the head are brought out and all the dark areas of the face, hair, and jacket are indicated. This seemingly sketchy outline provides me with all the initial information I'll require to execute the completed portrait. The only aspect that's missing is color.

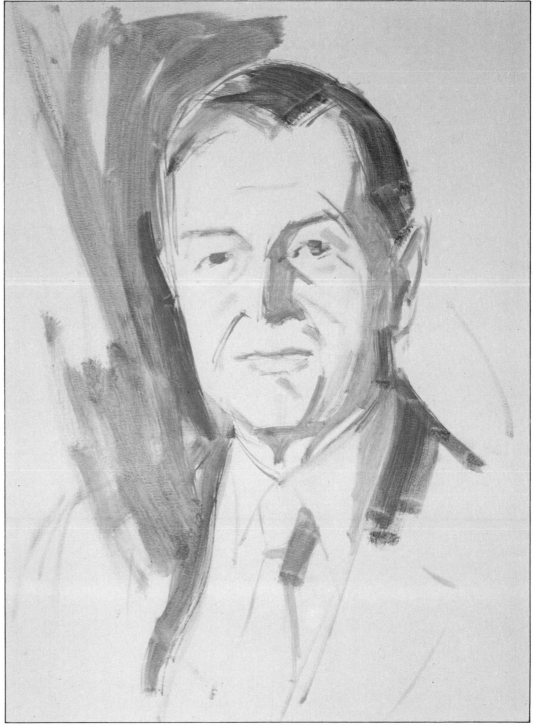

There's a firm historical tradition of successful portraits painted in three-quarter light. Hals and Velasquez employed it extensively, as did most of the skilled painters of the past. Because of the strong shadows it produces, this is an ideal illumination for emphasizing the strong, virile characteristics of male sitters. But, to maintain the strength of the shadows in this light, don't allow too many reflected lights to shine back into them.

Modeling is relatively easy in this type of illumination since it projects the nose forward, and with its full complement of lights, halftones, and shadows, it helps the artist to achieve the total estimate of volume and form. The halftones are distinct and noticeable and a nice subtlety of facial planes can be arrived at as the head rounds off into shadow. The eyes likewise receive good catchlights and a sense of shape.

Step 2. I now cover the underlying guidelines with color, but I've retained enough lines so that the acquired data isn't lost. Broad areas of bare canvas are left for subsequent highlights to be added in the forehead, the cheek on the right, the lip, and the ear. The shirt is filled in with a medium tone and the shadow of the tie is indicated. Dark greens are introduced into the background and the jacket is further developed.

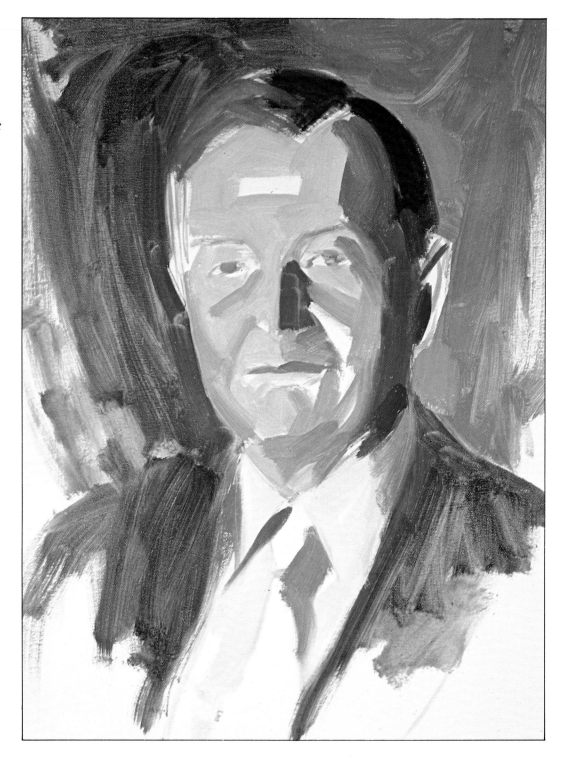

TIPS ON THREE-QUARTER LIGHTING

Be careful not to fall into the all-too-easy pattern of painting all your portraits in three-quarter light. This will result in a sameness of approach, a staleness, and a lack of innovation in your portraits.

Look hard for the halftones and make certain that they go around the head. Without this, the light and shadow areas will emerge flat and two-dimensional.

Step 3. Halftones are added all over and the planes of the face are pulled together. The highlights are placed in the appropriate places. The hair is broken up into light and dark values. The background on the left is darkened. Pinks and reds are introduced into the skintones. The details of the costume, including the tie, are pretty well worked out.

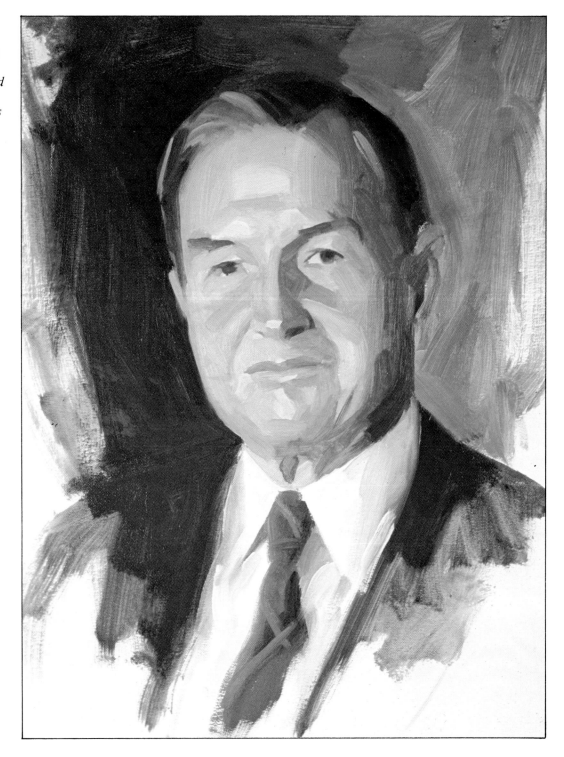

I painted David Rockefeller's portrait on location in Mr. Rockefeller's office. Since I only had limited time in which to work, I took many black and white and color photographs so I could finish the painting in my studio. During the sittings I concentrated on the head and hands, with all other large masses only blocked in.

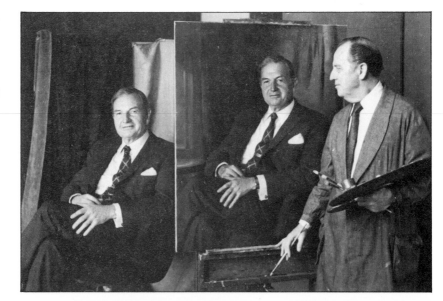

Step 4. A suggestion of folded drapery is made in the background. This is designed to promote a feeling of depth so that the head seems to be lying perhaps three inches in front of its backdrop. The hair is painted to suggest a feeling of its planes emerging from and drifting into the dark background behind it, and much attention is given to individual features. The blues and greens of the sitter's underlying beard in chin and lip areas are shown. The portrait is nearly completed, but there are a few details that I feel still need reworking.

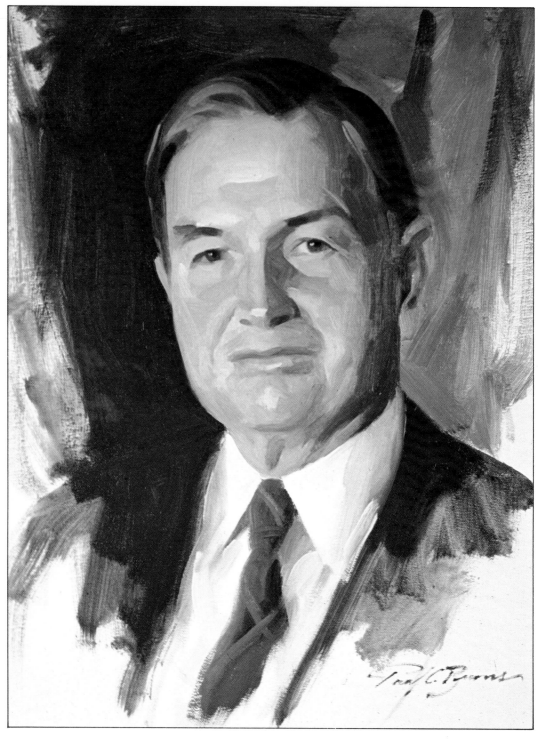

David Rockefeller, *oil on canvas, 40" x 32" (102 x 81 cm), Collection The Clearing House, New York. This is the finished portrait from which I made this demonstration.*

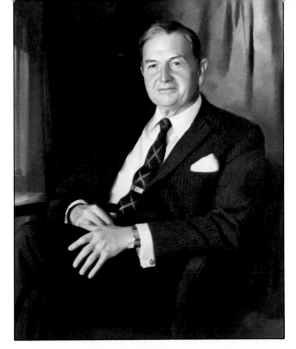

Step 5, David Rockefeller. *Having stored the canvas in the refrigerator overnight, I continue to work without the model. Most of the refining is confined to light areas on the subject that I feel require some additional work. The forehead is shortened somewhat and the hair is warmed a bit in color. By viewing the portrait freshly a day later, I can see small errors I might have missed the previous day, while engrossed in the painting.*

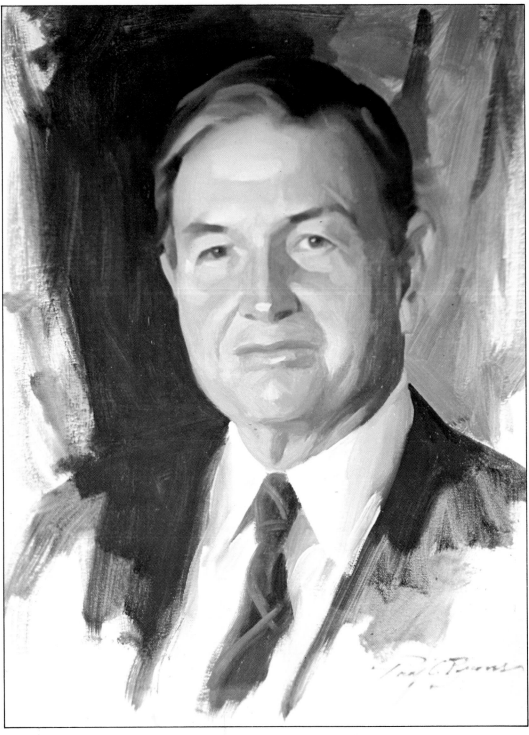

DEMONSTRATION 11

BACKLIGHTING

Backlighting is an exotic form of illumination that is rarely used in commercial portraiture since it tends to minimize the features and to work against getting a likeness by shifting the focus from the features to the overall dramatic effect and the shape of the head. A backlit head, however, can result in a most striking portrait, and is an excellent means of avoiding the usual and the mundane portrait.

THE SPECIFIC PROBLEM I had to keep enough light within the face to establish my sitter's likeness and to maintain his individual characteristics. At the same time, I had to remain true to the conditions that prevailed and retain the fidelity of the values created by the backlighting.

Costume and Background. I used a dark velvet drapery in the background as a foil against which the head would stand out.

Lighting. I worked under a high north daylight.

Palette. I used a full palette with the zinc/flake white combination.

Medium. As usual, my medium was a linseed oil/turpentine combination.

Surface. I worked on a 20″ x 16″ (51 x 41 cm) single-primed cotton canvas.

Brushes. My brushes were the following: nos. 10, 4, and 2 bristle flats; nos. 8, 5, and 1 bristle filberts; a no. 1 sable flat; and a no. 6 sable round.

Time of Execution. The painting took two and a half hours to complete.

Key Color Mixtures. The bluish background is a mixture of ultramarine blue, ivory black and white. The fleshtones—which are basically in shadow—are cadmium red, burnt sienna, ultramarine blue, raw sienna, and white, with touches of green where indicated.

Light is shown in the ear where the tissues are thin enough to render the area somewhat translucent. Ultramarine blue is added to the cheeks to cool them. Since the eyes in backlit situations are indistinct, the rim of the glasses is used as a means of relating the values around the eyes to the darks of the tie and the background. Touches of green are added to the area between the nose and the lips. Green is also employed in the subject's left temple. The nose is accented with the blue/white combination plus some warm pink reflecting from the interior of the room.

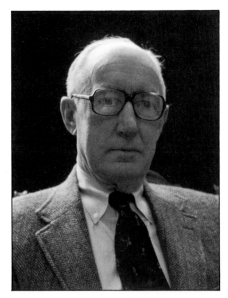

Step 1. Mixing ultramarine blue with white, I draw in the main outlines of the head and shoulders. I lay in part of the background to establish a tonal relationship between it and the head, which I want to seem to come forward out of the background. Having placed the eyes, nose, mouth, eyeglasses, tie, and collar, I make sure to indicate where the lights and darks of the face are separated.

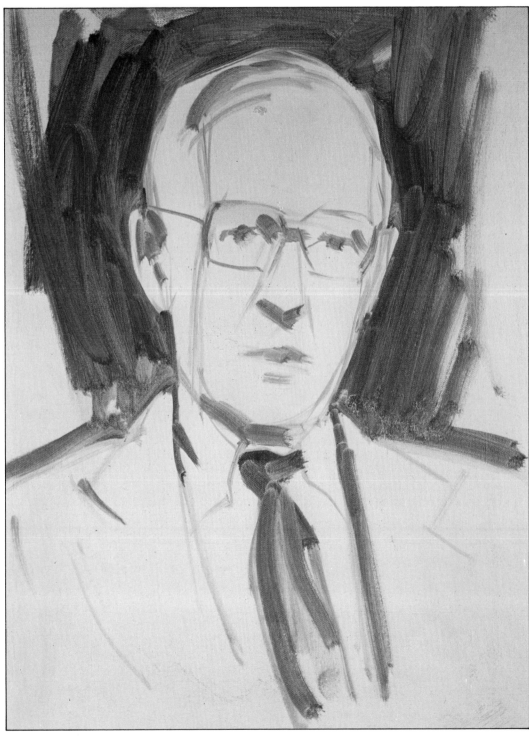

Painting a backlit portrait presents a number of obstacles. The light is thrown into your eyes and the resulting glare makes it rather difficult to distinguish the subject. You must therefore make adjustments in your position, and in the placement of your palette and canvas. An easel that tilts helps overcome some of these hindrances.

Backlighting lends form and volume to the head, but at the same time, it hides the features. The values in the face emerge rather equal in tone—they may look flat—and there's a strong danger that the picture won't hold together.

The painter may seek to compensate by seeing and recording more differences of tones than he actually sees in the face. But this exaggeration will merely serve to destroy the integrity of the values, that is, their proper relationship to each other, and what will emerge will be a false portrait which appears illuminated from both back *and* front.

Backlighting works advantageously when the painter elects to emphasize beautiful hair or a really interesting bald head. It's also an effective device to mercifully veil a face that has somewhat unpleasant features. An element of backlighting is always present outdoors, where light issues from many sources at once. However, backlighting tends to minimize the factor of character in the subject's features.

Step 2. In a backlit situation, I consider the most important element in the portrait to be the background, which must be painted accurately in value in order to set off the tones within the head. This type of illumination creates a kind of reverse silhouette effect, which depends upon the dark mass behind the head to make the portrait work. In this type of lighting, it's also vital to keep the color and value relationships within the head close enough so that they don't nullify the backlit situation.

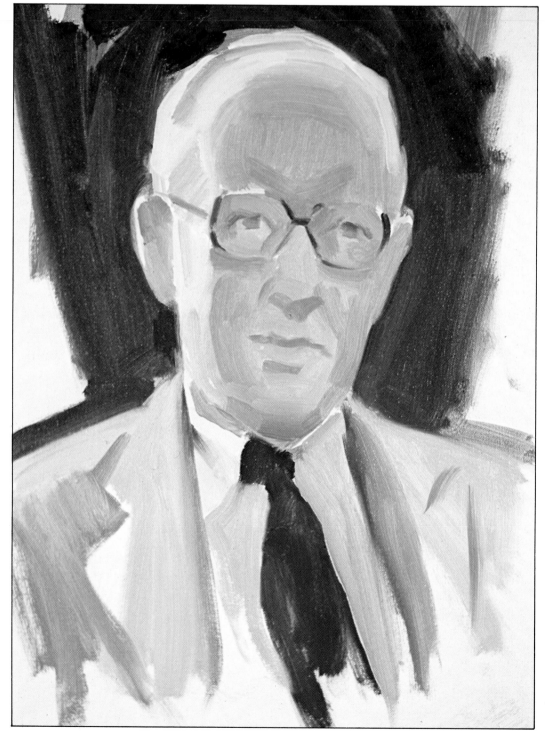

Paint the values in the backlit face just as they present themselves, not as your mind tells you they *should* be. The values in the shadows must be related to the values in the lights. Don't go groping in areas of shadow to pull out the features—paint shadow as shadow regardless of how deep in value it appears.

You can arrange the backlighting so that it lights up one or both edges of the head or illuminates the top of the head.

Step 3. I do more work all over to further develop all the features and to begin arriving at a greater semblance of likeness. I concentrate my effort on the right side, which is in shadow. I place the large olive halftone in the forehead on the right. The nose is given some pink accents. I work extensively on the eyes and ears. (In retrospect, I would have preferred to chose a subject without eyeglasses to demonstrate backlighting.)

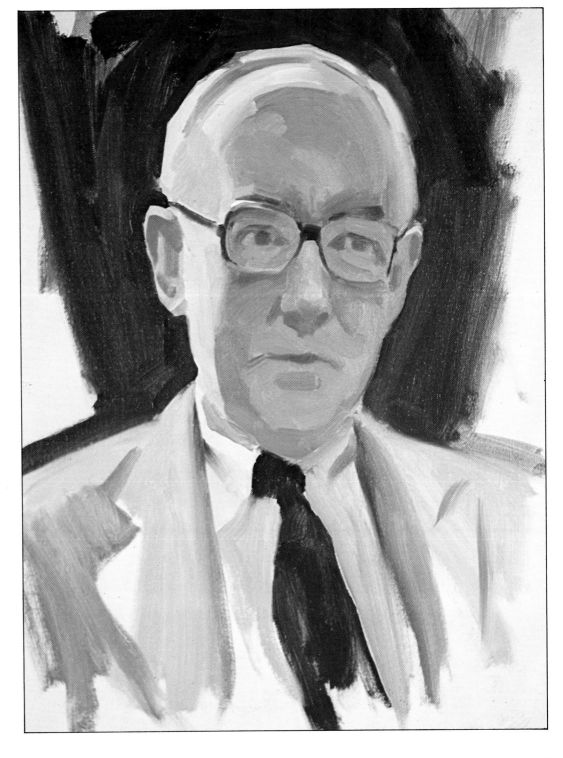

Jack Button *(Left) oil on canvas, 46" x 40" (117 x 102 cm), and* Mrs. John Edward Button *(Right), oil on canvas, 46" x 40" (117 x 102 cm), Collection Mr. and Mrs. John Edward Button. These companion pieces, painted five years apart, show how effectively a sunny back-lighting can be used in an outdoor portrait.*

Step 4, Gordon Butler. *The background is totally filled in. The olive halftone is carried over into the left forehead as well. I lower the values somewhat in the tones on the shaded side of the face. Highlights are defined on the nose and the forehead. The shirt and tie are more accurately drawn. Note the red in the right ear, which is a result of the light shining through the thin tissue of that area. The shadows cast by the eyeglass frames are also indicated.*

DEMONSTRATION 12

LOW LIGHT

A most intriguing portrait can be created from the type of illumination issuing from below, which could be a campfire, a fireplace, or some other source projecting a low, soft quality, such as candlelight. (Soft candlelight, incidentally, is very flattering to women.) However, lighting the face from below also reminds one of theatrical footlights, and therefore is especially useful for getting unusual, dramatic, and perhaps even sinister or occult effects.

THE SPECIFIC PROBLEM

I was faced with the challenge of simulating a low-angle illumination without creating a painting that would be more of an illustration than a portrait.

Costume and Background. I selected a bright red blouse to maintain the gypsylike atmosphere this type of light seemed to engender. The kerchief and trinkets further enhance this kind of mood.

Lighting. To simulate the campfire effect, I used a 60-watt tungsten bulb in a reflector aimed from below. I used a screen to block off most of the daylight from the model's face.

Palette. My palette for this painting consisted of alizarin crimson, cadmium yellow pale, ultramarine blue, cadmium orange, cadmium red light, burnt sienna, and zinc/flake white. I originally intended to use an even more limited palette, but I found that it wasn't sufficient to capture the warm effects of the light. I left out ivory black, since the alizarin crimson-ultramarine blue-burnt sienna combination sufficed for the warm darks I required. (I also used raw umber in the drawing of Step 1.)

Medium. I used a linseed oil/turpentine combination.

Surface. My support was a 20″ x 16″ (51 x 41 cm) single-primed cotton canvas.

Brushes. I employed the following brushes: nos. 6, 4, and 2 bristle flats; and nos. 8 and 5 bristle filberts.

Time of Execution. The painting took two and a half hours to complete.

Key Color Mixture. Except for the presence of ultramarine blue, this is an all-warm painting. There's no raw sienna, permanent green or ivory black in the mixtures.
 The green in the breast area is mixed with cadmium yellow pale, ultramarine blue, and white. The shadow area going into the blouse is burnt sienna, ultramarine blue, and cadmium yellow pale, with extra blue added to its darkest area.
 The hair is basically burnt sienna. The jewelry is ultramarine blue, cadmium yellow pale, and white, and the eyes—burnt sienna with ultramarine blue and alizarin crimson. White and cadmium yellow pale are mixed with cadmium red for the lips, and burnt sienna, cadmium red light, ultramarine blue, and white are used on the left, warmer side of the face.

Step 1. Using cadmium yellow pale, white, and raw umber I draw in the main thrusts of the pose, seeking to capture the flowing shapes on the model. Although the drawing seems to lack detail or refinement, it serves as a guideline to the ultimate effect I'm seeking. I'm most careful to get the proper proportions of all the forms.

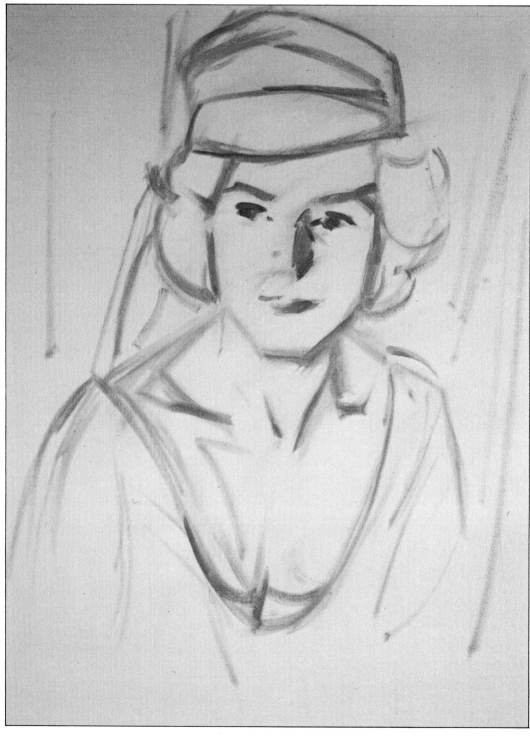

PRINCIPLES OF LOW LIGHT

This type of illumination is commonly associated with a warm light. Therefore, it seems to call for a bright, colorful costume.

Low light is soft and therefore tends to create soft edges. It also tends to hide wrinkles and minor imperfections in the face. Under low light, the natural placement of lights and shadows on the head is reversed.

Tungsten light can be used to recreate the effect of warm light issuing from below, as from a campfire. The closer this light is to the head, the crisper the shadows will emerge.

Step 2. Now, I color in all the large masses, beginning with the background, which sets the stage for getting the correct values of the fleshtones and of the darks of the portrait. The placement of shadows is especially important in a low-light situation, since it must indicate that the illumination is issuing from below and that the usual order of lights and darks is reversed in such instance. I also show the light on the earrings, which helps establish the portrait's value relationships, being the lightest tone in the picture, and the location of the light source. I carefully indicate the irises and whites of the eyes.

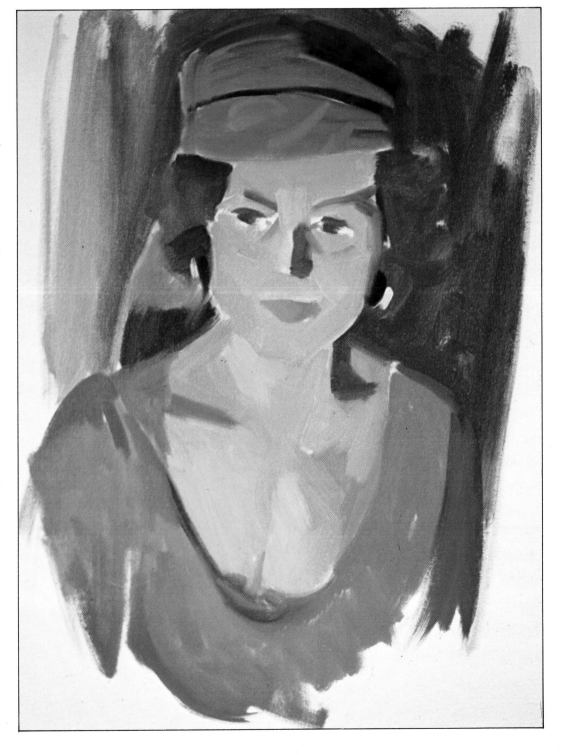

Make sure the shadows are dark enough. If not, the effect of light issuing from below will be lost. A dramatic shadow in the background will help to enhance the illustration of low firelight. There's little halftone in this type of illumination—it's almost a study in pure light and shadow. The halftones that do exist are very close in value to the lights.

Step 3. I now work into the highlight areas, which are cool on the breast area and warm within the face. The blouse and scarf are further developed. The highlight on the lips is put in. The color all over is warm and dramatic, as befits this type of illumination. I constantly look for and record all visible halftones, which lends additional roundness to the planes. The hair is broken up into light and dark areas.

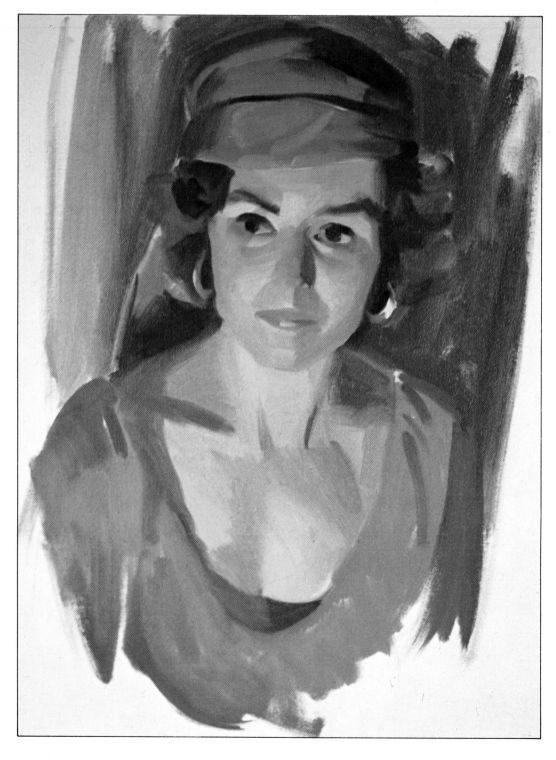

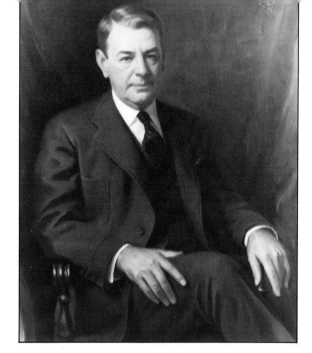

E.W. Marland, *oil on canvas, 36″ x 30″ (91 x 76 cm), Collection Executive Offices of Continental Oil Company, Stamford, Connecticut. Low lighting is especially effective here in creating the right mood for this posthumous portrait of the former governor of Oklahoma and pioneer of the Marland and Continental Oil Companies.*

Step 4, Mary Brehne. *The important catchlights are placed in the eyes. The necklace is introduced. The design in the scarf is fortified. More brilliance of color is added into the blouse, and the shadows are modified. The contour of the background is evened out somewhat, since it appeared too busy in the previous stage. The paint is applied fairly thickly all over to lend it the flowing quality the portrait seems to demand.*

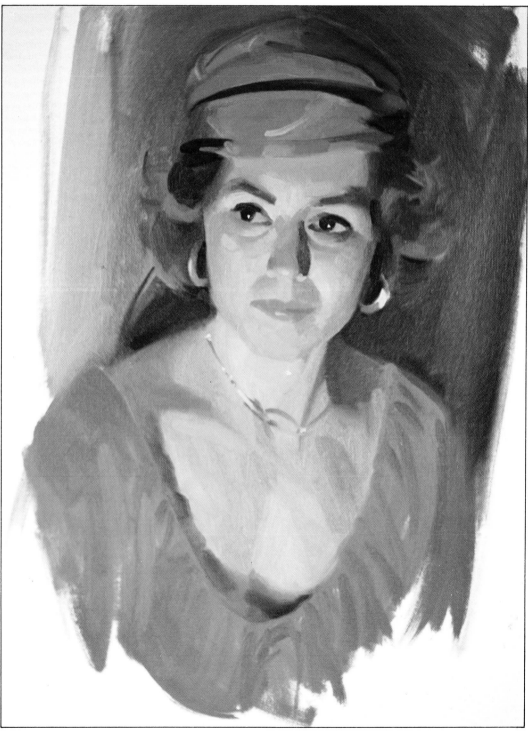

DEMONSTRATION 13

REMBRANDT LIGHTING

This is the lighting much favored by Rembrandt and the school of *chiaroscuro* (light and shadow) painting he helped to establish. It is said that the reason Rembrandt favored this kind of illumination was the physical setup of his father's mill, where Rembrandt first launched his painting career. In the mill, the light came from directly above. The so-called Rembrandt lighting, when properly arranged, produces magnificent, dramatic portraits. It's an illumination every aspiring portrait artist should become familiar with whether or not you intend to use it in your portraits.

THE SPECIFIC PROBLEM The problem was to produce a rounded, three-dimensional head without resorting to overmodeling, which would negate the blocky, sculptural effect I was after. I decided not to use a radical topside lighting because I felt it would throw too much of the face into shadow.

Costume and Background. Dark velvet provided the deep nonreflective background this illumination requires. The napped texture of the velvet has the tendency to absorb color. In retrospect, I feel that the costume could have been darker.

Lighting. To simulate the skylight effect, I used a 40-watt tungsten bulb set about two and a half feet (0.8 meters) above my model's head.

Palette. I used a semi-limited palette of cadmium orange, cadmium red light, cadmium yellow pale, yellow ochre, ultramarine blue, alizarin crimson, ivory black, and zinc/flake white.

Medium. My medium was a linseed oil/turpentine combination.

Surface. I worked on a 20″ x 16″ (51 x 41 cm) single-primed cotton canvas.

Brushes. I used nos. 10, two nos. 8, two nos. 6, two nos. 4, and a no. 2 bristle flats; and nos. 8 and 5 bristle filberts. I also used a large no. 18 bristle flat to pull the lights and darks of the hair together.

Time of Execution. The work was completed in a single sitting of two and three-quarter hours' duration.

Key Color Mixtures. The hair, which caught the strongest light, is probably the most attention-drawing color in this portrait. It's basically a combination of cadmium orange, yellow ochre, and white, with additional cadmium yellow pale in the lighter areas and some ultramarine blue to cool it and cadmium red light to warm it, where appropriate.

The face is cadmium orange and cadmium red light with white added in the lighter areas. The upper lip is alizarin crimson and ultramarine blue with touches of cadmium red light to enliven the color where it goes somewhat dead. White and ultramarine blue form the cool halftone of the left temple. The highlights on the face are largely cadmium orange, cadmium red light, and white.

Step 1. Working in raw umber and white, I make an immediate attempt to express the form. The shadows in the head are indicated and a suggestion of the background put in. Rembrandt lighting creates strong value contrasts, so the relationship of lights to darks is the most apparent factor to be sought. The drawing helps provide the blueprint for such a goal.

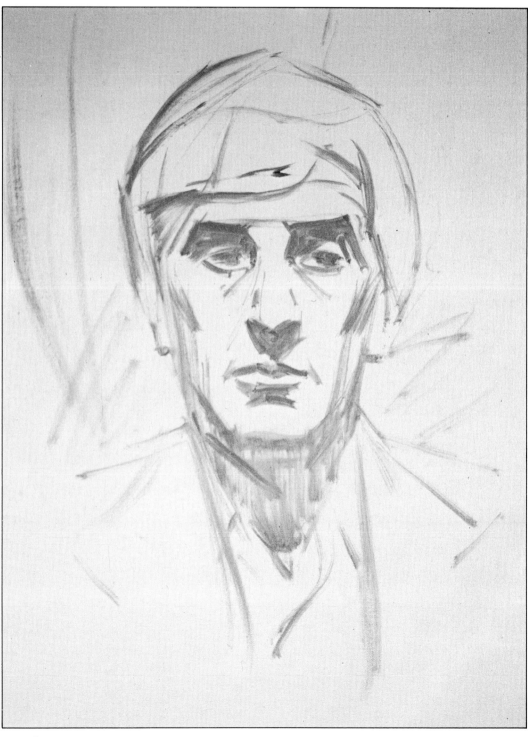

PRINCIPLES OF REMBRANDT LIGHTING

In this lighting, the factor of color is secondary to those of form and value. In order for it to function properly, like backlighting, Rembrandt lighting requires a dark background, and preferably a dark costume as well, so that the light is concentrated on the head and on the hands, if they're shown.

It's a lighting that's flattering to a handsome head of hair. But it is not the lighting you'd choose to show eye color, since it casts the eyesockets into shadow. Because of its tendency to cast deep, dense shadow, it's not the best light for painting women. It does, however, lend an air of virility to men's portraits.

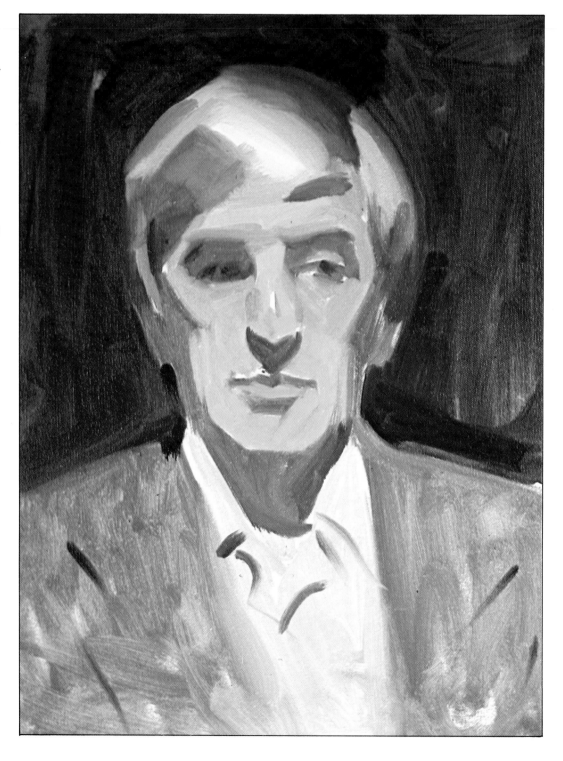

Step 2. All masses are now laid in in flat layers of color. The average color of the frontal plane in light is composed of cadmium orange, cadmium red light, white, with ultramarine blue to cool the mixture. All the areas of canvas are covered, save for small areas on the nose, upper lip, and hair, where the highlights will fall. So far, the head has been broken up into areas of light and shadow, with little evidence of halftones. The background is fully brushed in and the shirt and jacket are indicated. A strong light area is placed in the golden-yellow hair.

The strong value contrasts produced by this lighting make the modeling of the halftones particularly important. You must be careful not to let the areas of light and shadow come together too abruptly. The halftones must, in this instance, be related to the darks or the form of the head won't emerge correct and lifelike. That is, because of the dark darks, the halftones must be painted distinctly so that there's no sudden transition from dark to light.

Another danger to avoid is going too much into the shadow in search of planes or colors and reflected lights. Paint the shadows simply, in one or two values, and not fussily or as dark as they appear.

Step 3. Much modeling is accomplished in the features. Highlights are placed in the right cheek and the nose—now, all areas of the canvas are brushed in with paint. The shapes of the shirt are restated. The hair, which is the most striking area on the head, is broken up into smaller planes of light, halftone, and shadow. The light areas of the face receive heavier layers of paint and are modified with halftones, which shapes the head and causes its form to turn into the shadows.

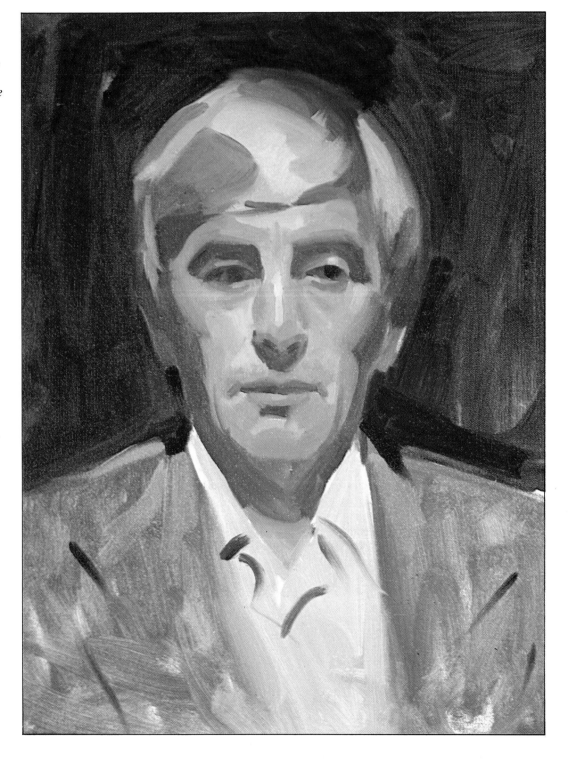

Gordon Butler, *oil on canvas, 36"
x 30" (91 x 76 cm), Collection of
the artist at Portraits Incorporated,
New York. This painting was re-
sponsible for more commissions
from businessmen than any other
portrait. The portrait of Mr. Butler,
who vaguely resembled Adlai Steven-
son, was featured in gallery advertise-
ments in the* Wall Street Journal,
New York Times, Town and
Country, *and* The New Yorker.

Step 4, Herbert Bartman. *All the
planes in the face are treated with
more subtlety so that they flow to-
gether more smoothly. The draw-
ing is corrected so that the head
emerges a bit less narrow. The chin
is rounded off more. The eyes are
painted with more fidelity. The
jacket is filled in. A feeling a har-
mony is established throughout the
head and figure, and a sense of like-
ness is achieved by adding the char-
acteristic expression, particularly
around the lips.*

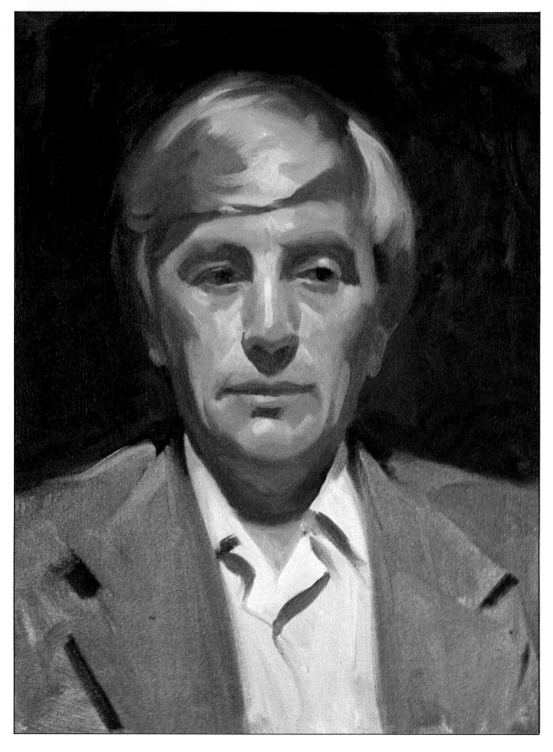

DEMONSTRATION 14

DIFFUSED OUTDOOR LIGHTING

For artistic purposes, outdoor light is divided into sunny and non-sunny categories. But when a subject poses in what is called "open shade"—which is neither bright sun nor total shadow—this results in a lighting situation that most students have enormous problems trying to capture.

THE SPECIFIC PROBLEM
The specific problem here was to capture the subtle lightness of color without allowing the portrait to go dead. I selected a pale-skinned subject with white hair to render the effect even more challenging. This way, if I succeeded, the victory would be all the more sweet. It's good to force yourself to confront the most difficult obstacles early in your career. Only through trial and hardship will you acquire the required skill, knowledge, and expertise.

Costume and Background. The light suit contrasted well with the background of dark foliage.

Lighting. The day was neither sunny nor cloudy, but somewhere in-between. The open sky exerted the most influence on the light areas within the head. The foliage cast reflected light mostly into the forehead and temple areas.

Palette. I used a full palette with a zinc/flake white combination.

Medium. I used a linseed oil/turpentine combination.

Surface. I worked on a 20″ x 16″ (51 x 41 cm) single-primed cotton canvas.

Brushes. I used bristle filberts nos. 8, 5, 4, and 1; a no. 4 bristle flat and a no. 2 sable round.

Time of Execution. The painting took two and a half hours.

Key Color Mixtures. The highlights in the face are subtle. The forehead is painted in ultramarine blue and white, and orange and white in the highlights, with touches of cadmium red light, yellow ochre, and white for the warmer, deeper areas. The highlight on the right cheek is cadmium red light and white, with touches of cadmium orange. The underflap of the cheek is Indian red and burnt sienna, with a touch of permanent green deep to cool it.

The bridge of the nose is basically yellow ochre, cadmium red light, and white. The warmer reds, running from the nose into the cheeks, are painted with burnt sienna and cadmium orange. Permanent green deep and yellow ochre plus white constitute the halftone on the left upper temple. The shadow under the lower lip is basically raw sienna.

Step 1. In this demonstration, I make the initial lay-in in line, tone, and color. It's a much more detailed outline than usual and it even includes the hue of the foliage behind my sitter. The paint has been thinned down with turpentine so that it assumes a watercolor, wash-like quality. With a combination of burnt umber and white, I lay in the darker tones in the forehead, beneath the nose, alongside the cheekbones and jaw, and in the shadow under the chin. The suit is a light, cool, grayish-mauve tone. Since the sitter is in open shade, with no sunlight, his complexion and clothing are influenced by the cool tones reflected from the sky.

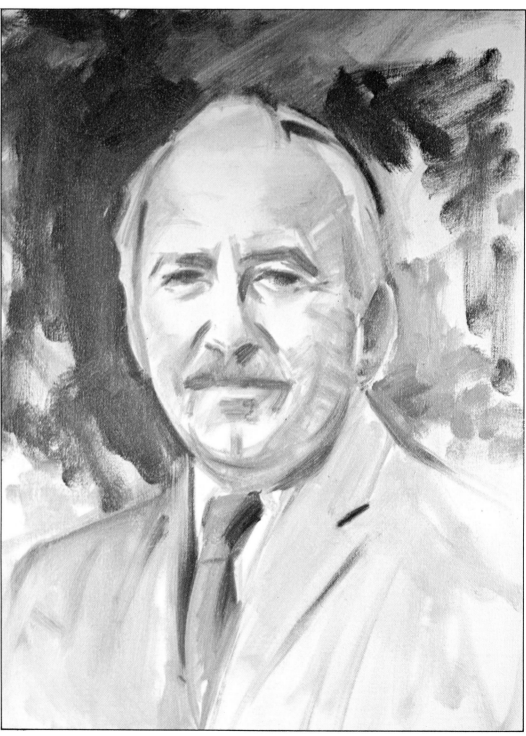

This produces a high-key, low tonal-range effect. The light is diffused, since it issues from many sides at once. The shadows tend to be very high and there's considerable reflected light present, resulting in a pale, pastel-like coloration.

Dark areas are produced at the corners of the mouth, beneath the nose, and under the eyelids. The lack of direct sun holds down the warm highlights, but because the day is overcast, there's no blue sky to add its cool tones to the light areas either. Instead, the highlights are neutral, reflecting the subdued tones overhead.

Step 2. The paint is applied more heavily all over. The dark mass of the background is brushed in in order to make the head seem to come forward. The contrast of values in the head—which is limited—is slightly exaggerated. This will be readjusted in the subsequent stages. All the colors are now more intense as I strive to add a measure of sparkle to the portrait. There's strong evidence of earthy reds and raw sienna accents in the skin. The blue of the tie is indicated.

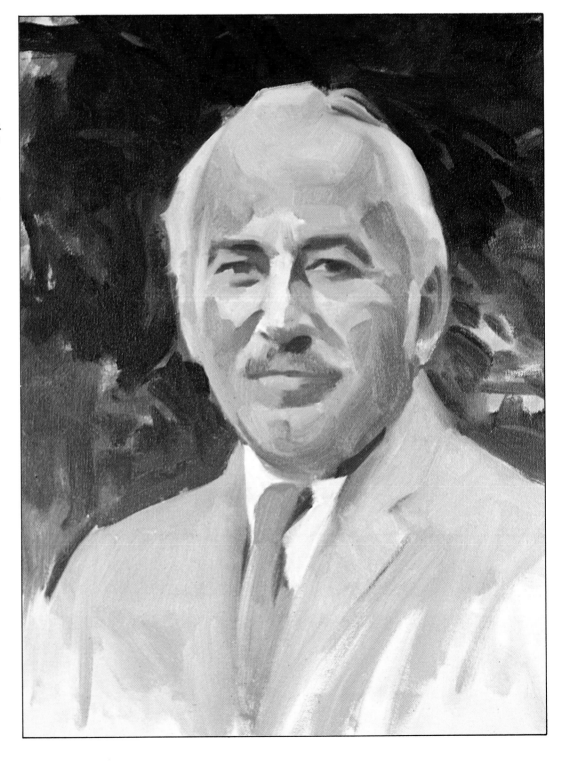

TIPS ON DIFFUSED OUTDOOR LIGHTING

If you're accustomed to painting heads only in your studio and you go outdoors to paint in the open shade, don't overstate the warms in the flesh just because your mind tells you that they're there. Learn to trust your eyes, which will alert you to the preponderence of cool lights present in open shade.

In open shade, the light issues from all over at once. The artist may seek to record this in a too-chalky, too-washed-out manner. The way to avoid this is to use color as much as possible and go easy on the white. Heighten the warms with yellow ochre and cadmium orange. Also, despite the abundance of reflected light in this type of illumination, don't use it too freely or it will destroy the forms of the head.

Make sure that your canvas and palette both receive the same illumination. And remember, the direction and amount of light outdoors is continually changing. At one point, therefore, you'll have to make a commitment to a particular light-and-shade pattern. The best solution is to retain the first impression the sitter presents, and stick with it despite any distractions and alterations nature provides. Finally, don't despair—most paintings executed outdoors look better when brought inside.

Step 3. I introduce some lighter areas into the background in order to break up its intensity. All the planes within the head are now broken up into smaller divisions. The pinks in the cheeks are painted in with Indian red and the ultramarine blue and white combination. The hair is shown flowing into the planes of the forehead. The highlights are adjusted and redrawn throughout the head.

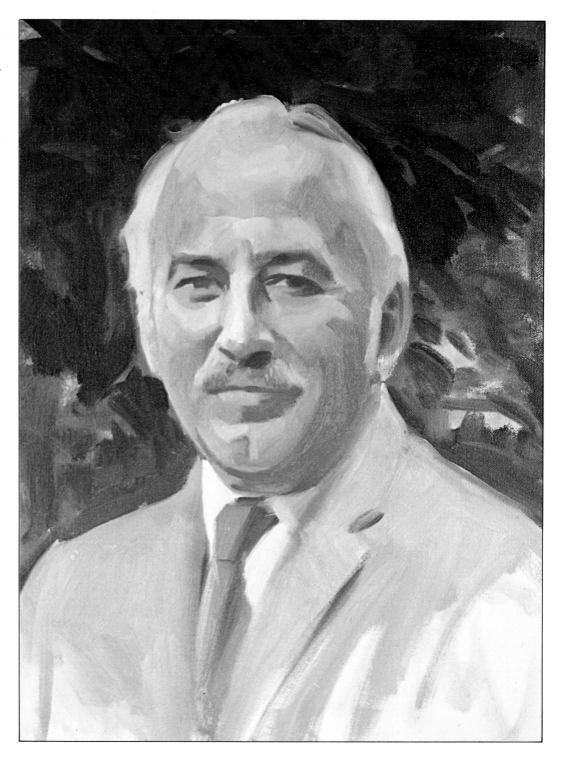

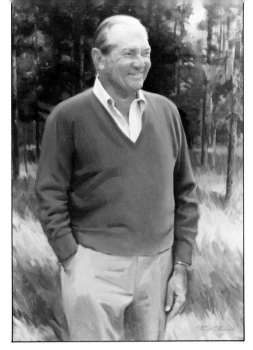

Warren Bicknell, Jr., *oil on canvas, 48" x 34" (122 x 86 cm), The Bicknell Collection. Like the portrait below, this was painted on a cloudy day under diffused outdoor lighting conditions. A colored photograph of the head was supplied by the family, but I used a model for the figure.*

Step 4, Anthony Heines. *All aspects of the head are now completed, with attention paid to attaining a likeness. There's considerable redrawing and correction of the relationship of the features which involves adding such characteristic marks as the V-shaped wrinkle above the bridge of the nose, and correcting the shape of the eyes. Such little touches are vital in the final stages of a portrait, when the effort no longer involves painting a head, but rather an individual person. All the halftones are pulled closer together and related in tone to the lights and darks. Finally, the color is cooled down all over.*

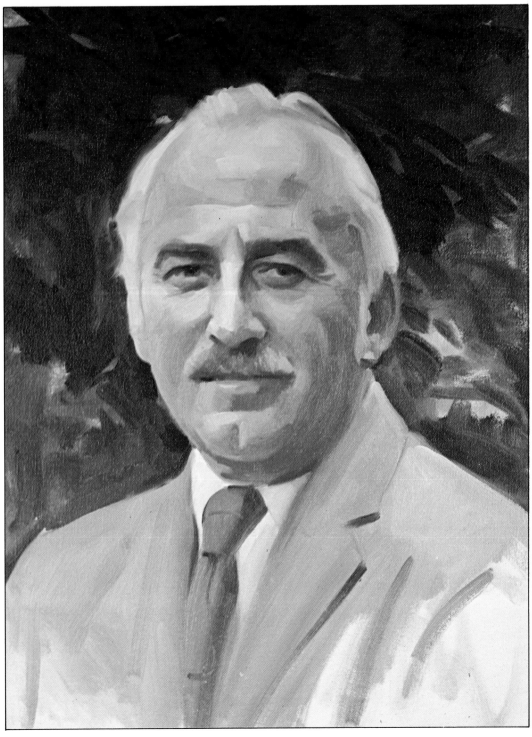

DEMONSTRATION 15

SUNNY OUTDOOR LIGHTING

Painting a portrait outdoors in bright sunlight is a difficult and tricky business. The startling difference between this and indoor lighting becomes instantly apparent to anyone who attempts it for the first time. The direct light of the sun creates unusual visual effects and dispels preconceived notions about color.

THE SPECIFIC PROBLEM
My model is a woman of warm, vivacious nature and is a great outdoors enthusiast. I felt that her outgoing personality would be most appropriately displayed in a sunny, outdoor setting. The challenge was to capture all the warmth of the scene without overdoing the intense bright colors.

Costume and Background. The setting of Mrs. Fisher's summer home in Pleasant Bay on Cape Cod seemed ideal to my purpose. The bay, shoreline, sky, and trees were a perfect foil for her healthy, high complexion. Her white dress picked up the reflected pinks and blues of sun and sky.

Lighting. The portrait was painted under the direct shine of a late afternoon sun on a summer's day.

Palette. I worked with a full palette of color, including my zinc/flake white combination.

Medium. A linseed oil/turpentine combination was employed.

Surface. I used a 20″ x 16″ (51 x 41 cm) single-primed cotton canvas.

Brushes. I used a no. 8 and 6 bristle flat, a no. 5 and 3 bristle filbert, and a no. 6 sable round.

Time of Execution. The painting was completed in two and a half hours.

Key Color Mixtures. The background contains ultramarine blue and white, plus permanent green deep and some alizarin crimson and white in the blue evergreens. There's ultramarine blue and alizarin crimson and white in the water of the bay, and an olive mixture in the shoreline.

The sitter's hair is a combination of ivory black, ultramarine blue, and burnt sienna, with additional touches of raw sienna for the top, light areas. Her face is basically cadmium orange, cadmium red light, cadmium yellow pale, and white, with a raw sienna/blue mixture used in the temple. The nose and left cheek, which are the warmest areas in the face, are cadmium red light and burnt sienna with white. Raw sienna, cadmium red light, and permanent green constitute the halftone area where the cheek turns toward the ear on the right.

The earring—which is quite an important accent in the head—is made up of ultramarine blue on the top, burnt sienna in the center, and raw sienna and yellow ochre in the light areas.

Step 1. In this instance, I begin by painting in the large masses in an attempt to put down the big forms immediately in full color. The fleshtones are made up of cadmium orange, cadmium red light, cadmium yellow pale, and white—all warm colors. The hair is shown as a dark mass with a few areas of canvas left blank for the placement of subsequent highlights. The basic shadows of the dress are suggested along with the basic colors of the bay, sky, and trees in the background. The shaded areas of the head are massed in with ultramarine blue and cadmium orange, with a touch of raw sienna included.

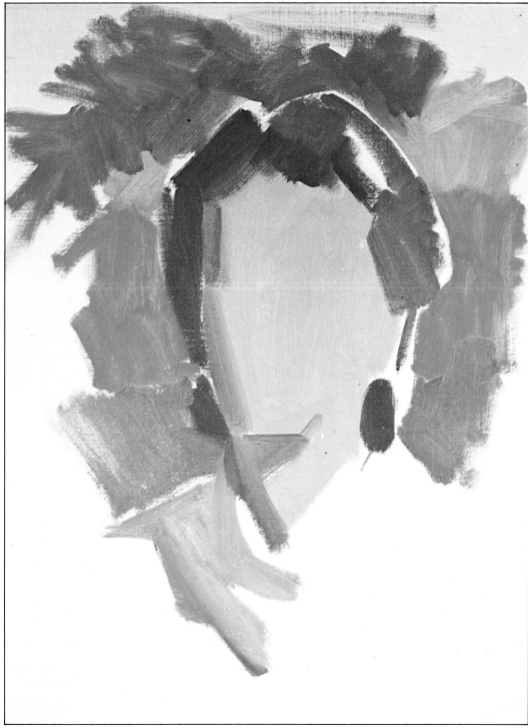

This illumination seems to bring out the vibrancy of skin color and evokes a happy, buoyant mood. Persons with tanned skin tend to make better subjects for portraits painted in bright sunlight. The blue of the clear sky heightens by contrast the reds and oranges within the face.

Direct sunlight creates very dark shadows and very bright highlights, making for a distinct contrast of lights and darks and a broad tonal range within the head. The half-tones tend to be less apparent under such illumination, and the shadows appear bluish in tone.

Step 2. With the canvas wet all over, I begin by breaking up the head into smaller planes of light and dark and start to delineate the features. The right temple receives some olive accents. Highlights are placed in the forehead and cheek. The muscles of the smiling face are suggested. The eyes are spotted into position. The hair is broken up into light and dark areas. A strong cast shadow is placed beneath the nose. The earring is indicated.

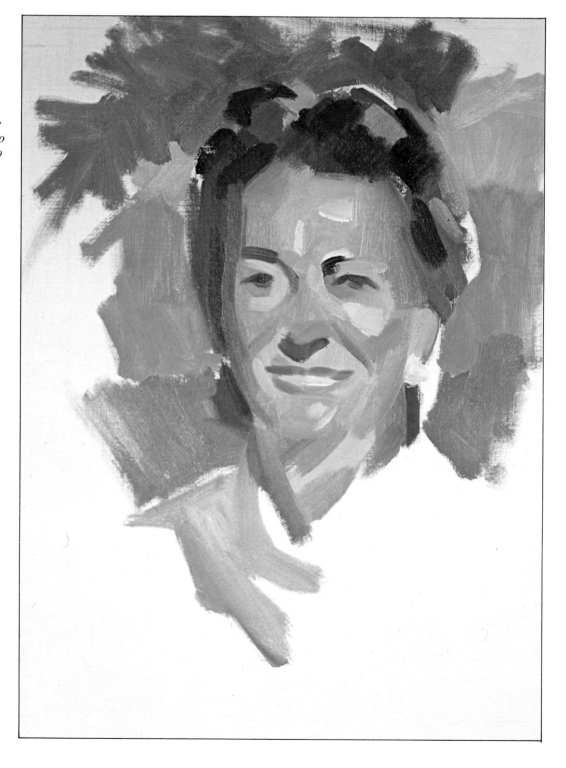

Even though your subject is in sunlight, place your canvas and your palette in open shade. Despite the apparent warmth of sunlit features, introduce some cools into the portrait or the skin will look like leather. Also, you must be conscious of the fact that people tend to squint in bright sunlight. If you don't paint this, your portrait won't be true to life.

Paint the shadows as dark as they appear—rely on what you see, not on what reason tells you that you *should* see. Also, because of the great degree of tonal contrast in the head, bring the values of the background closer together.

Sharp edges are characteristic of this type of illumination. Therefore, keep the edges of the highlights a bit sharper and more distinct and don't blend them excessively into the adjoining halftone areas.

Step 3. Further refinement of the facial planes continues. The shapes of the hair are defined. The half-tones around the chin and jaw are shown in greater detail. The jaw-line is outlined. The eyes are drawn in, as are the shapes around them. A likeness is still not attempted, but the accurate rendition of features continues. The lips and teeth are modeled with some care, and the ear and earring are brought to near completion.

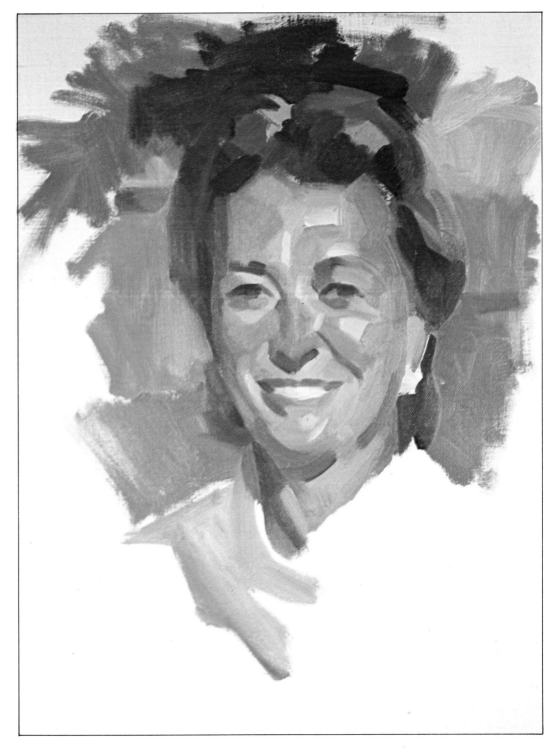

Mrs. Benjamin Fisher, *oil on canvas, 40" x 32" (102 x 81 cm), Collection Mr. and Mrs. Fisher. This is a larger version of the portrait I did for this demonstration. Ironically, because of inclement weather, I was forced to paint much of this portrait under conditions that had to simulate the sundrenched outdoors. Despite this difficulty, however, I believe that I've captured the feeling of sunlight and the outdoors. As a portrait painter, you must be prepared to cope with such problems as improper light and insufficient time by either adjusting to them or turning them to advantage. You must be inventive.*

Step 4, Lilian Fisher. *The contours of the vignette are carefully checked and corrected where necessary. The face is broadened somewhat. The eyes are drawn in with greater fidelity. Highlights are placed on the nose to lend it a modeled appearance. The cheek muscles that show the smile are strengthened in value. The earring is refined. The shape of the hairline in the right-hand side of the face is adjusted. The eyelids are widened somewhat to better show the smiling, squinted expression.*

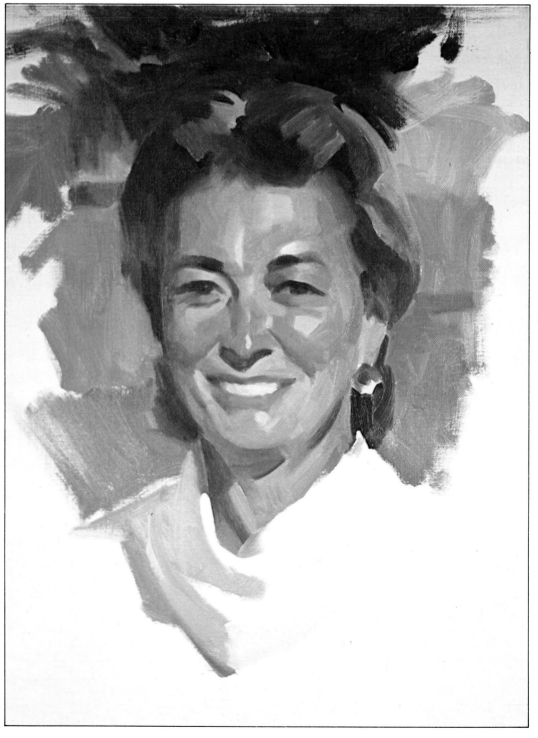

SPECIAL PROBLEMS

The following section is devoted to situations that are somewhat out of the ordinary, but are encountered often enough in the course of an artist's career to warrant their inclusion in a book concerned with portrait problems. The section constitutes a kind of potpourri of difficulties and challenges that I've assembled based on my years of teaching and the type of questions I'm most frequently asked by students of portraiture.

DEMONSTRATION 16

BEARD AND MUSTACHE

With the popularity of beards these days, the portrait painter frequently encounters the problem of depicting facial hair. All beards are obviously not alike, so I couldn't possibly tell you, within the confines of a single demonstration, precisely how to paint each type of beard you might encounter. But I can, however, offer solid principles and procedures for painting beards in general, as well as demonstrate how I applied these concepts and methods in a specific portrait so that you can adapt my methods to meet your particular problem. (You must understand, when I speak of the beard, that the same principles apply to mustaches, mutton chops, and all variations of facial hair.)

THE SPECIFIC PROBLEM

Keeping in mind both the general principles and the more definitive tips related to painting beards, I'm now ready to apply them to a specific portrait, that of Robert Bruton. Robert is a young man with a reddish brown, rather short, Vandyke-like beard. I note that his beard joins his sideburns to form a uniform mass with his head hair, as opposed to the kind of beard that's sharply trimmed and edged at some point within the face.

Costume and Background. I asked Robert to dress casually and in a cool color, like blue, to contrast with the warmth of his olive, brown beard. The beige background I chose, on the other hand, harmonized with these tones. I decided to vignette it.

Lighting. I worked with an overhead north skylight, placing the sitter so that the light struck his face at a 33° angle. This angle cast a relatively soft light with coolish tones on the skin and illuminated forehead, bridge and tip of the nose, lower lip, shirt collar, and areas just below the eyes.

Palette. I used a full palette for this painting, including a zinc/flake white combination.

Medium. My medium was a linseed oil/turpentine combination.

Surface. I worked on a 20″ x 16″ (51 x 41 cm) single-primed cotton canvas.

Brushes. I employed a full complement of various-sized bristle filberts, plus a no. 2 long flat, a no. 2 flat sable, and a no. 6 pointed round sable.

Time of Execution. I completed this portrait in a single sitting that lasted three and a half hours. All work, except for some minor final adjustments, was executed directly from the model.

Key Color Mixtures. For the reddish-brown beard, I used a mixture of cadmium orange, raw sienna, and white for the lighter areas. I added burnt sienna and permanent green deep to the above mixture for the halftones and the darks. I would have added touches of alizarin crimson, ultramarine blue, or ivory black if the shadows in the beard had been deeper, but the burnt sienna-permanent green deep mixture was sufficiently dark. To make areas of the beard cool, I added more permanent green deep to the mixtures; to warm them, I added more burnt sienna or cadmium orange.

Step 1. With a no. 4 bristle filbert, I draw in the general outlines of the various features of the head, trying to nail down the shapes as accurately as possible and establish a likeness. Since the beard, mustache, and sideburns occupy at least a fifth of the entire head, I'm very conscious of their proportions in relationship to the other components of the head. Although here I've indicated the bottom contour of the beard on the right-hand side, I note to myself that there is no truly discernible division between its edge and the neck, both of which form a continuous shadow area.

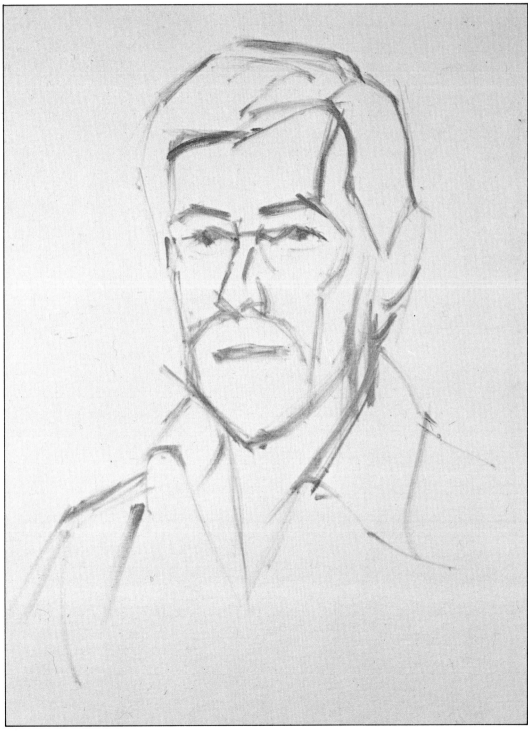

A beard is a part of the head and must be seen and painted as such—never as some pasted-on, autonomous shape independent of the head. It should be treated like any other feature of the head, that is, with no special emphasis given to value, color, or detail. The exception to this is when, for illustrative, commercial, or aesthetic reasons, you purposely draw attention to the beard and minimize the impact of the other features.

A beard isn't a collection of isolated little hairs, but rather a single whole—a mass composed of shapes, planes, and values like any other form. There are painters who like to depict individual hairs in the beard, but my painting method dictates viewing and painting the beard as an entity.

Step 2. I add two no. 2 long flat brushes for this most important stage, in which I quickly establish the general color and tonal patterns of all the parts of the head in flat areas, which come as close as possible to the overall hue and value of each particular feature. In this stage, the beard is painted in three basic values—in light over most of it, in halftone where it turns with the jawbone along and up the right-hand side, and in shadow below the chin. Raw sienna, cadmium orange, and white are used for the light parts; burnt sienna and permanent green deep are added to this mixture for the halftones; and burnt sienna and permanent green deep are used alone for the darks.

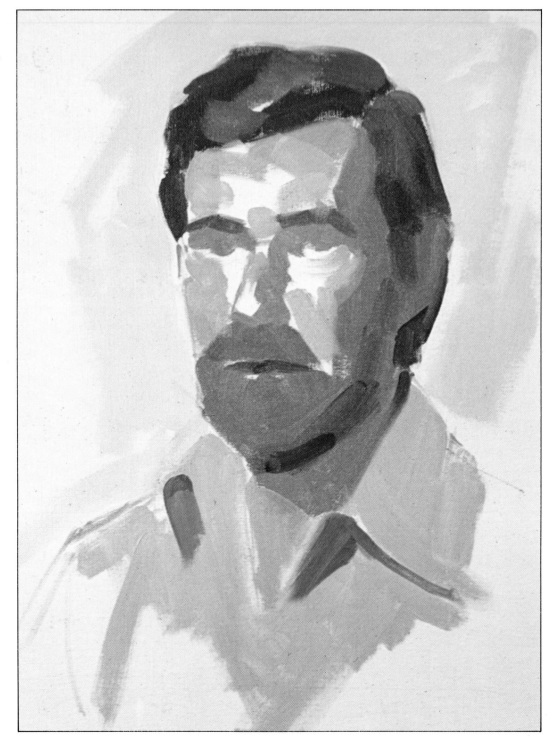

To help facilitate the process of painting for you, here are some tips on painting beards. Don't view the beard from too close—stand some distance away from it when painting. This allows a wider, more overall image.

Paint the beard as you would any other form—in three values only: light, halftone, and shadow. Always keep in mind how the beard relates in color, value, and proportion to the other parts of the head.

Paint the beard as a series of turning, sculptural planes, not as a bunch of separate hairs growing side by side. Keep the edges of the beard relatively soft, particularly in those areas where it flows into the skin. Some of the outer beard contours may be shown a bit sharper, if they appear that way to you.

Make quick sketches and notes of various types of bearded people you see in the street, in public places, and in conveyances. There's ample opportunity to study the dynamics of facial hair by just observing the people around you. Also, study the way masters like Hals, Rembrandt, and Sargent painted beards.

Step 3. Now I begin to refine and build up the smaller planes within the beard. This is basically a matter of selecting, classifying, then putting down the results of close observation. I use a no. 8 filbert bristle throughout most of this stage. For the warmer areas of the beard, I use more cadmium orange; for the cooler areas, touches of permanent green deep to attain the desired olive-gray tone. In this stage I pay particular attention to the halftones, using them to fuse together the areas where the beard hair thins and flows into the skin.

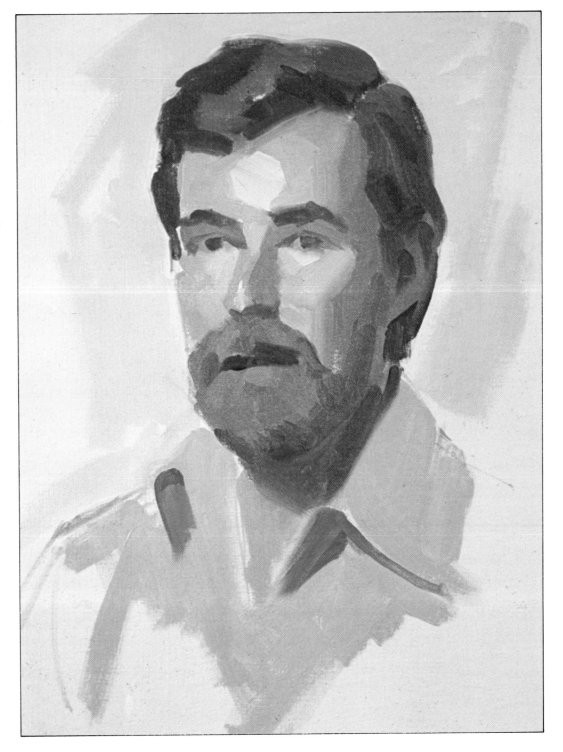

Step 4. Working with a no. 2 filbert bristle, I concentrate on working out the separation between the upper and lower lips. I want to achieve a likeness, but I'm very careful not to become too finicky about details. The upper edge of the mustache on the right is softened as it flows into the cheek. The beard is given more structure, particularly on the lefthand side. Darker lines are indicated, running downward from both corners of the mouth. Darks are also introduced along the bottom chinline as it fades into the shadow of the neck.

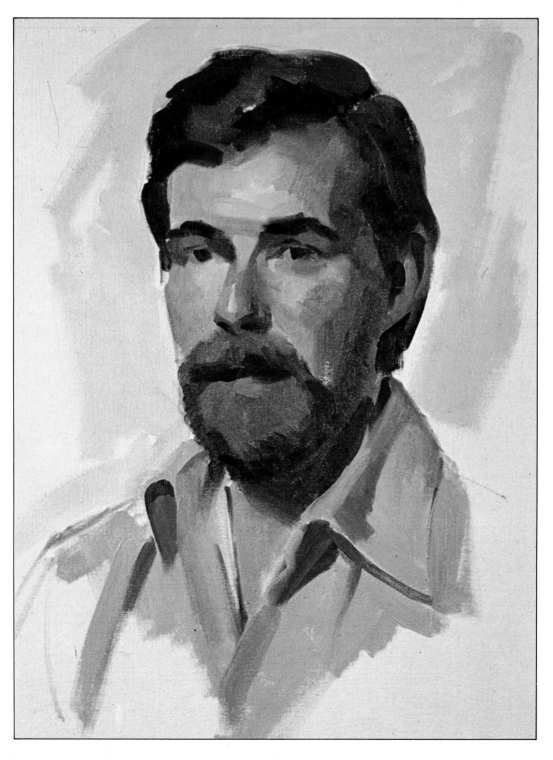

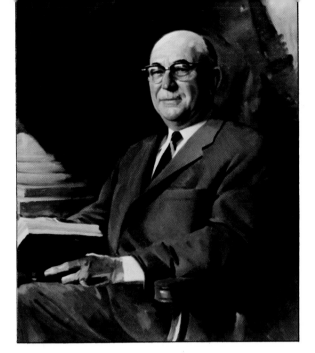

Judge Harry Randall, Sr., *oil on canvas, 30" x 36" (76 x 91 cm), The Randall Collection. Note the way I treated three of the problems discussed in this book: mustache, bald head, and glasses.*

Step 5, Robert Bruton. *Now I pick up the no. 2 flat sable and the no. 6 round sable, which I use primarily for the highlights. I blend the upper lip into the mustache. I put the highlight on the lower lip and indicate the halftone value below it, created by the lip's slight protrusion. I soften the beard throughout and make an effort to simulate its texture by running small brushstrokes against the grain, which provide the illusion of hair. I add several lights to the edge of the sideburn to produce the effect of thickness and protrusion. When painting a beard, I interpret the form simply, and build it up in clear, logical way.*

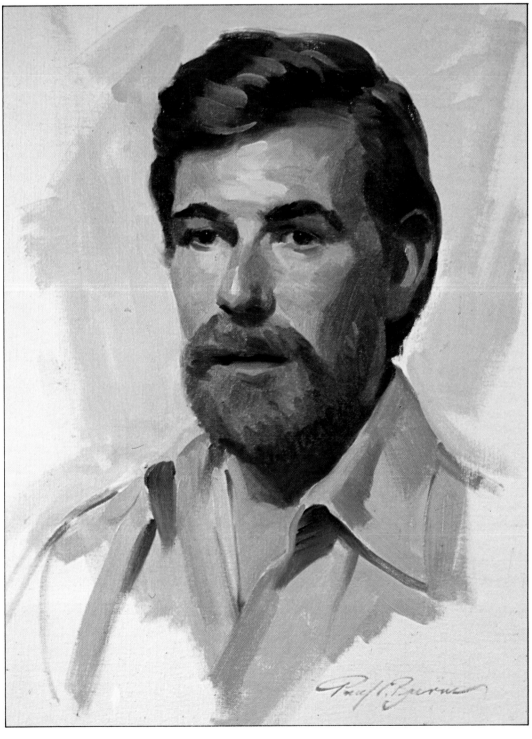

DEMONSTRATION 17

BROAD SMILE

Few artists choose to show a portrait subject smiling so broadly that teeth are revealed. One reason may be that such a picture may prove tiresome to look at after a period of time. Also, some artists may not feel sufficient confidence in their ability to paint teeth. But even though this is not often done, there's no valid reason a portrait may not be painted this way.

THE SPECIFIC PROBLEM I wanted to capture the bright, lively effect of the smile, yet not end up with something resembling a toothpaste ad.

Costume and Background. The dress and background are kept intentionally light and pastel-like in hue to complement the cheerful ambience such a broad smile dictates.

Lighting. Front lighting was used—the eastern light of my studio window—because it met the requirements of the high-key effect I was after.

Palette. Although a full palette was employed in this instance, I could have accomplished my ends with a severely limited palette, too. I used the zinc/flake white combination for my white.

Medium. I used a linseed oil/turpentine combination.

Surface. I worked on a 20″ x 16″ (51 x 41 cm) single-primed cotton canvas.

Brushes. I used only a few filberts and flats.

Time of Execution. The painting required two sittings. The first, with the model present, lasted two and a half hours. The next morning, I reworked some areas without the model present, after storing the canvas overnight in the refrigerator.

Key Color Mixtures. Everything but the sitter's dark brown eyes was deliberately kept in a high key to heighten the joyful, upbeat effect. The dress is alizarin crimson and ultramarine blue, with lots of white. The background is a blend of permanent green deep and white, with touches of flesh color to harmonize with the face.

The blond hair is generally a mixture of yellow ochre and white, with touches of ultramarine blue and permanent green deep to cool it, and burnt sienna to warm it.

The tones in the face never go very deep, except for some areas of greenish/grayish ivory, which are created by adding some permanent green deep and white to the basic skintones. The basic skintones are cadmium red light, yellow ochre, and white, with touches of the ultramarine blue and white combination used to cool the mixture.

The shadow cast by the nose is raw sienna, burnt sienna, and white. There's a deeper addition of burnt sienna in the darker nostril area. The shadow within the chin is burnt sienna, cadmium red light, and a touch of the ultramarine blue and white mixture.

The teeth are off-white in the center and yellow ochre, ultramarine blue, and white in the turning areas. The highlights on the teeth are almost pure white, with just a hint of alizarin crimson. The lips are cadmium red light and white, with touches of the permanent green deep and white combination used to cool it.

Step 1. With raw umber and white I draw in a rather detailed general outline. In an uplifted head, and particularly one that's smiling, it's vital to put down the angles and arcs of the features as accurately as possible early in the portrait. Unless the drawing is correct right now, you'll be devoting needless time to adjusting it later, instead of concerning yourself with the factors of value and color in the latter stages of painting.

Teeth must not be made too light or they'll render the surrounding areas dark and drab by contrast. They must be painted as a single form, not with each tooth outlined individually. Since they're set on a curved form within the head, the effect of roundness must also be retained. Never show both the top *and* the bottom rows at the same time—the effect will be ludicrous. Also, remember that a person smiles not only with the mouth, but with the entire face.

Step 2. I now mass in the color. There are few darks evident, just those in the eyes and around the jawline. A light green tone is placed in the background. Outside of the teeth and a few areas that will catch the highlights, the face is composed of a nearly uniform tone. The dress is massed in a similarly single-value tone.

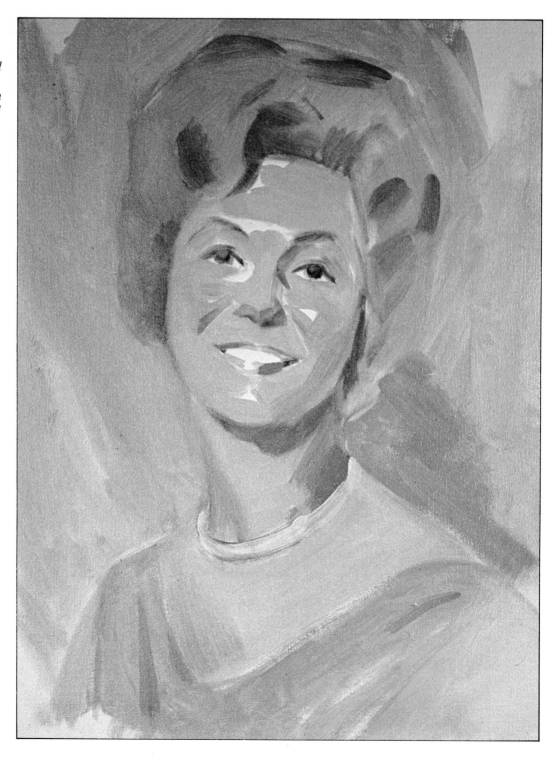

You must show the full range of light, halftone, and shadow values on teeth. This will heighten the effect of roundness, texture, and character in the teeth. Keep the light on the front two teeth highest, then darken them progressively as they near the corners of the mouth.

Make sure the whole face is smiling—the eyes and the muscles of the cheeks and jaws. Watch for the shadows a smile creates beneath the cheekbones and for the highlights on the cheeks. Look for the subtle value changes of the planes around the mouth. A good way to check this is to cover the mouth on the portrait and see if the rest of the face still appears to be smiling.

Don't make the corners of the mouth too hard in the edges or too dark in tone. They're flesh, and must be kept appropriately soft and pliant. Make sure the highlights on the smiling lips are precisely correct in value, or they won't relate properly to the teeth.

Step 3. More modeling of individual planes and features is accomplished. The reflected light on the left temple is put in. The hair receives darker accents within the recesses formed by the waves. The cheeks are rounded off to show the smile. The teeth are painted in in a single value and light highlights are placed on the lower lip and on the cheeks. The neck and breast areas are further developed. The light shadow is placed on the right-hand cheek.

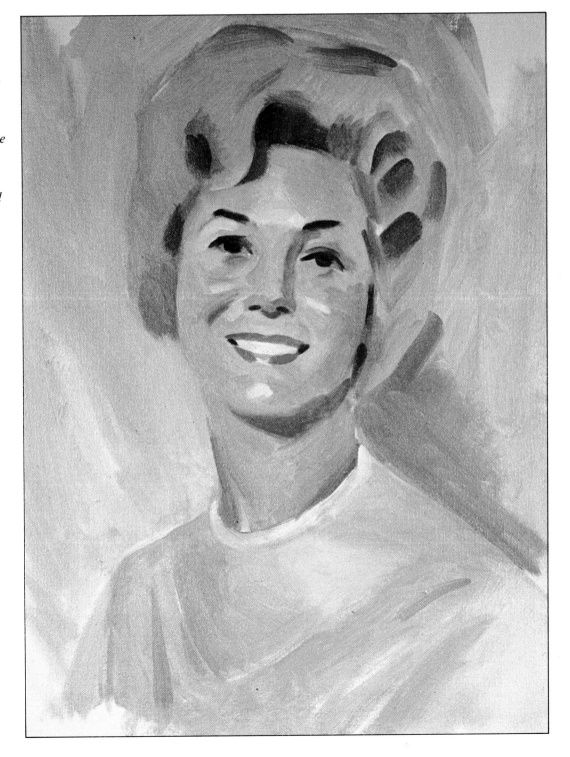

Mrs. John R. Wanamaker and Beany, *oil on canvas, 36" x 30" (91 x 76 cm), Collection Mr. and Mrs. John R. Wanamaker. I began this painting in the Wanamaker home in Germantown, Pennsylvania, and finished it in my studio. I think that the presence of the little dog adds a nice, lively touch to the portrait. The use of animals in portraiture has a long history. Velasquez, Goya, and Raeburn, are only a few of the many artists who used this device. I always try to add a different touch to my portraits for interest and variety. Compare the way I treated Mrs. Wanamaker's broad smile to those I painted on the facing page.*

Step 4. Everything is further drawn in and delineated—the eyes, hair, mouth, necklace, and dress. Highlights are placed on the teeth to promote a three-dimensional effect. The values are darkened in appropriate places. Still, I'm not satisfied with the result—the head seems to lack vigor and vitality. I, therefore, decide to store the canvas in the refrigerator and resume painting the following morning.

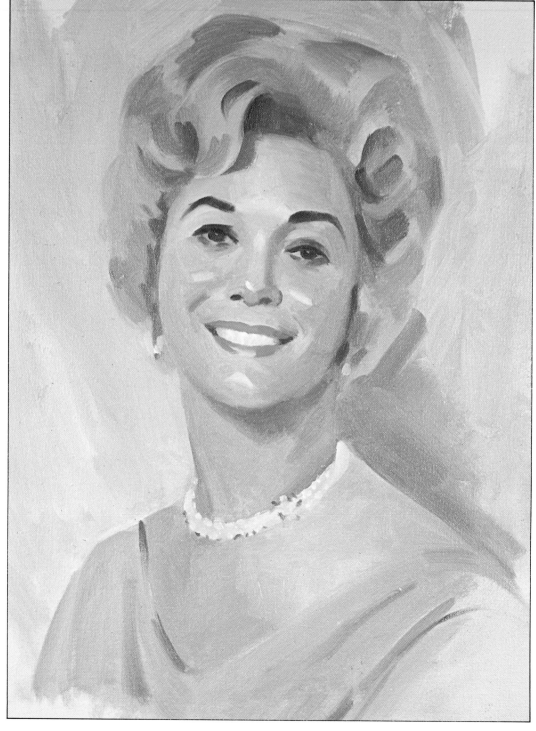

Mrs. Matthew Bohrer, *oil on canvas, 36" x 30" (91 x 76 cm), Bohrer Collection. This is a larger version of the portrait below. It's worthwhile to consider how much more than the subject's head is involved in a portrait. You must learn how to pose and paint hands, how to make compositional use of chairs, how to help the sitter select the appropriate costume, and how to fuse all of these elements into a harmonious whole.*

Step 5, Rhoda Bohrer. Although the changes apparent between this stage and the previous are small, they do exist. One is the shape of the muscles in the neck. Another is the general darkening of the tones in the face. The highlight just above the bridge of the nose is strengthened by darkening the adjoining values. The color of the lips is lightened. Although I might have stopped working on the portrait on the first day, I feel more content having carried it further. My conscience is satisfied and I feel that the portrait has been improved considerably.

DEMONSTRATION 18

EYEGLASSES

Since at least half the population wears eyeglasses, it's fair to assume that you'll be painting them with some regularity in your portrait career. Let's consider the options of treating a subject with eyeglasses.

THE SPECIFIC
PROBLEM

My intention was to paint a portrait of a man who happened to be wearing glasses—not a pair of glasses, with the head as an incidental feature.

Costume and Background. Since my subject was a clergyman, the choice of the costume was prescribed. I selected a dark blue background to match the value and color of the suit so that the head would stand out boldly and project forward.

Lighting. The side angle of natural east daylight.

Palette. I used a full palette, and a zinc/flake white combination.

Medium. My medium was a linseed oil/turpentine combination.

Surface. I worked on a 20″ x 16″ (51 x 41 cm) single-primed cotton canvas.

Brushes. I used the following: bristle flats, nos. 10, 8, two no. 4's, 2, and 1; a no. 5 bristle filbert; and a no. 6 and 2 sable flat.

Time of Execution. The painting was done in a single sitting of two and a half hours.

Key Color Mixtures. The basic skintones are mixtures of yellow ochre, raw sienna, Indian red, and white, with olive green highlights to cool them. The olive green is a mixture of ultramarine blue, cadmium orange, and white. The shadowed side of the head is burnt sienna, raw sienna, and the ultramarine blue/white combination.

There's yellow ochre, raw sienna, and some cadmium orange in the forehead; and cadmium red light and Indian red in the warmer cheek areas. The bridge of the nose is burnt sienna and cadmium red light. The eyes are burnt sienna, ultramarine blue, and white. The area beneath the nose is yellow ochre and white. The lips are Indian red, cadmium red light, ultramarine blue, and white.

The hair is ultramarine blue, burnt sienna, and white, with touches of raw sienna to warm it; the eyebrows are ivory black and white with touches of both raw and burnt sienna to warm them.

Step 1. I begin with a rather precise drawing, with the shadowed areas lightly indicated in a light gray wash of ivory black and white. The background is suggested, as are parts of the monsignor's suit. The eyeglass frames are drawn in. I work in a squarelike, blocky fashion—the forms will be rounded off later.

PRINCIPLES
OF EYEGLASSES

First of all, don't place too much importance on the glasses or you'll distract the viewer from the main area of interest—the face. Now, you can paint a subject without his glasses and add them on later, or you can leave them on from the very beginning. It's better to do the latter, however; if you try to paint a subject with his glasses off, his eyes may appear strained and unnatural.

Avoid using a frontal light on a person wearing glasses or you'll get a glare that will conceal the eyes. However, use the light that does strike the lenses or frames as a valuable guide against which to relate the rest of the values in the head.

Lenses that are thin don't affect the areas they cover to any noticeable extent. However, lenses of some thickness will darken the areas behind them to some degree. Don't paint the sidepiece too dark, since it's a reflective surface that catches the lights and colors of objects in the background. Also, be sure to include whatever shadow is cast by the glasses. The one cast by the sidepiece of the frame is especially revealing in that it helps show the form of the bone structure below.

Step 2. All the areas are filled in with the appropriate local colors. Still working in large masses, I paint the background a dark blue. This will help set off the reds of the face and allow me to establish the light tones of the head in relation to its dark backdrop. The shadowed sides of the hair and face are massed in first, then the lighter areas are thinly filled in. The distinct transition between the light and dark sides of the head is shown. The gray of the hair is broken up into dark and light values. The suggestion of the lens is shown in the corner of the left eye. The white of the collar will be used as a foil against which I'll relate the lights in the head.

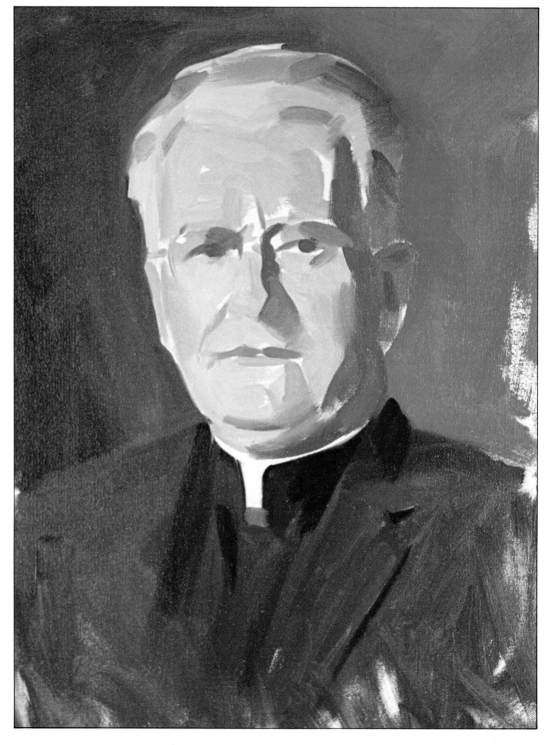

Leave the glasses on, but paint the subject as if he weren't wearing them, then add them last. Paint glasses by defining the three elements that constitute them: the highlights and reflected lights within the lenses themselves, and the rims containing them. If the frames are heavy, only suggest them at first, then refine them in the concluding stages of the portrait. Paint merely the suggestion of the lenses—don't try to carry to completion every part of the glass or plastic. If any refraction exists due to magnification in the lenses, by all means show it!

Try to light a person wearing glasses in such a way that the raking light strikes the top rim of the frame. Rimless glasses may be suggested by a highlight on one side of the lens and a shadow on the other. Bifocals present a highlight on the lower half of the lenses.

Step 3. Now I proceed to break up the larger planes within the head. Thicker layers of paint are placed in the lighter areas. Definite highlights are placed in the upper left corners of the lenses. A highlight is indicated on the nosepiece of the frame. Highlights are also shown in the hair and on the forehead.

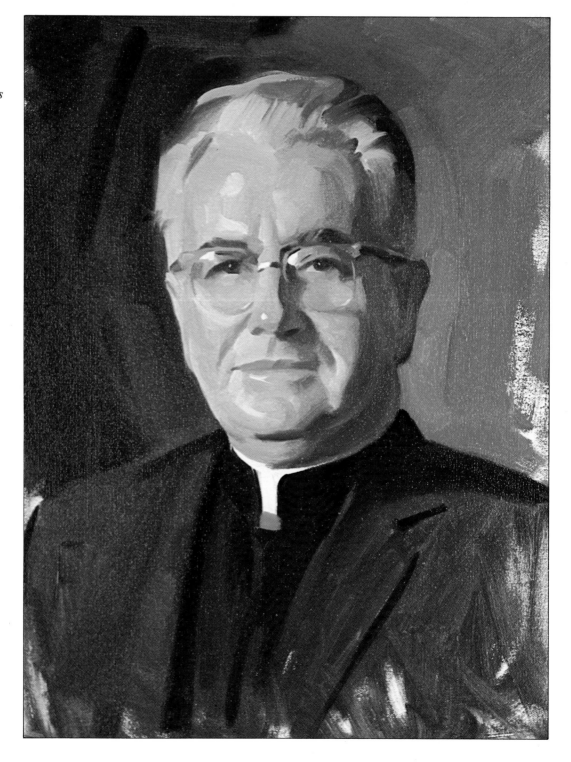

Monsignor Harold J. Dilger, S.T.L., *oil on canvas, 36" x 30" (91 x 76 cm), Collection St. Andrews Church, Westwood, New Jersey. This is the formal portrait of my subject, on which this demonstration is based. The low angle from which I painted adds dignity to his pose.*

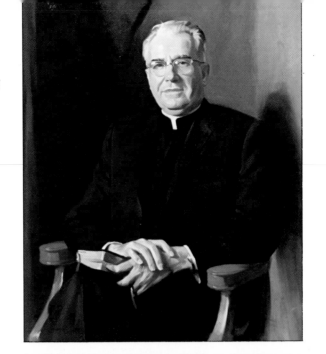

Step 4, Monsignor Harold J. Dilger, S.T.L. *Now I turn my attention to all the highlights. The shadow cast by the lens is painted in on the right. The flesh is darkened slightly underneath to show the presence of the rimless lenses. The sidepieces of the frames are shown, with the right side picking up some reflected lights. The character of the thick, iron-gray hair is developed. The blue and green tones on the subject's jowls are accentuated. The contour of the head is strengthened on the right to emphasize the power and forcefulness of the subject's leonine head.*

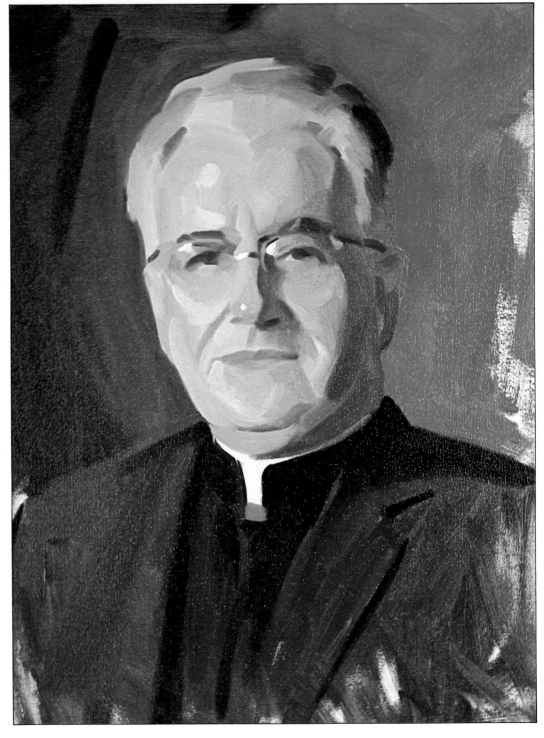

DEMONSTRATION 19

PROFILE

The notion of painting only half of a subject's face seems abhorrent to most aspiring artists and they circumvent the challenge by simply avoiding it. Yet, in the past, many superb profile portraits have been painted. The most obvious example that comes immediately to mind is the celebrated *Portrait of Madame X* by Sargent, an artist who was eternally searching for original, innovative approaches to a portrait. We can do far worse in expanding our own artistic vision than follow this great master's example.

THE SPECIFIC PROBLEM I wanted to capture the likeness and the essence of my model without creating the formal, Roman-head effect seen on coins, stamps, or medallions. This involved adding a measure of casualness to the pose, plus individual touches that characterized the sitter.

Costume and Background. The wide-brimmed hat so favored by Westerners seemed most appropriate to the man. It also helped the design of the portrait by providing a series of interesting arches plus dark and light masses which strengthened the tonal relationship of the picture.

The pale background helped promote the effect of a darker head silhouetted against a lighter plane, and helped bring the head forward.

Lighting. The portrait was painted on an overcast day in New Mexico, where the light is very intense and bright. The subject was faced into the light so that the heaviest shadows would emerge at the rear of his head.

Palette. I used a full palette of colors.

Medium. My medium was a linseed oil/turpentine combination.

Surface. I worked on a 20″ x 16″ (51 x 41 cm) single-primed cotton canvas.

Brushes. I used nos. 10, 4, and 2 bristle flats; nos. 8, 5, and 4 bristle filberts; and two no. 6 sable rounds.

Time of Execution. The protrait was painted in two and three-quarter hours.

Key Color Mixtures. The cool grays of the hat are designed to serve as a foil for the warm colors within the face. The darkest areas in the hat are ultramarine blue, burnt sienna, and white. The sweater is a combination of ultramarine blue with raw sienna, or of ultramarine blue with burnt sienna. Its warmer areas are composed of yellow ochre, white, and ultramarine blue. The shirt is ultramarine blue and white.

The skintones of the face are basically burnt sienna, Indian red, yellow ochre, and ultramarine blue in the lighter areas and ultramarine blue, yellow ochre, raw sienna, and white in the halftones, with touches of Indian red to turn it toward the mauvish side.

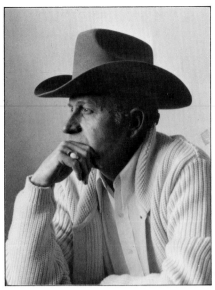

Step 1. On an untoned canvas, I draw the outline with raw umber and white thinned with turpentine. The outline is fairly accurately rendered, with special attention paid to the angles formed by the shirt, sweater, collar, jawbone, and the looping arches of the western hat. I indicate the break between the light and shadow in the head, the depths of the eyesocket, the shadow of the hand, and the indentation within the temple.

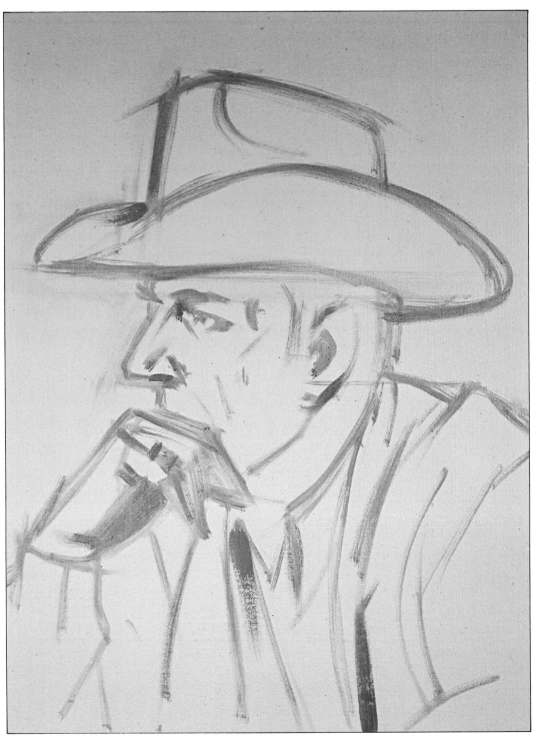

Don't attempt to paint a profile portrait until you've first painted a number of conventional heads. When painting a profile, keep in mind that there's a side of the face that you're not seeing at the moment, but one that's there nevertheless. This will help you strive for the effect of roundness the profile must possess in order to project a sense of reality.

You can obtain a good view of your own left and right profile through the use of a three-way mirror. This is a device painters have employed through the ages and it will provide you with an excellent opportunity to practice drawing or painting the profile.

Once you've done a number of profiles successfully, try enlivening subsequent profile portraits with such props as hats, cigars, cigarets, or a pipe.

Light your profile subjects from the side, so the light falls on the front of the face. Front lighting, which lights them from the side, robs the head of the good, solid shadows you'll require to overcome the effect of flatness a profile naturally projects. The side lighting also produces the quantity and quality of halftones you'll need to achieve a round, sculptured look.

Step 2. The head is broken up into divisions of light and darks the sweater, shirt, and hat. The canvas is left bare in selected areas that will receive subsequent light accents. The basic local colors are indicated. There's raw sienna and yellow ochre in the sweater and Indian red in the shadow side of the face. The ear, which protrudes and therefore catches some of the light, is brought out of the shadow.

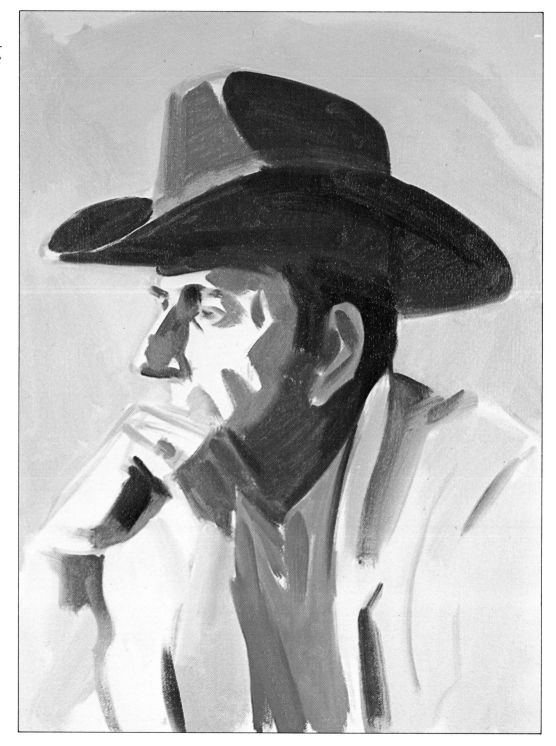

Emphasize contrasts of value in order to heighten the effect of roundness. Emphasize the presence of planes within the face for the same reason. Use imaginary horizontal and vertical plumb lines to relate the placement and angle of the subject's features to edges of objects in the room. Show a tiny trace of the hidden side of the face. This is a device that lends verity to the profile portrait, and also makes the visible eye appear less eliptical and more realistic.

Vary your edges! If the contour all around the head is sharp, the portrait will emerge looking like a cardboard cutout. Therefore, paint some edges harder and some softer.

Step 3. Now, I paint in the light areas of the face, including some of its halftones. These halftones bridge the gap between light and dark and help promote the illusion of the form of the head turning. The lights in the face are kept down in value, reserving the lightest highlights for later. I work into the background to some degree, darkening its value around the wrist in order to bring out its light tone by contrast.

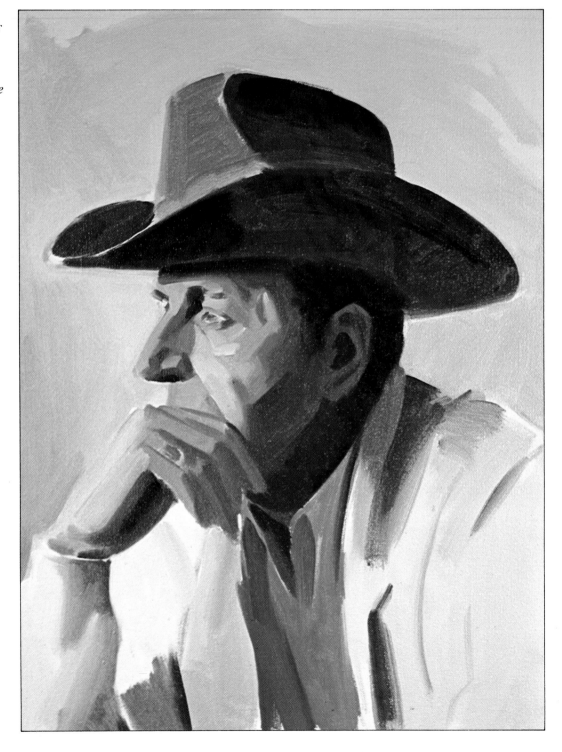

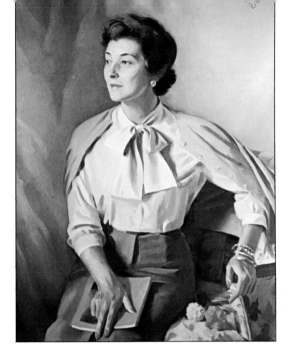

Mildred Simmons, *oil on canvas, 36" x 30" (91 x 76 cm), Collection of the artist. I sometimes ask people to pose for me so that I can paint sample portraits. Such pictures are occasionally needed for exhibitions to help establish an artist's reputation and to bring him portrait commissions. Since this book basically deals only with heads, it might be helpful to note how much importance is added to the overall portrait design by the arrangement of the body, the hands, and the props.*

Step 4, James Tanzola. The details within the eye are completed. The small halftone planes that flow from the nose into the cheekbone are shown. More color is introduced into the sweater. The hands are painted to completion with a strong highlight on the knuckles. All the forms in the subject's rather bony face are defined—I'm seeking to show its strong, rather knobby quality. This type of face, with its many distinct planes, is particularly suited to a profile portrait. Note the thin line of the hat brim in front. It was achieved by painting in the darks adjoining it with heavy strokes of color, rather than by drawing it in with a thin brushline.

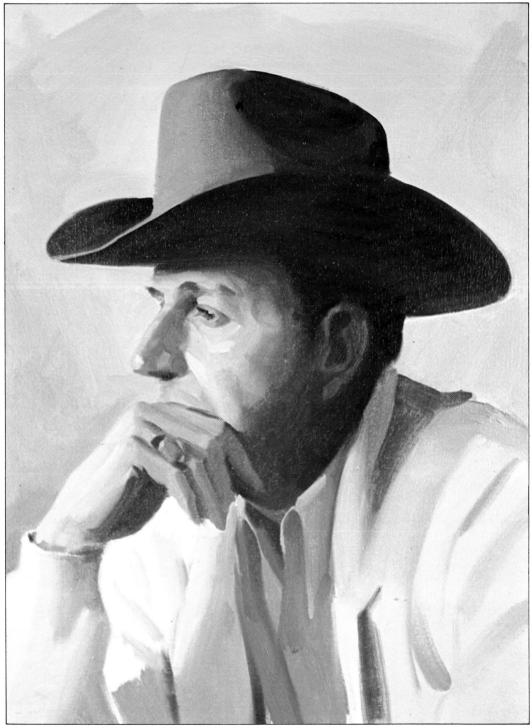

DEMONSTRATION 20

BALD HEAD

Painting a bald head poses some difficulties at first. A naked skull lacks the variety of planes present in the face, and its roundness, smoothness, and frequent shininess can prove a problem to the aspiring portraitist.

THE SPECIFIC PROBLEM

THE SPECIFIC PROBLEM

The specific challenge was to depict the noble, sleek head of my distinguished subject so that it emerged lifelike and as the flesh and blood it is, not as some marblelike statuary.

Background and Costume. I painted my sitter, who is a former federal judge, in the robes of his office. The vignetted background was designed to set off the intriguing outline of the judge's intellectual-like skull.

Lighting. I painted under cool north daylight issuing from a high angle.

Medium. My medium was a linseed oil/turpentine combination.

Palette. I used a limited palette of alizarin crimson, cadmium yellow pale, ultramarine blue, and zinc/flake white. I chose this severely restricted palette as a challenge, to see if I could make it suffice for a portrait.

Surface. My support was a 20″ x 16″ (51 x 41 cm) single-primed cotton canvas.

Brushes. I used nos. 6, 4, and 2 bristle flats, and nos. 8 and 5 bristle filberts.

Time of Execution. The painting required a single sitting of between two and three hours duration to execute.

Key Color Mixtures. Working with a limited palette forces the artist to exercise an economy of color that will serve him in good stead when he resumes with a full palette. Since the three colors and white are used in almost every mixture, it came down to a matter of proportion—where to use more of one color and less of another. For instance, the robe is basically alizarin crimson and ultramarine blue with white, plus a slight accent of the cadmium yellow pale here and there. The flesh is basically alizarin crimson, cadmium yellow pale, and white, with some ultramarine blue used to cool it. The highlight on the forehead is nearly white, with touches of cadmium yellow pale and pale ultramarine blue to cool it.

The one lesson to gain from painting in the three primaries, is that the addition of a third color always serves to gray down the other two. The more of the third color is added, the duller the mixture emerges. An example is the gray background, which received almost equal proportions of the three colors plus white.

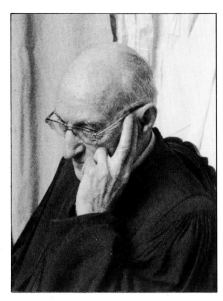

Step 1. As a departure from my usual approach, and since I'm working with a palette limited to the three primaries and white, I decide to make my initial drawing in ultramarine blue, cadmium yellow pale, and alizarin crimson. This outline is quite simple, and provides clues to where forms meet and shows the angles of the downcast face. The indentation of the skull is shown on the right. The fingers are roughly delineated.

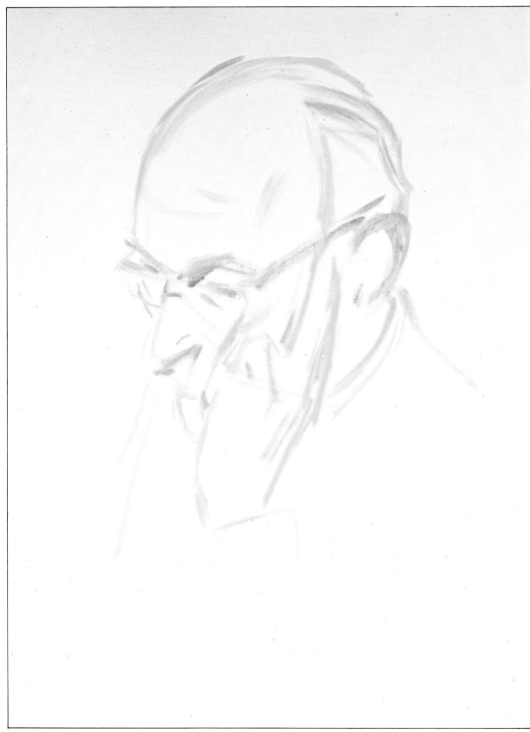

PRINCIPLES OF BALD HEADS

To promote the effect of roundness, it's best to light the bald head with a single source of illumination. To heighten the impact of a bald head—which may be quite striking—a dark background may be quite effective.

Since the bald head catches the direct rays of the sun, it may be quite tan or reddish in contrast to the face. The very opposite situation prevails among bald individuals accustomed to wearing hats outdoors, such as farmers, fishermen, and Westerners. When their hats are removed, their heads may be quite white in contrast to their faces.

Scalps tend to be oily, therefore bald heads are apt to reflect strong highlights.

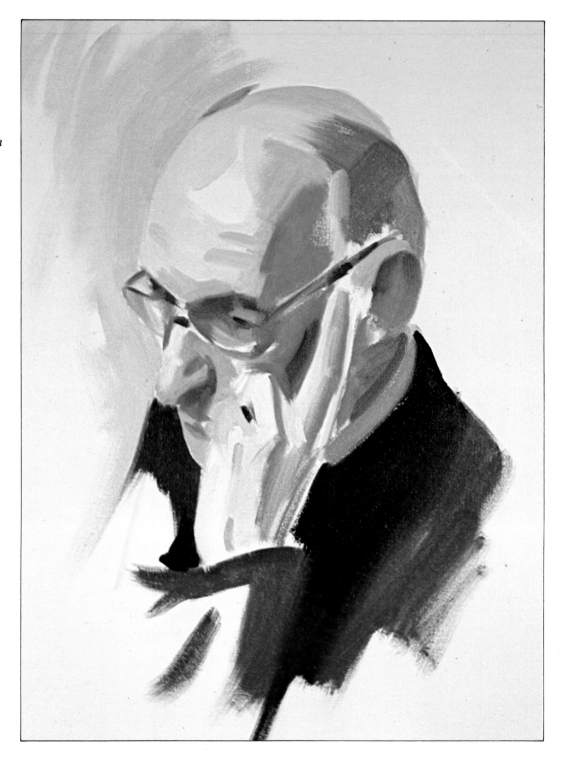

Step 2. Employing my full palette of four colors, I mass in the big forms in strong light and dark tones. A large area within the forehead is left bare for the forthcoming highlight. There's a yellowish tone in the front of the forehead that's closest to the source of the light. The robe is quickly massed in with combined alizarin crimson and ultramarine blue tones. The upheld hand appears pale due to the downward flow of blood away from it.

TIPS ON
BALD HEADS
Make the transitions where the bald scalp meets the existing hair very soft and gradual. The edge of a bald head that is seen against a dark background can probably be painted sharper than the edges where hair grows—hair has a softening effect.

In older bald subjects, there are apt to be a number of patches of pigmental discoloration on the head. Disregard these in painting the portrait. Also, play down the folds and wrinkles. A mere suggestion of blemishes will suffice.

To keep the bald head from emerging too smooth or sleek, retain, or even stress, the presence of planes in the skull.

Step 3. All the elements are carried along farther. The background and robe are left as is for the moment. The darks of the fingers now flow into the darks of the head. The highlights are put in so that all the painted areas of the canvas are now filled. In accordance with sound painting practices, the paint is applied more thickly in the lights than in the darks.

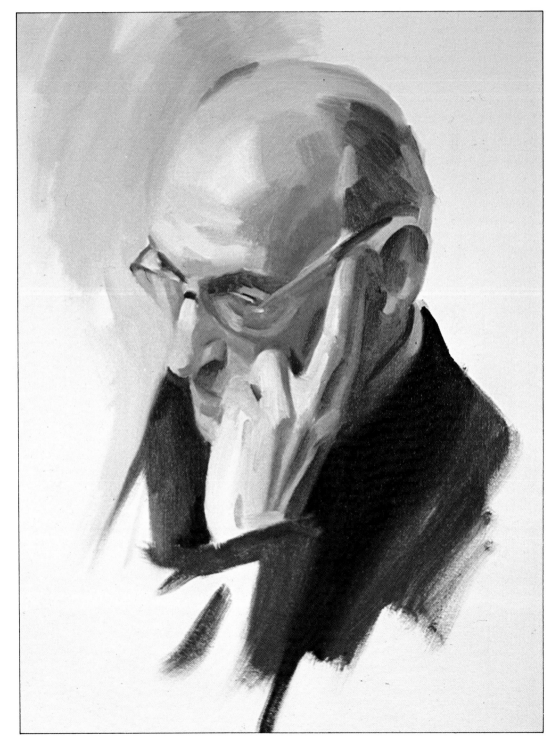

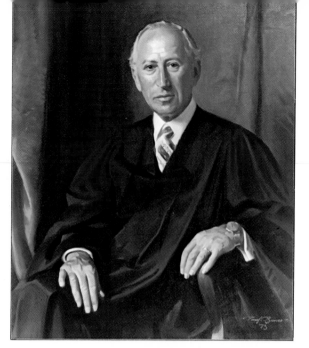

Chief Justice Joseph Weintraub, *oil on canvas, 38" x 32" (97 x 81 cm), Collection New Jersey Supreme Court, Trenton, New Jersey. I often paint subjects in the costumes of their office—military uniforms, medical smocks, clerical or judicial robes, and the like, because it lends the dignity of their position to the portrait. Here, the sweep and flow of the robe adds a feeling of movement to an otherwise static pose. You must always be alert to ways to make a portrait unusual and interesting.*

Step 4. The vignetted shapes of the robe and of the background are established. The planes in the face and skull are pulled closer together in value with the addition of halftones. The transitions between hair and skin are softened and lightened. Highlights are placed on the rims of the eyeglasses. The fold of skin pushed up by the fingers is indicated. Not much remains to be done.

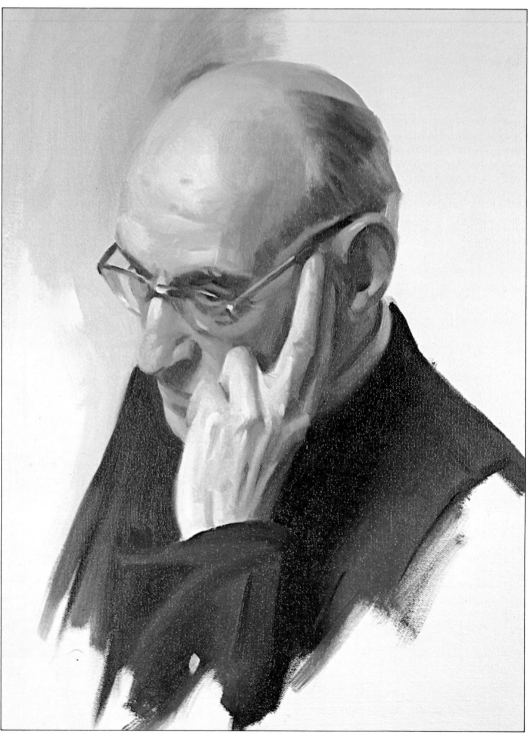

Judge Anthony T. Augelli, *Former Chief Justice, Federal Court of New Jersey, oil on canvas, 36″ x 30″ (91 x 76 cm), Collection Federal Court in Newark, New Jersey. The judge's sympathetic, compassionate nature is emphasized in this larger portrait. In both this portrait and the one below, he is shown resting his head in his hands in a contemplative pose often taken by judges. I treated the background in a contemporary fashion, selecting a light tone and bright pattern instead of the usual darker and more conservative background traditionally associated with portraits of judges.*

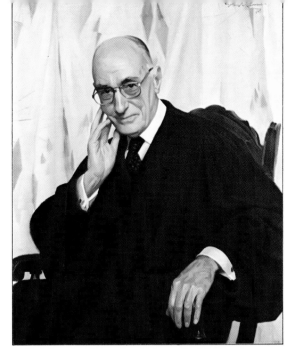

Step 5, Judge Anthony T. Augelli. *Some additional accents are placed into the background. The modeling of the hand is refined. The shadow cast by the nose is slightly strengthened. Areas of wrinkles or discoloration are minimized in the skull. I'm satisfied that I've gone as far as I wished to go with a painting that has fulfilled its requisite—a study of a hairless head painted in simple, sympathetic, yet totally revealing fashion.*

BIBLIOGRAPHY

Balcomb, Mary N. *Nicholi Fechin.* Flagstaff: Northland Press (P.O. Box North, Flagstaff, Arizona, 86001), 1975.

Baldry, A.L. *Painting a Portrait by DeLaszlo.* New York: The Studio Publishers, Inc., 1927 and London: The Studio Ltd., 1927.

Brown, Dale. *The World of Velasquez.* New York; Time-Life Books, 1969.

Charteris, Evan. *John S. Sargent.* New York: Charles Scribner's Sons, 1927. (Reprint of the 1927 edition now published by Arno Press, 3 Park Avenue, New York, N.Y. 10016 and by Gale Research Company, Book Tower, Detroit, Michigan 48226. Contains rare and excellent information regarding his method; see especially pp. 29, 181–188.)

Du Gué Trapier, Elizabeth. "Sorolla" (and others) in *Catalog of Paintings,* Vol. 1. New York: Hispanic Society, 1932.

Downes, William Howe. *John S. Sargent: His Life and Work.* Boston: Little, Brown & Company, 1925.

Kinstler, Everett Raymond. *Painting Portraits,* edited by Susan E. Meyer. New York: Watson-Guptill Publications, 1971. (Paperback edition, 1978.)

Mann, Harrington. *The Techniques of Portrait Painting.* London: The New White Library, 1933.

McKibbin, David. *Sargent's Boston.* Boston: Museum of Fine Arts, 1956.

Mount, Charles Merrill, *Gilbert Stuart.* New York: W.W. Norton & Company, 1964.

——. *John Singer Sargent: A Biography,* New York: W.W. Norton & Company. (Reprint of a 1969 edition, available from Kraus Reprint Company, Rte. 100, Millwood, N.Y. 10546.)

Ormond, Richard. *J.S. Sargent: Paintings, Drawings, Watercolors.* New York: Harper & Row, 1970.

Pantorba, Bernardino de. *Guia del Museo Sorolla.* Madrid: Campo del Martinez. (Museum guidebook.)

Raggianti, Carlo L. *Boldini.* Milan: Rizzoli, 1970.

Sanden, John Howard. *Painting the Head in Oil,* edited by Joe Singer. New York: Watson-Guptill Publications, 1976.

Sargent Exhibition Catalog. London: Royal Academy, 1926. (Excellent reproductions.)

Singer, Joe. *Painting Men's Portraits.* New York: Watson-Guptill Publications, 1977.

——. *Painting Women's Portraits.* New York: Watson-Guptill Publications, 1977.

Stevenson, R.A.M. *Velasquez.* 1928.

Trivas, N.S., ed. *The Paintings of Frans Hals.* New York: Oxford University Press, 1941 and London: The Phaidon Press, 1941.

INDEX

Edited by Bonnie Silverstein
Designed by Bob Fillie
Set in 11-point Times Roman